Look, Learn & Create

Calligraphy

A WORKSHOP
101
IN A BOOK

Creative Publishing
international

Creative Publishing international

Calligraphy 101

Copyright © 2010
Creative Publishing international, Inc.
400 First Avenue North
Suite 300
Minneapolis, Minnesota 55401
1-800-328-3895
www.creativepub.com

Printed in China
10 9 8 7 6 5 4 3 2 1

Library of Congress Cataloging-in-Publication Data

Gauthier, Jeaneen.
 Calligraphy 101 / Jeaneen Gauthier.
 p. cm.
 Includes index.
 Summary: "Beginner's guide to materials and
techniques for learning to do calligraphy. Includes
instructional DVD-ROM"--Provided by publisher.
 ISBN-13: 978-1-58923-503-8 (soft cover)
 ISBN-10: 1-58923-503-7 (soft cover)
 1. Calligraphy--Technique. I. Title.

 NK3600.G38 2010
 745.6'1--dc22

2010016769

Photographer: Corean Komarec
Photo Coordinator: Joanne Wawra
Copy Editor: Ellen Goldstein
Cover & Book Design: Mighty Media, Inc.
Page Layout: Mighty Media, Inc.
Videographer: Tom Siler

Visit www.Craftside.Typepad.com for a behind-the-scenes peek at our crafty world!

Due to differing conditions, materials, and skill levels, the publisher and various manufacturers disclaim any liability for unsatisfactory results or injury due to improper use of tools, materials, or information in this publication.

CONTENTS

How to Use This Book

Calligraphy—from the Greek word for "beautiful writing"—is lovely to look at and a joy to create. Even in today's world of text messaging and digital printing, beautifully written words have a special place. If you've ever wanted to learn how to do calligraphy, but weren't sure how to begin, this is the book for you. Here you will learn the basics of calligraphy step by step as you create projects that are easy, satisfying, and fun! You'll also be encouraged to experiment, play, and even break the rules a little as you develop your own personal style of beautiful writing.

The materials needed to do calligraphy are very simple: ink, pen, and paper. However, choosing the right ink, the right pen, and the right paper is not always as simple, especially when you are just beginning. This book will help you navigate the wide array of calligraphy products available and show you which tools and supplies are a pleasure to use and which also deliver consistent, high-quality results. You will be happy to discover that having good materials to work with is a major first step on your way to creating beautiful calligraphy.

In this book you will also learn the essential skills and techniques that all calligraphers use. Most of these skills are very simple, such as learning how to hold the pen, and how to position the writing paper. However, these skills may not seem obvious at first, and they do require practice. Throughout this book

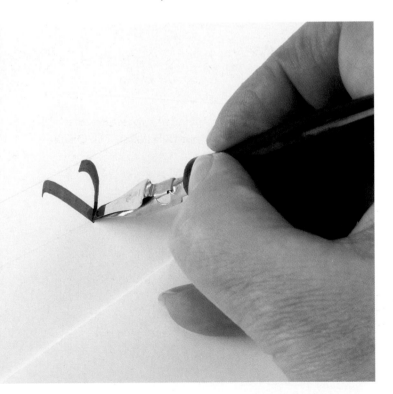

you will find suggestions for practicing the skills you learn in ways that are fun and relaxing, and that will spark your creativity.

Many beginners get discouraged when starting to learn calligraphy because their early efforts aren't "perfect." The aim of this book is to inspire you to explore and develop a style of writing that is "personal" rather than "perfect." You are encouraged to experiment, play, and keep an open mind—skills essential for any artist. It's a commonly known fact that no two calligraphers can write exactly alike, no matter how skilled and experienced they are. So, don't feel like you have to copy every project in this book exactly. Instead, use this book as a guide for developing your penmanship skills and as a source of inspiration for allowing your own beautiful writing to flow.

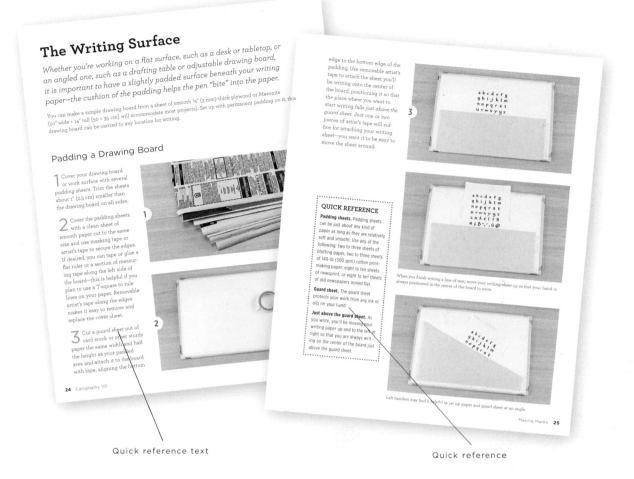

Quick reference text

Quick reference

The first section of this book introduces you to the vast array of tools and supplies used in calligraphy, explaining what the various items are used for, and letting you know which items you'll need to get started (as well as which ones you won't). The second section introduces the basics of using the calligraphy pen, and encourages you to explore the various kinds of marks you can make with it. Each of the following sections introduces you to a unique calligraphic alphabet, a set of projects, the skills necessary to complete the projects, and various technical tips and tricks. A list of necessary supplies precedes each project, and every step of each project is photographed so that you can see exactly what to do at each point along the way. Tips appear throughout the book to give more detailed suggestions that will help you improve your techniques. The Quick Reference sidebars are there to clarify words or phrases printed *like this*. Many of the projects also include variations—different wording, papers, colors, etc.—and you are encouraged to make your own variations to any project whenever you feel inspired to do so.

The DVD-ROM included with this book is an additional learning tool that will show you the essential techniques used for calligraphy. It is both PC and Mac compatible, and can be viewed using Quicktime software. To download the latest version of Quicktime for free, visit http://www.apple.com/quicktime/download.

You can do calligraphy! Now, let's get started.

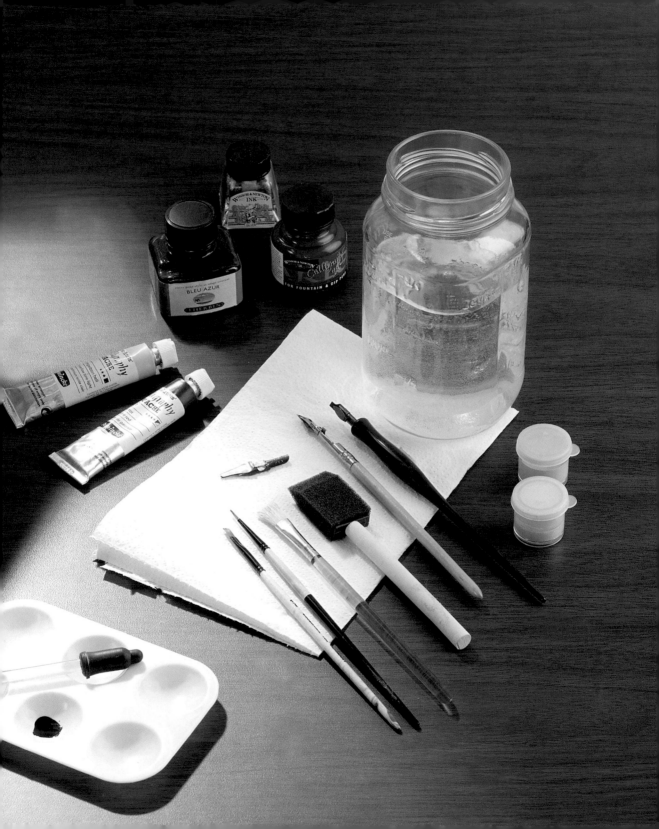

Tools and Supplies

One of the great advantages of learning the art of calligraphy is that you need only a few simple supplies to get started. This chapter will introduce you to the tools and supplies needed for calligraphy, explaining what they are used for and whether or not they are essential for getting started.

Basic Supplies to Get Started

- calligraphy fountain pen with a flat-tipped nib measuring 2 to 3 mm wide, and equipped with refillable ink reservoir
- dipping pen nib with a flat tip (often called a round-hand nib) measuring 2 to 3 mm wide
- dipping pen nib with angled tip (Italic nib, Brause nib) measuring about 2 mm wide
- nib holder
- #0 round brush, ⅛" (3 mm) flat brush, craft brush for glue
- black calligraphy ink (as well as red, blue, yellow, and white calligraphy ink, if you want to mix colors)
- paper for pens/markers
- inexpensive practice paper (heavy copier paper, graph paper, heavy notebook paper)
- Bristol
- pencil
- gray kneadable and white plastic erasers
- T-square, 12" (30.5 cm)
- grid/lined ruler with steel edge, 12" (30.5 cm)
- craft knife
- scissors
- craft glue
- drafting tape or artist's tape
- little containers for ink
- glass jar for rinse water
- paper towels or cotton rags

Other tools and supplies used in this book —purchase these as you need them:

- agate burnisher for applying gold leaf
- artist's spray fixative for stabilizing metallic pigments so they don't brush off the paper
- bookbinder's awl for poking holes in paper
- brads for attaching layers of card stock together
- brushes in assorted shapes and sizes for illuminating
- self-healing cutting mat to place under paper when cutting with a craft knife
- distilled water for mixing with gouache or pigment
- gold and silver leaf for gilding
- gold leaf sizing liquid
- gum arabic for use with metallic pigments
- ⅛" (3 mm) hole punch for punching holes in paper
- palette for holding several colors of ink or paint
- polyurethane spray sealant for sealing painted surfaces
- assorted ribbon, cord, and beads for binding and decoration
- fine sandpaper for preparing surfaces for painting
- scoring wheel, used with a ruler to impress grooves into paper to make a crisp fold
- wax paper

Writing Instruments

Calligraphers use a variety of tools to make marks, including calligraphy fountain pens, dipping pens, markers, quills, and brushes.

Pens and Nibs

Calligraphy fountain pens are much like ordinary fountain pens; the main difference is that the nib (writing edge) of a calligraphy fountain pen is broader than that of an ordinary fountain pen. The broad edge of the nib is what makes the characteristic thick-and-thin pen lines of calligraphy possible. Calligraphy fountain pens are usually sold with an ink reservoir—a removable tubelike device that can be filled with ink and used over and over again. Disposable fountain pen cartridges can also be used in calligraphy fountain pens, but the ink tends to be less dense and thus not as suitable for calligraphy artwork.

Calligraphy fountain pen sets include interchangeable nibs of various sizes, cartridges, and an ink reservoir. Calligraphy fountain pens for left-handed writing are also available. While calligraphy fountain pens may tend to write a bit less cleanly and precisely than a traditional dipping pen, they are very useful when you are just starting out.

Dipping pens are the traditional pens used by calligraphers, and consist of a removable writing nib inserted in a wooden, ceramic, or plastic handle called a nib holder. Many calligraphy nibs are also equipped with reservoirs, which in this context means a small metal flap that fits over or under the nib and allows the nib to hold a small amount of extra ink in reserve. Dipping pens give the sharpest, cleanest writing line, and are capable of producing extremely fine details. Because they are more delicate and flexible, they take some getting used to, however, and it takes more practice to get good results.

Calligraphy fountain pen set

Dipping pens

Calligraphy fountain pens, reservoirs, and cartridges

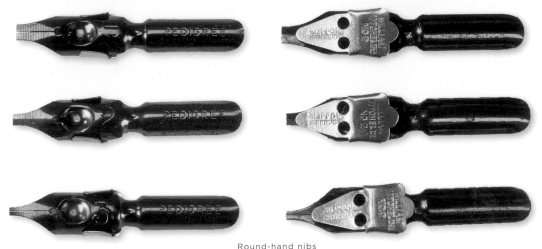

Round-hand nibs

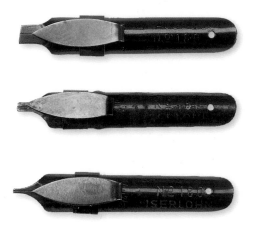

Italic nibs

Nibs for dipping pens are available in myriad shapes and sizes. To avoid confusion when trying to choose a nib, it helps to know what kind of nib is used to create the style of lettering you want:

Round-hand nibs (also called broad nibs or chisel-tip nibs) have a writing edge that is flat rather than angled. They are used for most calligraphy styles where the lettering stands upright. For the first three alphabets presented in this book (Foundational Hand, Uncial Hand, and Gothic Hand), round-hand nibs of various widths are used.

Slanted nibs (also called Italic nibs or angled nibs) have a writing edge that is cut at a slant rather than straight across. These nibs are used for sloped writing such as Italic Hand, and for styles of alphabets having very angular or slanting features. In this book Italic nibs are used only in the "Italic Hand" chapter. Note: you may come across certain calligraphy fountain pens and markers that are labeled "Italic Pens"—look closely at the tip to see if the nib is in fact slanted—often a regular broad pen will be marketed as an Italic pen, because you can use it to write in Italics.

Other types of nibs and pens. There are many kinds of writing nibs other than those mentioned here. A majority of these will be nibs ending in a distinct point rather than a flat or slanted tip— these are called "Copperplate" or "Spencerian"

nibs, and are used for handwriting in the old-fashioned Copperplate or Spencerian penmanship styles. While these nibs are not used for any of the projects in this book, you may wish to try them out once you have learned the Italic Hand, of which the Copperplate and Spencerian Hands are more recent relatives.

Various companies sell nibs designed for posters and other forms of lettering—for example, the Speedball company's "A" series nibs, which can be used for monoline lettering (lettering where there is no variation of thick and thin lines) and "C"

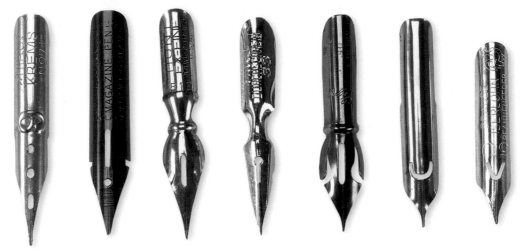

Copperplate and Spencerian nibs

series, which has larger nibs designed to hold a lot of ink for drawing letters for signs and posters.

"Automatic" or "Coit" pens are designed to hold very large amounts of ink for posters and large-format work. You may also come across very small nibs, often labeled as "crow quill," "drawing," "artist," or "map" nibs. These nibs require a smaller nib holder and are designed for fine lines and cross-hatching required in mapmaking and illustration. You may wish to experiment with these nibs, but they are not needed for any of the projects in this book.

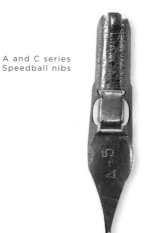
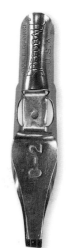

A and C series
Speedball nibs

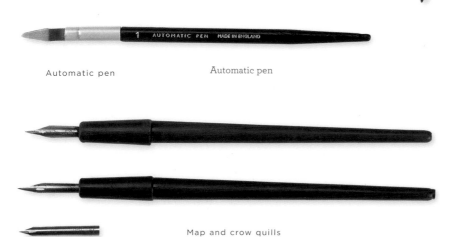

Automatic pen Automatic pen

Map and crow quills

Markers

A wide variety of calligraphy markers are available, although very few are really suitable for finished work. The others are used more for practice or novelty purposes. Most calligraphy markers use inks that are dye-based and tend to fade over time and with exposure to light, which is the main reason you wouldn't want to use them in a piece you'd like to last for a long time.

The positive aspects of calligraphy markers are that they are extremely useful for trying out ideas and sketching out rough layouts, and for practicing in circumstances where a dipping pen and bottled ink would be impractical. Two very good brands of calligraphy marker are the Zig Pigment-Based markers, which use ink that does not fade and are available in more than 40 colors, and Staedtler Duo markers, which have a large and small marker tip at either end, good quality ink, and well-wearing tips. When at all possible, try out a calligraphy marker before you buy it, as the quality of the marker tips can vary immensely from brand to brand.

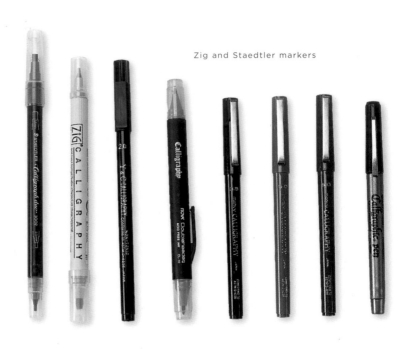

Zig and Staedtler markers

Parallel Pens

The recently introduced Pilot Parallel Pen is a blend of a calligraphy fountain pen and a combination-tip marker. Available in a range of flat-tipped nib widths, the nib can also be turned on its side to draw thin, straight lines. Parallel pens require their own special ink cartridges, and the quality of the colored inks is closer to marker ink than calligraphy ink: that is, less dense and prone to bleeding. However, a Parallel Pen used with a black ink cartridge is capable of writing very dense, crisp lines, and has excellent ink flow.

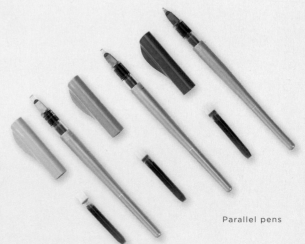

Parallel pens

Quills and Reed Pens

These writing instruments made from natural materials—the quill from a turkey feather and the reed pen from a length of hardened bamboo—have enjoyed a long history in the art of calligraphy, as they are durable and easily produced. Although not required for any of the projects in this book, you may enjoy trying them out once you've begun to master the basics of using a calligraphy pen. There are also numerous publications available that teach you how to make your own quill and reed pens.

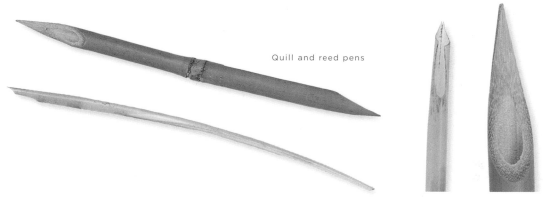

Quill and reed pens

Brushes

Brushes play an important role in calligraphy. For brush lettering, a flat brush with medium-long bristles (preferably synthetic, which tend to be stiffer and more durable for lettering) is ideal. Flat brushes are also used to make borders and fill in areas of color, while small, round-tipped brushes are used for adding details and decorations. For "Illumination" (page 110) you will find a description of the different types of brushes and the marks that they make. Just as with nibs, it's important to know ahead of time what sort of mark you want to make so you can purchase exactly the right brush for your needs. For the projects in this book we use flat brushes (sometimes called "brights") in ⅛" and ¼" (3 and 6 mm) widths, small (sizes 00, 0, 1 and 2) round brushes for detailing, and a soft long-bristle brush called a script liner. A Chinese writing brush (maobi) in the smallest size you can find is also a fun option, as you'll see in the chapter on "Brushwork and Gilding." Wider brushes and foam brushes (as used for painting house interiors) can be used for moistening paper and laying down large washes of color. You'll also want to have a few inexpensive craft brushes for applying glue.

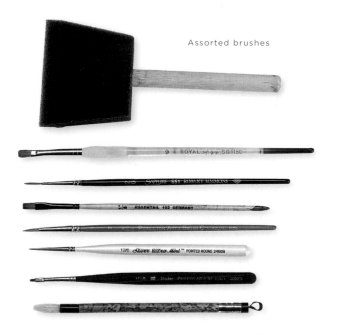

Assorted brushes

Inks and Paints

There are as many kinds of ink and paints that can be used in calligraphy as there are projects. It is important to know what you want to set out to do before you buy a particular product.

Calligraphy ink should always be your first choice for use with a dipping pen or calligraphy fountain pen. Make sure the ink is specifically labeled "calligraphy ink," which means the ink has a higher density of pigment and thus a stronger, more permanent color. Calligraphy ink is an all-purpose ink, performing well with a variety of papers and pens. While most calligraphy inks can be used in calligraphy fountain pens (check the bottle), avoid leaving ink in the pen when you are not using it. A thorough soaking of the nib and reservoir will remove any clinging bits of pigment and reduce the likelihood of blockages forming. Metallic gold and silver calligraphy inks are also available, although these should not be used in calligraphy fountain pens since the metallic bits can clog up the pen. Whenever possible, purchase your calligraphy ink from an art supply store or online calligraphy supplier (see Resources) to be sure you are getting real calligraphy ink.

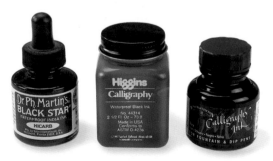

Calligraphy ink

India ink (also sometimes called "Encre de Chine") is a dense, black, permanent ink suitable for use with dipping pens and brushes. It is waterproof, which means the dried ink will not run or bleed when exposed to water or when it is inked over. (For this reason, never use India ink, or any waterproof ink, in a calligraphy fountain pen, because once the ink dries inside the nib it cannot be washed out.) India ink will not fade and thus is ideal for documents and other important writings. Iron-gall ink is a similar permanent ink, which appears light brown when writing but turns deep, permanent black once it is exposed to air. Like India ink, it is not suitable for use in calligraphy fountain pens. Drafting inks can be used with dipping pens, and certain brands also offer non-waterproof formulations that can be used in calligraphy fountain pens. Drafting inks are usually very free-flowing and dense in color.

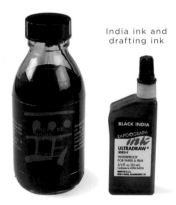

India ink and drafting ink

Acrylic inks can be found in abundance in craft and art supply stores, in a wide array of colors, many of them metallic or pearlescent. They can be used with dipping pens and brushes, but not with calligraphy fountain pens. Because acrylic inks are waterproof, they are very useful when you want to layer one color of ink over another; however, they tend to dry very quickly, sometimes right on the nib, so it is a good idea to frequently rinse

and wipe your nib when using acrylic inks. When using acrylic inks with a brush, be sure to rinse the brush often in water, and when finished, clean with soap and a fine-tooth comb to remove any dried particles of ink from the bristles of the brush.

Assorted acrylic inks

Sumi and Chinese stick inks can be interesting to use in calligraphy, especially where brushwork is involved. Sumi ink is a Japanese liquid ink that is very dense black and can be thinned with water to obtain delicate shades of gray. Chinese stick ink is rubbed on a slate stone with a small amount of water until the desired color and consistency is obtained. This can be an especially good ink to use if you want to obtain a very rich, thick black ink. With both types of ink, use a dipping pen or brush.

Fountain pen ink is perhaps the most plentiful type of bottled ink, available in a wide variety of colors, and while it can be used with a dipping pen or calligraphy fountain pen, generally these inks lack the density of color of calligraphy inks. Some bottled fountain pen inks are sold at gift and stationery shops and tend to be more of a novelty item, in spite of being labeled as suitable for calligraphy. On the other hand, if you are looking to create a piece that has a somewhat faded, romantic, old-letter-found-in-the-attic look, fountain pen ink would be a perfect choice. You may also have success increasing the density of fountain pen ink by adding a small amount of a similar color of calligraphy ink.

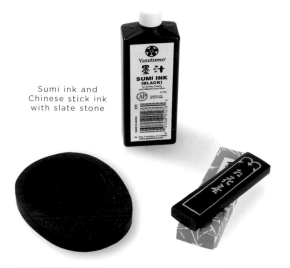

Sumi ink and Chinese stick ink with slate stone

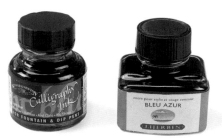

Bottles of fountain pen ink

Waterproof vs. Non-Waterproof

There are two types of inks and paints—waterproof and non-waterproof. Non-waterproof ink or paint—such as calligraphy ink, gouache, and watercolors—will dissolve, bleed, or run if touched again by water (or ink or paint) even after they have dried. Waterproof ink—such as acrylic ink, acrylic and latex paint, India ink, or any ink labeled "waterproof"—won't dissolve or bleed when in contact with ink, paint, or water, and so is ideal for using when you want to layer inks or colors.

Metallic pigments and inks. Powdered metallic pigments can be mixed with distilled water to an inklike consistency to create metallic inks for use with a dipping pen or brush. Often a small amount of liquid gum arabic is added to keep the metallic particles from separating. This type of ink is non-waterproof, and will dissolve or separate when touched with water or applied to a wet surface. It is also a good idea to finish the work with a light spraying of artist's fixative to prevent the metallic particles from rubbing off once the work is dry.

Many liquid metallic inks are also available, and differ widely in their amount of luster and waterfastness, so it is best to try them out before buying if possible. As a general rule, ink that contains metallic pigment should never be used in a fountain pen, because the metallic particles can clog the inside of the nib.

Artist colors. Often you will come across ink that is simply called "ink," "drawing ink," or "artist color." These inks are usually used for drawing with brush or fine nib, or in conjunction with watercolor painting. Many of them are waterproof (check the label to see if the ink contains shellac) and can be used successfully for creating backgrounds of color. Many of these inks lack the density to flow well when used with a broad-nib calligraphy pen, although they can work very well with a brush.

Artist color inks

Metallic pigment powders and bottled metallic inks

TIP Inks and paints will last a long time when they are stored in a cool, dry place with lids or tops tightly screwed on. Avoid storing bottled ink in direct sunlight. As with all art supplies, paints and inks should be kept away from heat sources and out of the reach of pets or young children.

Calligraphy gouache is packaged in tubes and is mixed with distilled water to an inklike consistency for use with dipping pens or brushes. With a basic palette of calligraphy gouache paints, you can create dense, permanent colors in any shade you desire. Gouache dries to a flat finish, so if you want a little shine to your color, you can add a drop or two of liquid gum arabic or a small amount of sugar dissolved in hot water. Dried gouache appears a shade or two darker than it does in liquid form, so mix your colors slightly lighter than you want them to appear on paper. Designer's gouache can be used in the same way as calligraphy gouache, not to mention that it is usually easier to find at art supply stores, whereas calligraphy gouache may have to be special-ordered or ordered online.

Tube watercolors, like gouache, can be thinned with distilled water to an inklike consistency and used with a dipping pen or brush. Most watercolors are transparent, so lettering written with watercolor will often appear somewhat washed out. Watercolors are most useful for filling in color and painting details or for building up layers of transparent color. Pan watercolors, while not very practical for using with a dipping pen, can be used with a brush in the same way as tube watercolors.

Acrylic paint is very useful in calligraphy when it is thinned with water and used as a background wash—once dry, you can write on a background of smoothly applied acrylic paint with either waterproof or non-waterproof inks with no danger of bleeding.

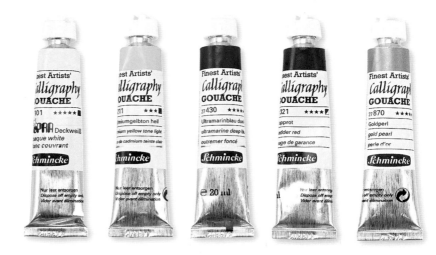

Calligraphy and designer's gouache

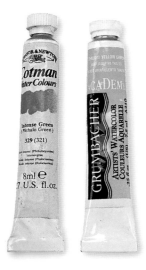

Tube watercolors

Papers

There is such a huge variety of fabulous papers on the market today that shopping for paper can feel like being a kid at a candy store! Knowing what you want to do ahead of time will help you to choose the right paper.

Papers for ink. Several types of paper are manufactured specifically for use with ink; they are often labeled "Paper for Pens," "Pen and Ink Paper," "Paper for Markers," "Designer Layout Paper," or "Layout Bond." A pad of this type of paper is essential for practicing calligraphy, as it will show your pen work at its best, with strokes appearing sharp and crisp without bleeding. These papers are commonly available at art and drafting supply stores. The downside is that they tend to be expensive, so it helps to find an inexpensive alternative for practicing, especially when you are just starting out.

Practice paper. Finding a suitable, inexpensive paper for practicing your calligraphy is well worth the effort. Calligraphy practice pads are commonly available, although most of these are ruled for italic writing, and thus somewhat limiting. Often thicker, high-quality ruled notebook paper or heavy (80 lb or higher [116 gsm]) text-weight

commercial paper works very well for practicing, especially when used with acrylic inks, which have less of a tendency to bleed on the paper. Graph paper is also very useful for practicing, especially the smaller-grid engineering-style graph paper. Look for paper that is relatively thick and has a smooth surface, without any coating or texture.

Bristol. For projects where card stock is required, 100-lb (260 gsm) Bristol is a good all-purpose choice. It is acid free, absorbs ink well without bleeding, and is available in various weights and finishes. A smooth finish is the best choice for penwork.

Parchment and vellum. In the past, these two writing surfaces were prepared from scraped and smoothed animal skins—parchment from sheepskin and vellum from calfskin. Nowadays, the parchment and vellum you will find at art and craft stores are of the paper variety, both of which

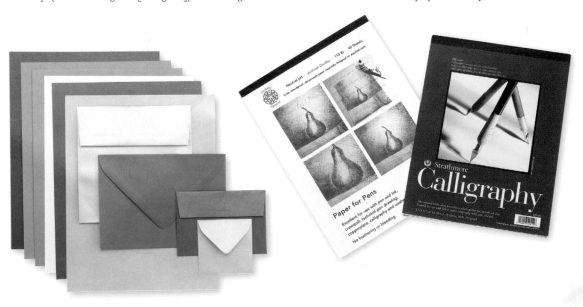

can be useful in calligraphy. Parchment has a somewhat mottled finish and color, lending itself to projects where the paper should look somewhat aged. It is available in text and cover weights, as well as in various colors. Vellum has a very fine surface and is translucent, allowing colored surfaces beneath it to show through. Vellum can present problems for the beginning calligrapher because the ink sits on the surface of the paper rather than being absorbed; you will have best results on vellum when using waterproof or acrylic ink and being very sure not to overink your nib.

Printmaking and watercolor papers. Also called "rag" paper, "100% cotton rag," or "artist's papers," these are high-quality papers made from cotton fiber that are pH neutral and archival. They are the papers of choice for fine art projects from printmaking to painting to calligraphy. "Hot pressed" paper has a relatively smooth finish, while "cold-pressed" paper has a textured finish and is often sold as "watercolor paper." One hundred percent cotton bond paper is also available from stationers, mainly for use in creating stationery and invitations. Cotton papers are a real joy to work with, although you may find you need to clean off your nib from time to time, as the fine cotton fibers can accumulate between the prongs of the nib.

Commercial papers. Many craft and stationery suppliers sell commercially made paper and matching envelopes by the sheet or pound or gram, many of which are inexpensive and quite suitable for calligraphy. Purchase small amounts of commercial paper and try it out with various inks (calligraphy ink, acrylic ink, gouache) before buying large quantities. Pearlescent papers (colored papers coated with a pearlescent or sparkly finish) are especially fun to use for calligraphy projects, but take note that certain inks do not adhere well to them. Calligraphy gouache or acrylic ink is usually the best choice for working on pearlescent paper.

Other art papers. You will find a huge variety of papers not mentioned here at art and craft supply stores, including rice paper, decorative printed papers, handmade papers, origami papers, kraft, and natural-fiber papers. Most art supply stores keep sample books with hundreds of swatches for you to choose from, and selections are always changing. Papers that are not necessarily suitable for writing on can be ideal for background mounting, collage, matting and framing, and so on.

TIP Paper is best stored flat, in a cool, dry place away from light and dust. A flat file is an ideal place to store paper; a more affordable option is to use an artist's portfolio for storing large sheets. Papers are extremely sensitive to changes in humidity, so avoid leaving paper laying about on muggy days—you may notice the paper start to warp and bleed when you write on it.

Art Supplies

For calligraphy, the art supplies needed are very simple. The only things you really need to get started are a T-square, a ruler, pencil, erasers, a utility knife, scissors, craft glue, drafting tape, small containers to hold ink, a cup to hold rinse water, paper towels, and a tabletop or drawing board. Other items can be added as needed.

(A) A small T-square, no more than 12" (30.5 cm) long, is sufficient for ruling lines for most calligraphy projects.

(B) A 12" (30.5 cm) ruler, preferably clear and printed with a grid or guidelines. A steel edge on one side of the ruler makes it a useful tool for trimming paper with a utility knife.

(C) Pencils and erasers. Marks from #1 or H pencils are the easiest to erase. I use a mechanical pencil with .5mm H lead. A gray kneadable eraser is essential for erasing pencil marks from your work. A white plastic eraser is also good to have for removing stubborn marks from the paper. It will also remove ink and gouache slightly, so be careful when using it.

(D) Craft knife. A rubber-handled knife grip is comfortable to use and the least likely to slip. Have a good supply of blades (#11 is a good all-purpose size) and change them often—cutting goes much easier with a fresh blade.

(E) Scissors. Paper shears (shears with very long blades) will make the straightest cuts with the least amount of effort. Smaller scissors are useful for trimming delicate curves.

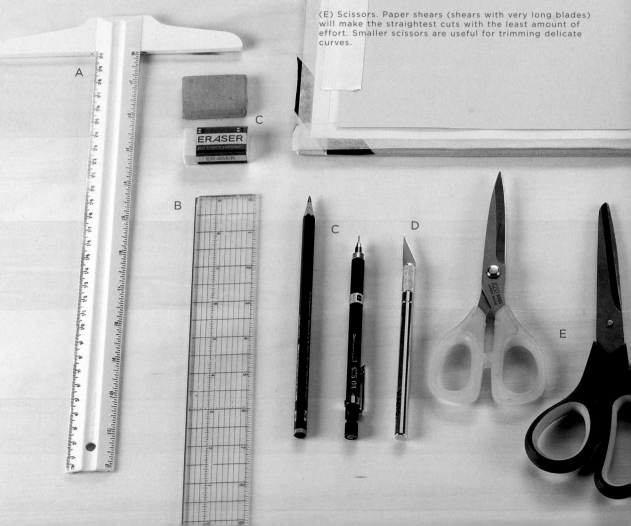

(F) Bone folder. This is used with a ruler for scoring paper into crisp folds.

(G) Craft glue. Craft glue is sold under a variety of names; PVA (polyvinyl acetate) or basic white glue are the most common and will not discolor paper over time. Use liquid glue (applied with a brush if needed) rather than glue sticks, which tend to form a weaker bond with the paper.

(H) Drafting tape and artist's tape are low-tack tapes that can be easily removed from paper. Use artist's tape if you plan to get the paper wet or to paint on it while taped down.

(I) Ink containers. Containers can hold small amounts of ink while you are working, so you don't have to dip directly into the ink bottle. The caps from old bottles of ink work well, as do many odd household objects such as salt cellars, or cups from children's tea sets.

(J) A glass container for rinsing nibs and brushes—preferably heavy and not too large so it is not easily spilled.

(K) Paper towels—or even better, old cotton rags—are essential for blotting and cleaning up ink spots.

(L) Drawing board or tabletop. A drawing board is very useful for maintaining your posture and avoiding fatigue when writing, and can be something as simple as a piece of masonite propped up on a tabletop. (See page 24 for instructions on setting up a simple drawing board.) You can also purchase writing easels and drawing boards from art supply stores. Plenty of people just use a regular desk or tabletop, as well.

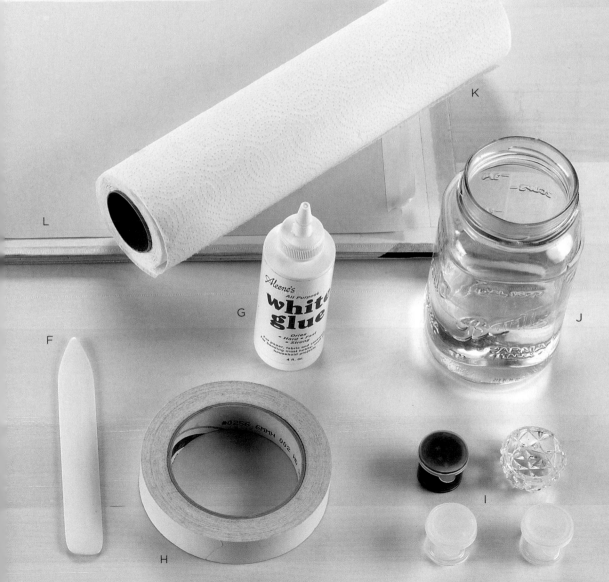

abcdefg
ghijklm

Making Marks

Now that you have the basic supplies, it's time to start making some marks! In this chapter you will learn how to use a calligraphy pen to create the basic strokes that form letters. You'll also learn how to set up your writing surface and work area, and how to get started using a dipping pen.

The Writing Surface

Whether you're working on a flat surface, such as a desk or tabletop, or an angled one, such as a drafting table or adjustable drawing board, it is important to have a slightly padded surface beneath your writing paper—the cushion of the padding helps the pen "bite" into the paper.

You can make a simple drawing board from a sheet of smooth ⅛" (3 mm)-thick plywood or Masonite (20" wide × 14" tall [50 × 35 cm] will accommodate most projects). Set up with permanent padding on it, this drawing board can be carried to any location for writing.

Padding a Drawing Board

1 Cover your drawing board or work surface with several *padding sheets*. Trim the sheets about 1" (2.5 cm) smaller than the drawing board on all sides.

2 Cover the padding sheets with a clean sheet of smooth paper cut to the same size and use masking tape or artist's tape to secure the edges. If desired, you can tape or glue a flat ruler or a section of measuring tape along the left side of the board—this is helpful if you plan to use a T-square to rule lines on your paper. Removable artist's tape along the edges makes it easy to remove and replace the cover sheet.

3 Cut a *guard sheet* out of card stock or other sturdy paper the same width and half the height as your padded area and attach it to the board with tape, aligning the bottom

edge to the bottom edge of the padding. Use removable artist's tape to attach the sheet you'll be writing onto the center of the board, positioning it so that the place where you want to start writing falls *just above the guard sheet*. Just one or two pieces of artist's tape will suffice for attaching your writing sheet—you want it to be easy to move the sheet around.

3

When you finish writing a line of text, move your writing sheet up so that your hand is always positioned in the center of the board to write.

Left-handers may find it helpful to set up paper and guard sheet at an angle.

QUICK REFERENCE

Padding sheets. Padding sheets can be just about any kind of paper as long as they are relatively soft and smooth. Use any of the following: two to three sheets of blotting paper, two to three sheets of 140-lb (300 gsm) cotton print-making paper, eight to ten sheets of newsprint, or eight to ten sheets of old newspapers ironed flat.

Guard sheet. The guard sheet protects your work from any ink or oils on your hand.

Just above the guard sheet. As you write, you'll be moving your writing paper up and to the left or right so that you are always writing on the center of the board just above the guard sheet.

Setting Up Your Workstation

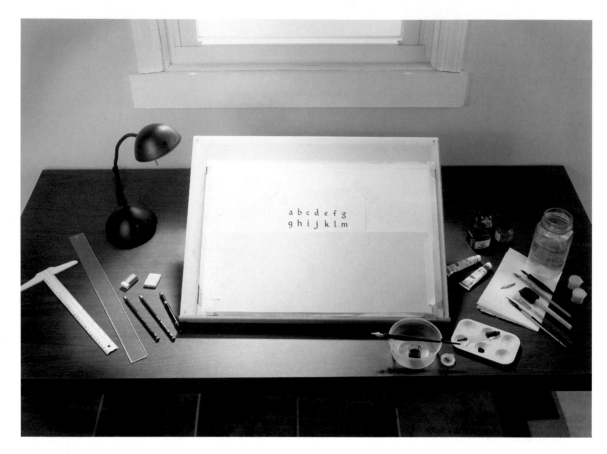

Set up your "wet" supplies, such as ink, pens and nibs, brushes, water for rinsing, and paper towel or blotting paper for wiping just off to the side of your writing hand. On the other side put your T-square, ruler, erasers, pencils, and other items you want to keep away from getting wet or ink-stained. To avoid spilling ink, never dip or pour directly from the bottle. Use an eyedropper instead to squeeze out small amounts of ink into a small container—the smaller and heavier, the better. A small plastic container lid makes a handy tray for holding your ink container (if it spills, the spill will be confined to the tray), and a few notches cut into the rim creates a convenient place to set down your pen without getting ink on anything. Pen rests can also be purchased for this purpose. Porcelain palettes

sold at art supply stores are useful for holding ink, especially if you are using more than one color, and heavy enough to be hard to spill.

Your light source should come from the opposite side of your writing hand so that shadows aren't cast across your work. A swing-arm desk lamp that has both a fluorescent and regular bulb (with both bulbs switched on at the same time) is helpful for closely lighting your work and helping you to see your colors accurately. Regular diffused daylight is also very good for calligraphy. A north-facing window (if you live in the Northern Hemisphere) provides the most even light. Avoid any lighting that is excessively bright, which will strain your eyes and cast shadows that make it difficult to see details and colors.

Drawing Board Angle and Posture

An angled writing surface of about 45° is ideal for lettering and will help you avoid the back or shoulder pain that can come from leaning over your work. Drawing boards are available with special frames that can be adjusted to various angles, but before making this investment, try propping up a flat drawing board with books on a desk or table. Or sit at a table with the base of the drawing board in your lap and the middle of the board propped against the edge of the table. A drafting table with the top angled to about 45° also works well, the only disadvantage being that you'll need another table with a level surface nearby to hold your supplies.

Whatever setup you choose, make sure your chair is comfortable and that you sit up straight. When working at an angled drawing board or drafting table, you may find that sitting on a stool allows greater freedom of movement for your writing arm. Some people are more comfortable with their feet placed flat on the floor, others prefer to rest their feet on the rungs of a chair or stool—do whatever is most comfortable for you and keeps you from bending your back or neck too far over your work.

A peaceful, undisturbed environment is also important. Surrounding yourself with objects of inspiration, playing relaxing music, or simply setting up a block of time where you won't be disturbed are all very helpful. Allow yourself time to doodle, scribble, draw, or just play with your pen before getting down to work. Like any other artistic endeavor, it takes a little time to get into the flow of things, and often the best results happen when you are very relaxed and just playing around. It's also important to take a break every so often to get up and walk around, stretch your hands and arms, rest your eyes, and look at something else for a while—this will help you avoid tension and fatigue—and return to your writing with renewed energy.

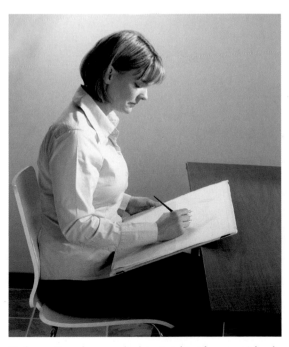

Find a position where your back is straight and you aren't bending your neck too far over your work.

Trying Out Your Pens

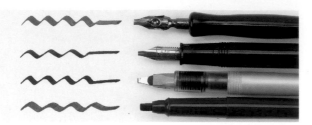

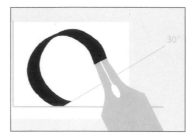

For the exercises in this chapter you'll need a broad-nib 2- or 3-mm calligraphy fountain pen, a dipping pen with a 2- or 3-mm nib, black calligraphy ink, a 2- or 3-mm calligraphy marker, tracing paper, and plenty of smooth white paper to practice on, such as designer's layout bond, smooth Bristol, or heavy-weight text paper. Try out the examples and exercises in this chapter several times, using each type of pen each time. You will notice that each kind of pen yields different results, and you may find that a certain type of pen will feel most comfortable.

The thick and thin strokes of calligraphic letters are made by using a broad-nib pen with the nib positioned at a constant angle—usually about 30°. When maintaining this constant angle, as the pen travels through the entire direction of a stroke, the width of the stroke changes as the direction the pen is traveling changes. As long as the nib is held at the same angle, the changes in width will happen automatically, without any special effort or movement on your part.

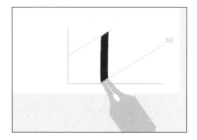

With the nib angled at 30°, the pen is drawn straight downward, creating a thick stroke.

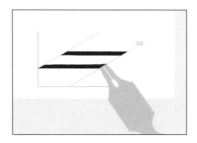

The pen is drawn horizontally from left to right, creating a medium-thick stroke.

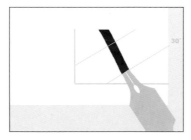

The left-to-right downward diagonal stroke produces the thickest line. A right-to-left stroke will produce a thinner diagonal.

When the nib is held at a steady 30° angle, the circular stroke shows the whole range of thick and thin widths that the nib is capable of producing.

Learning to maintain a constant pen angle is the first step to creating well-formed letters, and because it is different from the way we hold a pen for everyday writing, it requires practice at first. The good news is that with practice it will quickly become second nature. Develop this good habit: before beginning to write, check your pen angle on a scrap of paper by drawing a vertical line. If your pen is properly angled, the line will have sloping points at either end. The slope should be in the direction of somewhere between 1 and 2 on a clock face.

Line drawn with an angled nib (left) will have sloping points at either end. The line on the right has a flat top and bottom—increase the pen angle.

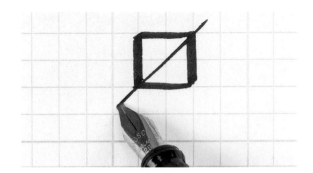

How to Hold the Pen

The position of the pen in the hand will vary with each individual; what's most important is that you find a grip that feels comfortable for you and allows you to keep your nib angled at 30˚. A general rule is to hold the pen between the thumb and forefinger with some of the weight of the pen resting on your middle finger. The pen as a whole should be aligned so it points toward the outer edge of your shoulder (if you are left-handed, refer to page 30 for Tips for Left-handers). Keep your hand relaxed—squeezing or gripping hard will only tire out your fingers. Don't bear down hard on the paper; just let the pen write.

The angle of your pen in relation to the drawing board should be somewhere between the 45˚ and 90˚ mark. Experiment with the angle a bit until you find the point where the ink flows freely from the nib and the nib travels smoothly across the paper.

If you angle the pen too steeply against the paper, your the nib will scratch and splatter ink; if the pen is angled to low, the ink won't flow well from the nib to the paper.

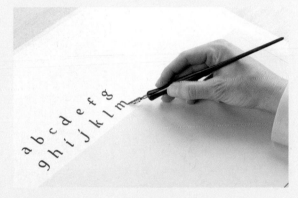

Angle your pen against the paper like this . . .

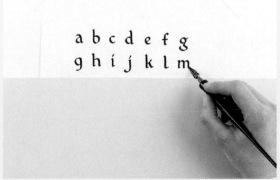

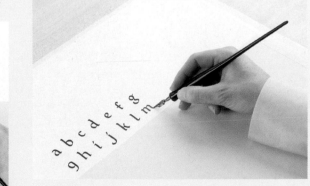

not like this.

Tips for Left-handers

For most calligraphy alphabets, the strokes are written in a downward (pulled) direction rather than upward (pushed). This is convenient for right-handers, but presents obstacles for left-handed calligraphers. If you are left-handed, try the following:

- An oblique nib (also called a left-handed nib) has an angled tip designed so that it can be angled easily to 30° when held in the left hand. Left-handed nibs for dipping pens are usually readily available at art supply stores; left-handed calligraphy fountain pens are also available, although you may have to place a special order or order online (see Resources).

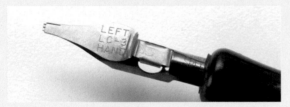

Oblique nibs and left-handed pen are angled in the opposite direction of nibs for right-handers.

Hand position. There are three specific left-handed positions for calligraphy: the underarm position, the hook position, and the vertical position.

- Left-hand underarm position. Turn your wrist as far to the left as you comfortably can until you can place the nib on the paper at a 30° angle. It will help to use the slanted paper set-up for left-handers pictured on page 25, and position your

writing paper slightly to your left so that as you write, your left arm isn't drawn in too closely to your body.

- Left-hand hook position. Flex your wrist downward in a hook shape and position your hand above the writing line. It may help if you slant your paper slightly to the left in this position. One drawback of the hook position is that the hand covers the writing and makes it difficult to see the work. Some left-handers overcome this by drawing the strokes in the reverse order and direction.

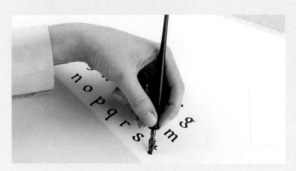

- Left-hand vertical position. Set up your paper with your writing lines at a 90° horizontal angle and work from top to bottom instead of left to right. It might take a while to get a sense of how your letters should look from a vertical position. It is a big help to practice your alphabets with the example alphabets also turned to a 90° angle.

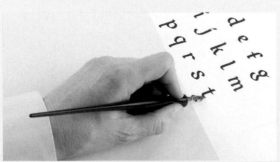

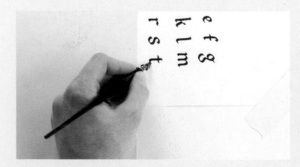

Getting Started

Start with a calligraphy fountain pen and some paper (if desired, use a T-square to rule lines on your paper about ½" [1.3 cm] apart). Position your nib at a 30° angle and experiment making the following lines:

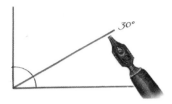

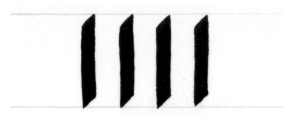

Vertical lines should begin and end with angled points. Draw quickly, moving your whole hand downward rather than moving your wrist or fingers.

Horizontal strokes should begin and end with angled points. A 30° pen angle makes a thicker line; a flatter angle makes a thinner line. Draw these quickly—lines will be straighter when you're not concentrating too hard. Focus your eyes where you want the line to end, not on the line itself as you are making it.

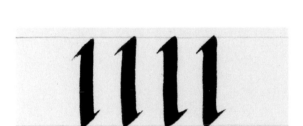

Vertical lines with serifs: start with a small upward movement to get the ink flow started, then move the pen straight down. Finish with a small upward movement, maintaining the 30° nib angle.

Try making diagonal lines that go up and down in one continuous stroke. The nib angle remains constant, and the change of direction in the pen determines the width of the line. If you are using a dipping pen, this is a good way to gauge how long you can write before needing to replenish the nib with ink.

A row of dots is a very good way to practice maintaining your nib angle and establish a rhythm to your writing.

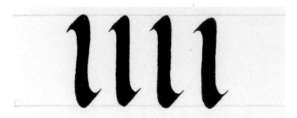

Serifs can be sharply pointed, or gently curved, depending on the style of alphabet.

Try to make your curved strokes look like little crescent moons.

Keep the paper straight to help keep the straight lines vertical. Arches can be rounded, pointy, or flat, depending on the alphabet style.

Table of Basic Strokes

The following basic strokes are the essential components that make up all calligraphy letterforms. Their shapes and angles will vary somewhat depending on the kind of alphabet, as well as on your own personal writing style. Practice these strokes, keeping your pen nib at a 30˚ angle and following the stroke direction indicated by the arrows.

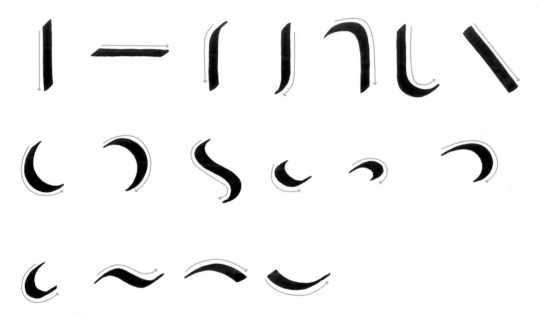

Some of the strokes used in calligraphy require steeper or flatter pen angles—for example, when writing letters that have diagonal lines, such as *W*, *X*, and, *K*, the pen is angled more steeply, at about 45˚. A very steep pen angle is used to draw the upright strokes of the capital letter *N*, and often a flatter angled line is used to make the crossbars on lowercase *f* and *t*.

(left to right) A 45˚ pen angle is used to draw strokes for *M*, *W*, *K*, *A*; a 45˚ pen angle is also used to make square dots; the nib is angled very steeply for the upright strokes of the letter *N*; a flatter nib angle used for the crossbar of a lowercase *f* or *t*.

TIP Photocopy this page at actual size and practice tracing over the basic strokes on tracing paper or translucent vellum with a 3-mm calligraphy fountain pen. Tracing is a good way to get acquainted with the "feel" of the strokes and good practice for maintaining a constant pen angle.

Using a Dipping Pen

Calligraphy fountain pens provide smooth, clean lines and a constant flow of ink. They are especially useful for practicing strokes and letters.

Once you feel comfortable making the basic strokes with a calligraphy fountain pen, practice the basic strokes with a dipping pen and nib. Dipping pens are not always easy to use at first—but with time and practice you will get the hang of it. Here are a few tips for using a dipping pen:

1 Start with the right kind of nib. Use a broad-tip nib that is 2 to 3 mm wide. With a smaller nib you may find it difficult to clearly see the details of what you are doing. The tip of the nib should be cut straight across, not angled (unless you are using a specially angled left-hand nib), and equipped with a reservoir—a small metal flap that allows the pen to hold extra ink so you won't need to load up on ink quite as often. This type of nib is often referred to as a "round-hand nib" or "chisel-tip nib" (page 10). Suggested brands are the Mitchell/Rexel Round Hand Square-Tip nib (sizes 1.5 or 2), Leonhardt Round Hand nib (sizes 1.5 or 1), and Speedball "C" series nib, sizes C 2 or C-3. The Speedball and Mitchell nibs are also available in left-hand versions.

2 A brand-new nib can be somewhat stiff and sharp, and needs to be used for a while, or broken in, before it is really at its best. New nibs also usually need to be "seasoned" to remove any oils or shellac remaining from the manufacturing process (see page 34).

3 Check to make sure your nib isn't damaged. When purchasing a nib, examine it closely to make sure it isn't bent or defective in any way. Look closely at the tip of the nib to make sure the prongs are perfectly aligned—if they don't form a straight edge, you are sure to have problems later. Nibs can easily become damaged by being dropped or put under too much pressure, so handle and store them carefully. Nibs also become dull and worn out over time, so avoid starting out with an old nib.

4 Use the right kind of paper. Look for paper that is somewhat thick with a smooth, uncoated finish. Papers made especially for calligraphy, markers, or pen-and-ink work are ideal, but because they tend to be expensive, look for high-quality commercial papers that are reasonably priced and will take calligraphy ink without bleeding. Try out a variety of these with your particular nib and brand of ink and note which ones work best for you.

5 Use the right ink. For learning to use a dipping pen, look for ink specifically labeled "calligraphy ink." It should be non-waterproof and provide dense color. Fountain pen ink can also be used, but usually has a watery consistency that results in less dense color. Avoid using acrylic or waterproof inks at first.

6 Be patient. The dipping pen nib is a highly specialized writing instrument, and it takes time to learn how to handle it. Don't attempt to write too much, for too long, setting up expectations that are unrealistic for a beginner. Rather, start by doodling and drawing and getting the feel of the pen. Limit yourself at first to drawing lines with the nib held at a 30° angle and making strokes and patterns rather than words. Learning to write with a dipping pen is very much like learning to play a musical instrument.

Seasoning and Inking a Pen Nib

1. Seasoning a nib: To remove any traces of oil or shellac remaining from the manufacturing process, place a new nib in its holder and pass the nib quickly through the flame of a match or candle—one time with the nib faceup, and one time facedown. Do not hold the nib in the flame; just pass it quickly through. (Also, never use a butane lighter or gas flame from a stove to heat the nib, and never hold the nib with your fingers while heating it.)

Be careful! And don't overdo it.

2. Inking a nib: Contrary to their names, dipping pens are not dipped into ink. Instead their nibs are loaded with ink using a small pointed brush. A good method is to dip the brush into the ink until it is fully saturated (but not dripping), touch the brush to the underside of the nib or reservoir, and deposit a blob of ink there. Some nibs also have a small indentation on top designed for filling with ink. If needed, you can also brush a small amount of ink onto the very tip of the nib.

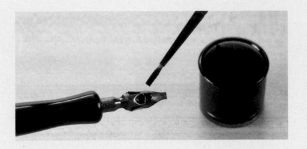

For convenience, once you have loaded the nib, you can replenish the ink a few times by taking very small dips into the ink container—just dot the surface of the ink with the very tip of the nib. After a few dips you will need to reload with the brush, but you will find that using a brush to ink the nib actually lets you write longer and is easier than dipping every time. Be careful not to over-ink your nib. You can tell when a nib is properly inked by looking at your lines: they should be crisp and fine.

Dipping Pen Troubleshooting

If the line is ragged on one side, try pressing the nib more evenly onto the surface of the paper.

Blobby lines mean you have too much ink on the nib.

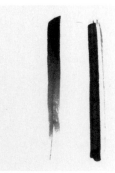

Make sure your nib is seasoned and properly inked. A tiny back-and-forth diagonal movement at the start of stroke will often help the pen get started.

Skill Builders

Exercise 1: PATTERN PLAY WITH BASIC STROKES

To learn to make the basic strokes well, you will need to practice, which means writing them repeatedly. However, focusing on one stroke at a time and doing it over and over until it's perfect can be boring. Instead, try this way of practicing:

WHAT YOU'LL NEED

- lined paper
- 3-mm calligraphy fountain pen or marker

1 Starting on the left-hand side of a sheet of *lined paper*, practice alternating between two pairs of strokes until you reach the opposite edge of the paper. The combination of stroke pairs you choose is up to you.

2 For the second line, pick a new set of stroke pairs and repeat, again going all the way to the edge of the paper. Try not to spend too much time on any one stroke—just let yourself get into a steady rhythm.

3 For the third line, repeat the strokes you made on the first line, and for the fourth line, repeat the strokes of the second line, maintaining an even rhythm and spacing to your strokes. You can keep going down the page this way or start the next line with a new combination of stroke pairs. Try out different combinations of stroke pairs to see what kind of interesting patterns you can make.

QUICK REFERENCE

Lined paper. You can draw the lines yourself, about ½" (1.3 cm) apart, or use regular notebook paper, allowing two lines per line. A half-size sheet, about 9" wide x 6" high (22.9 x 15.2 cm) will be easier to move around on the drawing board as you move from line to line.

Exercise 2: FREEHAND LINES, SHAPES, AND BOXES

Many of the calligraphy projects you may want to try will have lines, borders, boxes, and images, as well as text. Taking some time to practice freehand drawing will help you build your graphic skills and gain confidence with the calligraphy pen. Try out the following (a calligraphy fountain pen or marker is ideal to start out with):

WHAT YOU'LL NEED

- paper
- 3-mm calligraphy fountain pen or marker

1 Boxes from lines and L shapes. Notice how the 30° pen angle creates box lines of different widths.

2 Lines and swooshes. Practice moving the pen quickly and freely. Don't look at the line as you're drawing it, instead keep your eye on the point where you want the line to end.

3 Strokes combined to make shapes/icons. Practice drawing simple shapes, keeping your pen angles and avoiding upward strokes, which can makes the pen nib skip or splatter.

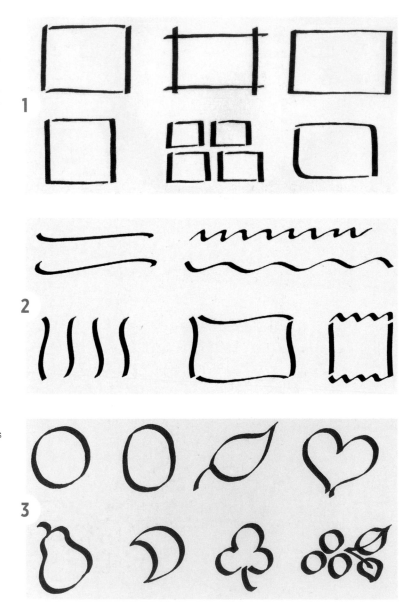

Exercise 3: **BORDER-BUILDING**

Borders can enclose a space or embellish an edge, and can be almost any shape, including asymmetrical. Practice making the following types of borders, substituting any stroke or graphic element of your choice.

WHAT YOU'LL NEED

- paper
- 3-mm calligraphy fountain pen or marker

Band

1 Start out by marking your outer lines lightly in pencil, then fill in the center and end elements.

2 Fill in middle elements next, using your eye to judge placement and keep elements evenly spaced. Draw the outer lines of the border last.

TIP Start a scrapbook of your various calligraphy exercises. Or just cut out the parts you like the best and paste those in. By saving bits of your work, you'll be able to watch your progress over time and have a store of ideas for future inspiration.

Box

1 Lightly pencil in your inner and outer lines. Mark the center points of each side in case you plan to put specific graphic elements there.

2 Add corner and center elements. Note that border decorations don't have to be confined to the inner or outer lines of the border.

3 Fill in the rest of the border elements. The inner lines should be added last.

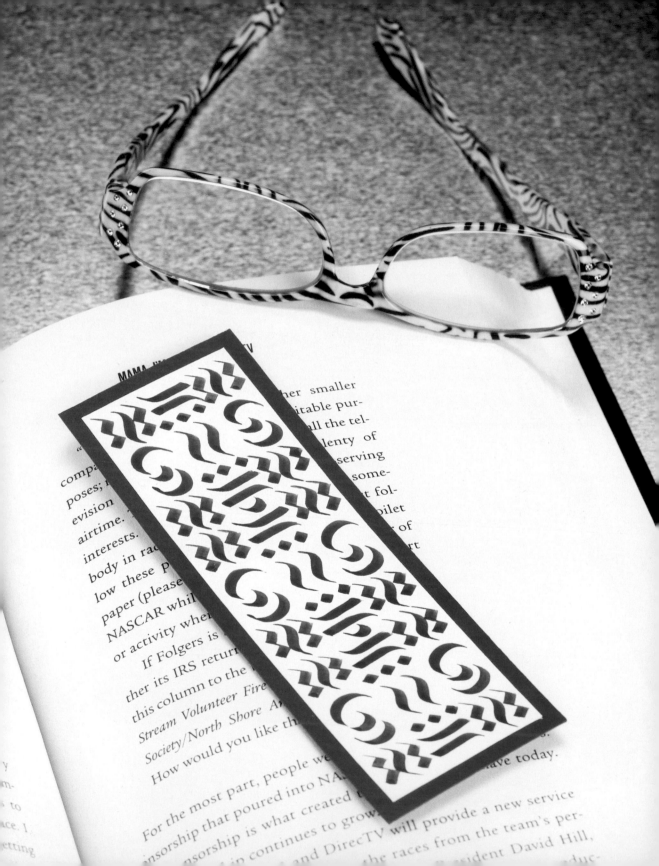

Patterned Bookmark

Here's a fun way to create a handy item that makes use of the interesting patterns you created during your basic stroke practice.

WHAT YOU'LL LEARN

- How basic strokes, repeated in patterns, make interesting designs for paper crafts
- How to align pattern repeats on paper
- How to frame your design with a precise border

WHAT YOU'LL NEED

- heavy-weight (110 lb [165.5 gsm]) white text paper
- colored card stock
- 3-mm calligraphy fountain pen or dipping pen
- calligraphy ink
- craft knife
- steel-edged clear ruler
- cutting mat
- glue and glue brush
- wax paper
- pencil
- kneadable eraser
- T-square
- optional: paper cutter, ⅛" (3 mm) hole punch, ribbon or cord

Let's Begin

1 Cut a sheet of white paper to 6" wide × 9" high (15.2 × 22.9 cm). Starting at about ¾" (1.9 cm) from the top of the page, use a T-square and pencil to lightly rule 16 lines spaced ½" (1.3 cm) apart across the sheet. Leave about ½" (1.3 cm) unruled margin on each side.

TIP If it's not obvious by looking, mark the front side of the paper with a small pencil dot in the lower corner as there is often a difference in the way ink adheres to front and back of a sheet.

(continued)

Patterned Bookmark

2 Choose a combination of two or more basic strokes that you find graphically interesting and repeat across the page. Draw the largest strokes so that they come right up to pencil lines without touching, but try to use some smaller strokes, or pairs of smaller strokes, too. Feel free to join or overlap strokes, but keep the overall spacing loose and even. End the line with the same stroke you used at the start of the line.

3 For the *second line,* choose a new combination of strokes and repeat to the end.

4 For the third line, repeat the strokes you made for the first line. Refer to the first line as you draw so you can recreate the same spacing.

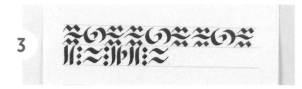

> ## QUICK REFERENCE
>
> **Second line.** When starting a new line, move the paper up (rather than moving your hand down). Similarly, move the paper slightly to the left as you progress across the line, so that your hand is always positioning in the center of the drawing board and the space where you are writing is always centered in front of you.

5 (optional) Leave the fourth line blank and start a new pattern of strokes on the fifth line, continuing until you have four sets of three lines. It often helps to do a few versions of the patterns to get warmed up and also so you can try out variations, colors, etc.

6 Allow ink to dry thoroughly and then erase pencil lines with a kneadable eraser. Trim closely with a craft knife and steel-edged ruler.

(continued)

5

6

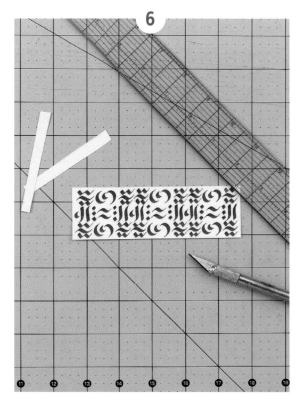

Patterned Bookmark

7 Lay the trimmed pieces facedown on a sheet of paper and use a brush to apply a thin layer of glue to the back of the paper. Brush all the way up to and just beyond the edges to cover the paper fully.

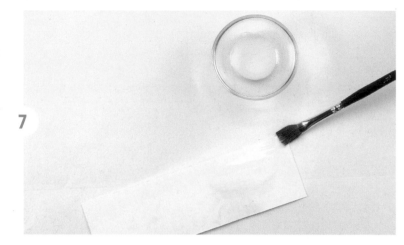

7

8 Handling it by the very edges, place glued paper onto card stock. (Note that card stock should not be trimmed to final size at this point.) Cover with a piece of wax paper and use a bone folder or your hand to smooth over the surface, making sure the paper gets fully stuck down. Cover with a different piece of wax paper (the first one may have glue on it) and place a heavy object, such as a book, over it until glue has dried fully (about 30 minutes).

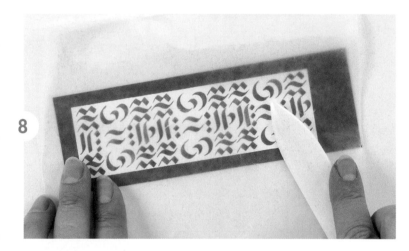

8

9 When dry, use a craft knife and steel-edged ruler (or a paper cutter) to trim the cardstock, leaving a *border* ⅛" to ¼" (3 to 6 mm) from the edge of the patterned paper. When trimming with a craft knife, position a line of the clear ruler along the edge the inner piece of paper.

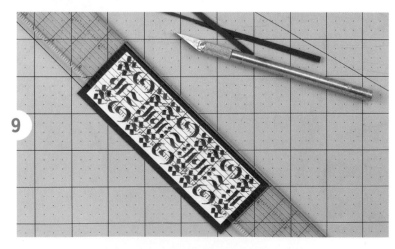

9

> ### QUICK REFERENCE
>
> **Border.** A good rule of thumb is to make this border the same width as your widest stroke, but you can also experiment and see what looks good to you.

Variations

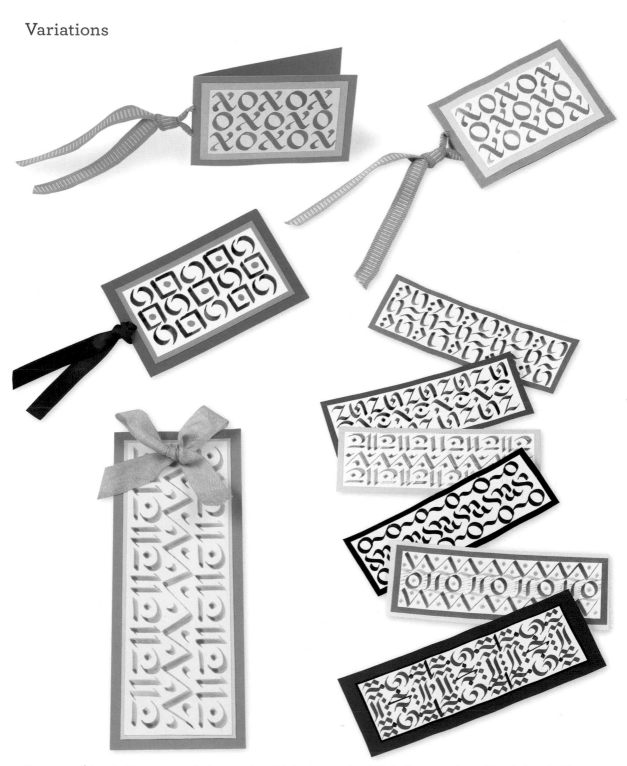

You can vary this project in many ways, for instance, changing the size to make a folded gift tag or card, punching a hole and adding ribbon or cord, or adding a second color ink or paper backing.

Passe-Partout Picture Frame

For this project a simple 4" × 6" (10.2 × 15.2 cm) black-and-white or sepia-toned photo, or a black-and-white line drawing will work the best. You'll be using dark ink on dark paper so that your decorations on the frame won't distract from the main picture. If you have access to a computer image-editing program, you can convert a color photo to grayscale, or crop the relevant part of the image to 4" × 6" (10.2 × 15.2 cm). The simpler the image, the better it will look in the decorated frame. The frame will overlap the picture edges by ⅛" (3 mm), so make sure your photo won't lose any important details by being cropped.

WHAT YOU'LL LEARN

- How to transfer a template to dark paper
- How to cut a perfect rectangular opening in paper
- How to create a subtle design on dark paper with calligraphy strokes

WHAT YOU'LL NEED

- one sheet 8½" × 11" (21.6 X 27.9 cm) black card stock
- one large sheet 25½" × 11" (65 x 27.9 cm) medium-weight artists' drawing paper in deep gray or chocolate brown
- 1.5-, 2-, or 3-mm calligraphy fountain pen or nib
- black calligraphy ink
- PVA and glue brush
- wax paper
- clear steel-edge ruler
- T-square
- pencil
- craft knife and cutting mat
- kneadable eraser
- optional: ⅛" (3 mm) hole punch, ribbon or cord

Let's Begin

1 Using a photocopier or computer scanner and printer, print a copy of the template (page 237) enlarged to 200%. When enlarged 200%, the inner rectangle should measure 4" × 6" (10.2 × 15.2 cm). Attach the template to the back of the dark-colored paper, using removable artist's tape, and *trace the edges of the template carefully* with a pencil.

2 Keeping the template in place, use a pin to prick a small hole in each corner of the "picture cutout area," passing the pin through the template as well as through your paper. Do not cut out this area.

(steps 1 and 2 shown on next page)

QUICK REFERENCE

Trace the edges of the template carefully. Lay a clear ruler over template, aligning the ruler edge to the very edge of the template, and use the ruler as a guide for tracing perfectly straight lines. A fine-point pastel or chalk pencil in a light color will help you better see the lines you are tracing on the dark paper, but test the pencil on a scrap of the paper to make sure lines can be erased completely.

Passe-Partout Picture Frame

3 Trim the paper, carefully following the outlines of the template. Use a ruler and bone folder to *gently score* the four flaps of the template; fold these to the back.

4 To mark guidelines, first orient your frame in the direction of the photo it will hold. Using a pencil and T-square, lightly rule lines, beginning with a line that intersects the top pin holes. Draw lines ¼" (6 mm) apart if you will use a pen with a 1.5-mm nib, or ½" (1.3 cm) apart for a 2-mm nib. Rule lines downward to the bottom pinholes. If the last line doesn't intersect the pinholes, go back and adjust the lines. Continue ruling lines on the top and bottom, ending at the flap folds.

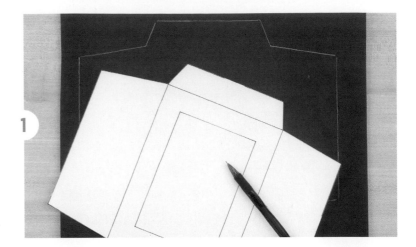

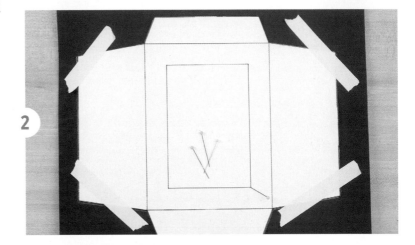

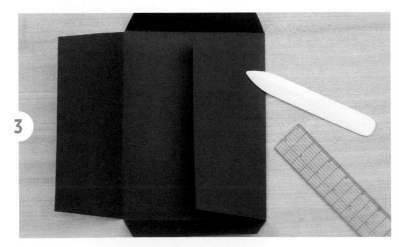

QUICK REFERENCE

Gently score. A bone folder dragged against the side of a ruler creates a small dent in the paper, which makes it easier to fold.

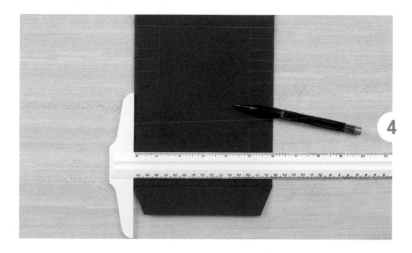

5 Unfold the flaps and position the paper faceup on your drawing board. Create your pattern. You might start with a simple repeating line of strokes and repeat the line every time, slightly offsetting the start of each new line ¼" to ½" (6 mm to 1.3 cm), then going back to fill in the beginning of the line with whatever was cut off at the end. This gives a repeat effect much like printed fabric. Or, start by creating a border of strokes around the area to be cut out and work out a pattern around that. The possibilities are endless. Try to arrange it so that the spacing between the strokes is even and your writing goes right to the edge where the flaps fold. And remember, you don't have to draw anything in the area that will be cut out.

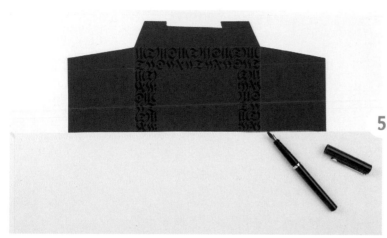

6 When the ink is thoroughly dry, use a kneadable eraser to erase all pencil lines but the four lines connecting the pinholes. Place the paper faceup on a cutting mat, making sure none of the flaps are tucked under the paper, and use a craft knife and a steel-edged ruler to cut out the 4" × 6" (10.2 × 15. 2 cm) opening. Use a pinhole as a starting point, making sure your cut does not extend beyond the next pinhole.

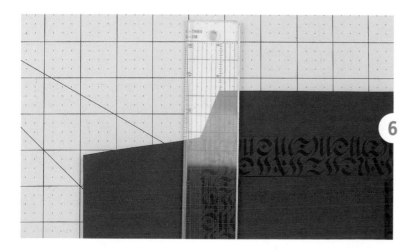

(continued)

Passe-Partout Picture Frame

7 Cut a 5" × 7" (12.7 × 17.8 cm) piece of black card stock (or other dark-colored card stock if you prefer). Turn your photo frame paper facedown on a piece of wax paper and apply a ½" (1.3 cm) band of glue around the margins of the cut-out area. Use a minimal amount of glue and do not let the glue go past the cutout edge. Lay the black paper facedown over the glued area, cover with wax paper, and press under a heavy book until the glue is dry (about thirty minutes.)

8 To trim a ⅛" (3 mm) border in the black paper that now fills the frame window, position a clear ruler so that the first ⅛" (3 mm) vertical line of the ruler is aligned exactly over the cut line of the frame paper. Use a fine-point pencil to very lightly rule a line on each side of the window. Place the paper on a cutting mat and use a steel-edged ruler and a craft knife to trim the ⅛" (3 mm) border, taking care to begin and end your cuts ⅛" (3 mm) away from the corners. Use a knead-able eraser to gently erase any pencil marks, taking care not to tear the thin border (use a bone folder to smooth out any dents or ripples).

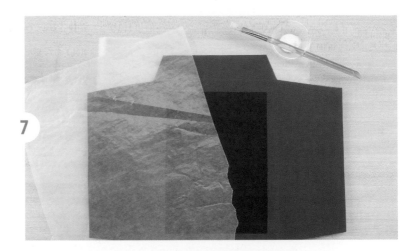

7

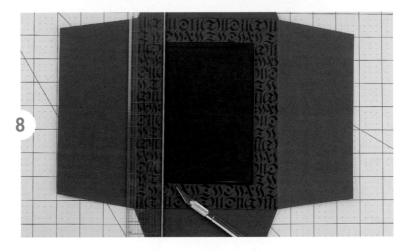

8

9

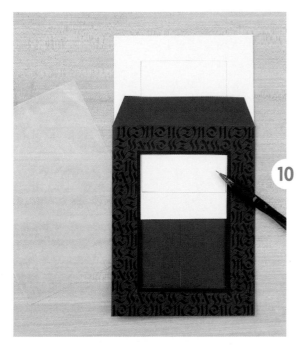

9 Turn the piece facedown, cut a piece of wax paper slightly smaller than 6" × 8" (15.2 × 20.3 cm), and place inside the frame. Fold in the two large flaps, applying glue to the area where they overlap (the wax paper prevents any glue from accidentally sticking to the inside of the frame).

10 When the glue has dried, remove the wax paper and tuck in one of the shorter flaps. Cut a piece of 100% cotton or other archival paper just smaller than 6" × 8" (15.2 × 20.3 cm). Place this sheet inside the frame (if needed, trim the sheet so that it fits easily inside) and use a pencil to lightly trace around the inside of the black border of the window.

11 Remove the inside sheet and use these pencil lines as guides for where you want to place your photo—anything falling outside the pencil lines will be cropped out. You want the edges of your photo to extend ⅛" (3 mm) over the pencil lines.

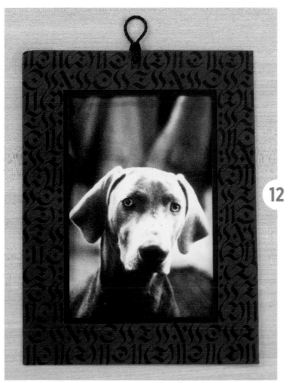

12 Position your photo so that it covers the rectangle lines you drew, apply a thin layer of glue to the back of the photo, cover it with a sheet of waxed paper, and press until dry (about 30 minutes). Insert the mounted photo into the frame and tuck in the upper flap by very gently squeezing the two long sides of the frame to create an opening. (Flaps are tucked rather than glued so you can easily change photos.) If desired, punch a ⅛" (3 mm) diameter hole through the top flap and loop ribbon or cord through the hole for hanging the picture.

Foundational Hand

Foundational Hand is the traditional calligraphy style, and the writing style most people think of when they think of calligraphy. It was developed in the early twentieth century by Edward Johnston, a British designer and calligrapher who created the simplified letterforms inspired by the calligraphy in English manuscripts of the Middle Ages. Foundational Hand is a simple style that is easy both to write and to read, and is a great place to begin learning the basics of calligraphy.

The Foundational Hand Alphabets

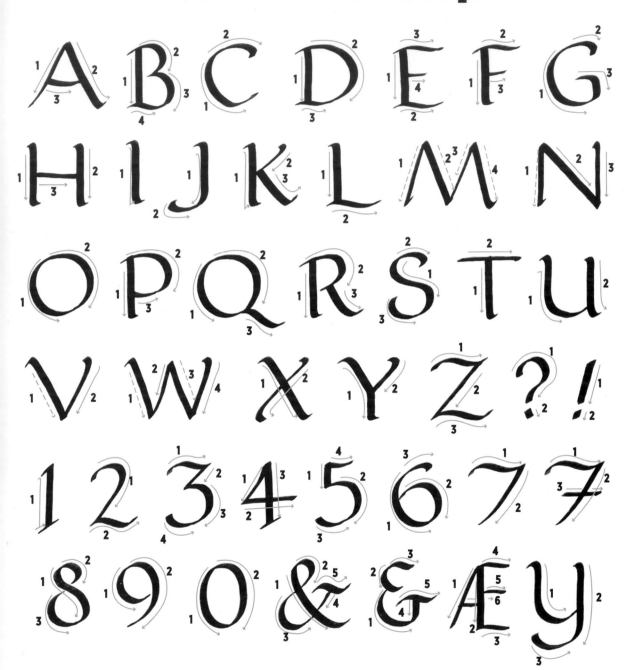

Uppercase Foundational Hand

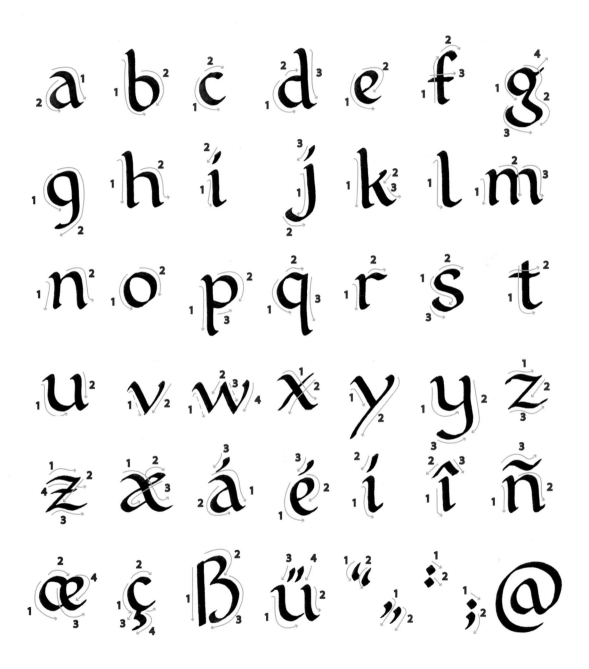

Lowercase Foundational Hand

Skill Builders
Exercise 1: TRACING THE ALPHABET

The purpose of this exercise is to become familiar with stroke order, stroke direction, and the shapes made by the pen when it is held at a constant 30° angle.

WHAT YOU'LL NEED

- tracing paper
- 2-mm calligraphy fountain pen or marker
- artist's tape
- photocopies of alphabet pages

1 For this and all other tracing exercises in this book, photocopy the alphabet pages and tape them to your tabletop or drawing board before tracing. Use removable artist's tape to secure the alphabet page to your writing surface, then tape your sheet of *tracing paper* over the alphabet page so that everything stays in place.

2 Holding your nib at a 30° angle, begin tracing the letters of the alphabet, following the stroke order and stroke direction for each letter shown in blue. Concentrate on maintaining a constant 30° pen angle and following the strokes with a smooth, fluid motion. Notice how it is the direction of the stroke combined with the unchanging angle of the pen that creates the interplay of thick and thin lines. Keep your writing hand poised lightly on the paper, and follow the strokes by moving your arm from the wrist or elbow, not by moving your fingers or flicking the pen.

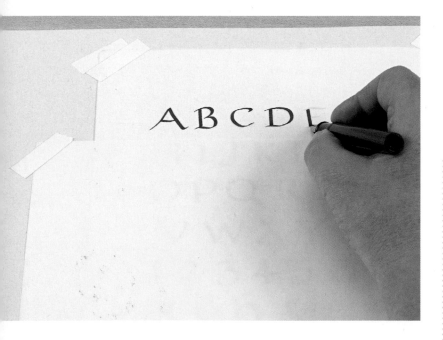

QUICK REFERENCE

Tracing paper is your friend. Tracing over examples of calligraphy you admire is one of the best ways to get a feel for how the piece was done and for learning how to execute the strokes with confidence. To do this, determine what size nib was used to make them by measuring the widest part of a stroke and selecting a nib that matches that width. Tracing is a great way to get the feel for how particular strokes and curves are made.

3 For the diagonal strokes indicated by the dashed arrows on the letters *M, N, V,* and *W,* angle the nib slightly upward to about 45°. This makes the diagonal stroke a little thinner. Tracing will help you feel the difference between the 45° and 30° angles.

4 Don't worry about making perfect tracings. The point of this exercise is to relax and let your pen follow the path of each stroke and learn how it feels (literally!) to make the letters using the proper pen angle. When you have finished, remove your tracing and compare it to the photocopied sheet. Look for areas where your tracings don't match up with the original—these will be areas to pay extra attention to when practicing.

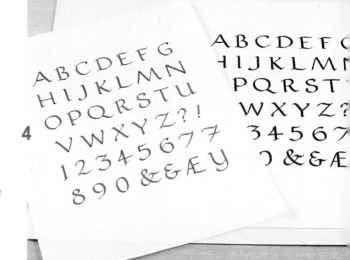

Foundational Hand: Key Points

- Foundational Hand letters should stand upright and not slant. It helps to keep your paper lined up straight on the writing surface—do not cant it to one side as you might for writing in cursive. If you are left-handed, however, you may find it helpful to tilt the paper slightly to the left.

- A broad-tip nib is generally used for Foundational Hand, as it creates the characteristic thick and thin strokes of this alphabet. A 2-mm nib is a good size to begin with.

- Hold the pen so that the nib is angled at 30° and remains at that angle throughout the length of each stroke. Maintaining a consistent pen angle is what creates the particular thick and thin qualities of line, and is one of the key essentials for success with calligraphy.

- Each letter in the Foundational Hand alphabet is made up of two or more separate strokes, and you lift the pen from the surface of the paper after each stroke. On the alphabet charts on pages 52 and 53, every stroke is written in its own proper direction and order. Following the correct stroke order and direction is essential for creating good calligraphy.

TIP Always check your pen angle before beginning each stroke. When letters come out looking wrong, often it's because the pen angle shifted slightly. Constantly checking your pen angle can slow you down at first but soon it will become second nature, and you'll notice the strokes of your letters joining up perfectly as you maintain a constant pen angle.

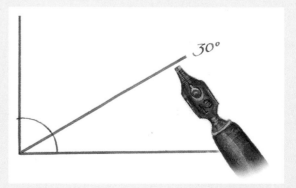

30° pen angle

Exercise 2: PRACTICING LETTER GROUPS

Instead of practicing writing the alphabet straight through from *a* to *z*, this exercise introduces the idea of practicing groups of letters that share common strokes, shapes, and proportions. If you wish, you can use a ruler and pencil to lightly rule lines across your page about ¾" (1.9 cm) apart. Aim to fill each page with repetitions of each particular letter group, concentrating on establishing a steady rhythm and repeating the strokes the same way each time.

WHAT YOU'LL NEED

- 2-mm calligraphy fountain pen or marker
- writing paper

1st stroke

2nd stroke

3rd stroke

Arched Letter Group

Notice how the arches join fairly high up on the stems of the letters. As you come over the round of the arch, pull the pen in straight, downward motion, ending with a very slight upward angle to create the serif. Align your paper squarely in front of you (don't angle it); this helps keep vertical strokes from leaning.

Round Letter Group

Most of the letters in the Foundational Hand alphabet echo the curves of the letter *o*.

The letters in the *round group* all rely on the crescent moon stroke practiced on page 32. Notice that the crescent moon stroke doesn't begin at the top of a letter, but slightly below.

The first and second strokes of the lowercase *a* sit slightly below the baseline to keep the letter from appearing cramped.

The crescent moon stroke is used in most of the round group letters.

Keep the arches the same distance apart.

Diagonal Letter Group

kvwxyz

Sometimes with diagonal strokes, the 30° pen angle makes the strokes look too wide. For example, for the letters *v*, *w*, and *x*, angle the pen more toward 45° to get a thinner line.

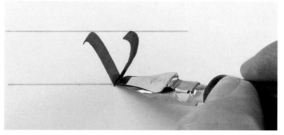

A 45° pen angle keeps the diagonal lines from splaying out too widely.

Miscellaneous Letter Group

fgijst

Keep the pen at a 30° angle for these letters. It is traditional to use an angled dash over the lowercase *i* and *j* rather than a dot.

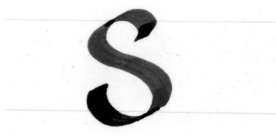

The lowercase *s* is written slightly larger so it doesn't appear cramped.

ahlmnruÿahmnruÿ
ahlmnruÿahmnruy
kvwxyzkvwxykvwx
yzkvwxyzkvwxyz

For practicing letter groups, graph paper is an inexpensive option, and useful for helping you learn to keep your lines straight and letters uniformly sized.

QUICK REFERENCE

Round group. Foundational Hand is often called "Round Hand," because almost all the letters in this alphabet contain circles or arches, with the lowercase *o* being a nearly perfect circle. The width of the lowercase *o* provides a guideline for the proportions of other letters of the alphabet as well, which should be more or less the same width as the lowercase *o*, with the exception of *m* and *w*, which should be about 50% wider.

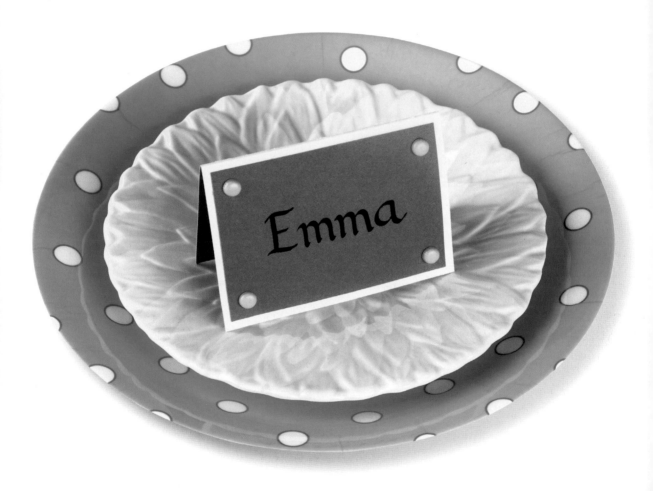

Two-Tone Place Cards

Use contrasting colors of paper and black ink to jazz up a simple name card. You can use folded place cards available at paper shops, or make your own from your choice of card stock. Two-tone card stock was used for these place cards, providing lots of options for intermixing colors.

WHAT YOU'LL LEARN

- How to determine grain direction in card stock
- How to score card stock
- How to write names
- How to layer paper panels
- How to attach brads

WHAT YOU'LL NEED

- three contrasting colors of card stock
- pencil
- T-square, ruler
- scoring wheel
- craft knife
- craft glue
- 2- or 3-mm calligraphy fountain pen
- calligraphy ink
- small hole punch or bookbinder's awl
- three contrasting colors of paper brads (four brads per card)

Let's Begin

1 Study the directions on page 63 for finding grain direction and marking out card stock. Determine the grain direction of the place card paper. Mark out and cut 3½" × 5" (8.9 × 12.7 cm) rectangles, with the shorter sides parallel to the grain direction. Use a ruler to lightly pencil in the fold line, bisecting the card. Place the card on a stack of paper and score the fold line with a scoring wheel held against a steel-edge ruler.

(continued)

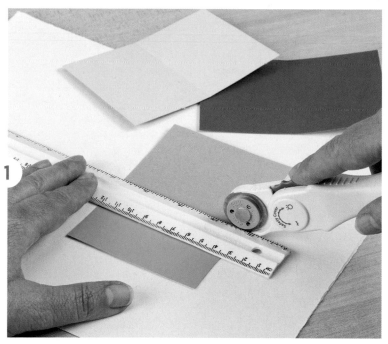

Two-Tone Place Cards

2 Cut contrasting color panels 3¼" wide × 2¼" high (8.3 × 5.7 cm). Write the place card names on the small panels in Foundational Hand.

3 Lay the finished panels facedown on a large sheet of clean scrap paper. Apply glue to the back of one panel at a time, taking care to cover it all the way to the edges (a brush is helpful for this).

4 Center a glued panel on the lower front panel of an unfolded scored card in a contrasting color. Cover with a sheet of paper, smooth gently to make sure the panel sticks firmly, and then press under a heavy book until dry (about 30 minutes). You can stack your entire batch of unfolded glued cards this way if you *interleave paper* between each card and stack them neatly.

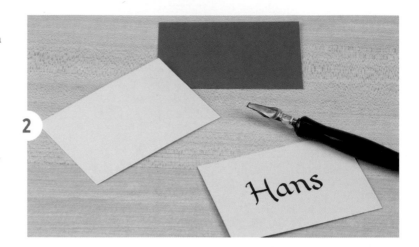

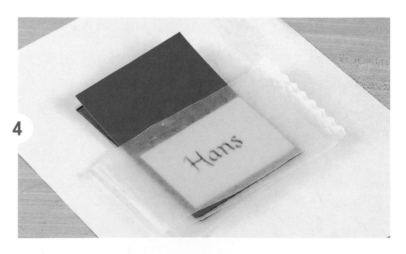

> **QUICK REFERENCE**
>
> **Interleave paper.** Wax paper is very useful for interleaving between glued sheets and can be pulled away cleanly if any stray bits of glue happen to stick to it.

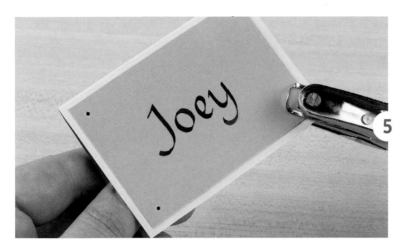

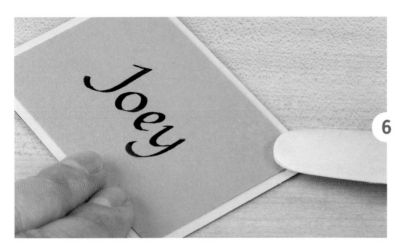

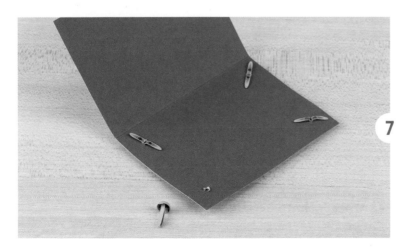

5 When the cards are dry, use a pencil to make a dot in each corner of the small panel about ⅛" to ¼" (3 to 6 mm) in from the corner, depending on the size of the brads you will use. Use a small hand-held hole punch or bookbinder's awl to punch holes in each corner.

6 Fold the card, lay it face-down on a clean surface, and smooth over the fold with a bone folder.

7 Position one contrasting color brad through the hole in each corner. Bend back the prongs of the brads diagonally toward the corners of the card so that they don't show from the front.

(continued)

Variations

Choose two or three bright colors of two-tone card stock so you can mix and match cards and name plates for your next party. Your guests will appreciate your calligraphy skills and treasure their place cards as a party memento.

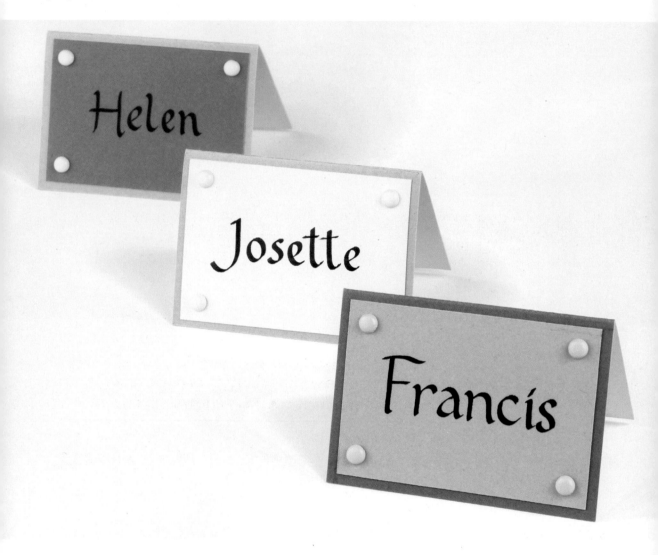

How to Find Grain Direction

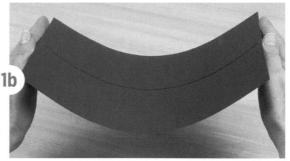

1a 1b

Card stock bends easily parallel to the grain direction of the paper (indicated by arrow).

You will feel more resistance when trying to bend the paper against the grain.

1 Hold two parallel edges of a sheet of card stock lightly between your fingertips and gently push the edges of the paper up into a slight U shape. If the paper bends easily, that means the grain direction follows the direction of the two sides you are holding.

2 Use a T-square and pencil to rule out the size of the folded card you want, aligning the fold line with the grain direction. Mark a dashed line for the fold line exactly in the middle of the card.

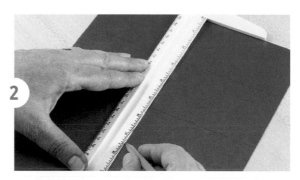

3 Place card stock on a stack of several sheets of paper, or any a surface that has a bit of give to it. Align a ruler against the edge of your fold line. With a scoring wheel or a narrow-edge bone folder, press a groove into the paper, following the ruler edge as a guide. Be sure to hold the ruler firmly. Repeat as many times as necessary, depending on the hardness and thickness of the stock.

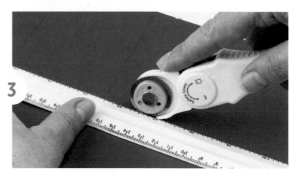

4 Gently bend the paper along the fold and smooth over the fold with a bone folder.

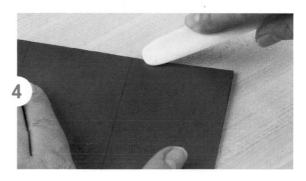

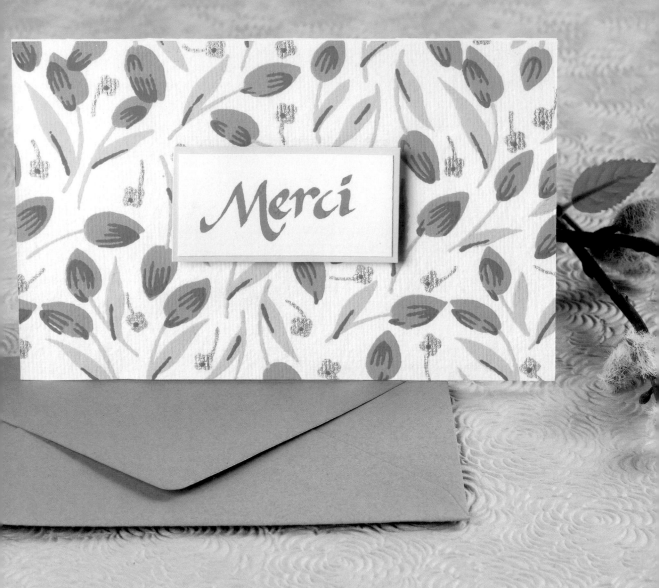

Floating-Layer Thank-You Notes

These thank-you notes use decorated paper and layers of paper to build up a simple "thank you" into something special. You will find a myriad of papers and embellishments to choose from at specialty paper and art supply stores.

WHAT YOU'LL LEARN

- How to make paper panels seem to float above the surface
- How to glue paper layers without making a mess
- How to prevent rippling when gluing paper layers

WHAT YOU'LL NEED

- pre-scored folded card and envelope
- one sheet of decorative paper
- one small sheet of card stock for text panel
- one small sheet of contrasting color card stock for backing panel
- embellishments of your choice
- self-adhesive foam dots
- scrap paper
- steel-edge ruler
- craft knife
- bone folder
- glue stick
- 2- or 3-mm calligraphy fountain pen
- calligraphy ink

Let's Begin

1 Measure the width and height of the card when folded. On the reverse side of the decorative paper, rule out the width and height, and add ¼" (6 mm) to both sides and the bottom edge. Then cut out.

(continued)

Floating-Layer Thank-You Notes

2 On your work surface, lay two sheets of clean scrap paper larger than the unfolded card. Lay the card, unfolded and faceup, on one of the sheets. Apply glue stick thoroughly to the lower panel (card front), taking care that glue is applied right up to the score line and covers all edges. Move the card to the second sheet of scrap paper and place the decorative paper onto the glued area, taking care to line the top of the paper right up to (but not over) the score line. Cover with a sheet of clean paper and rub with a bone folder to ensure that the paper is thoroughly glued down. Cover with a sheet of paper, place on a clean, flat surface, weight it down with a heavy book or two until dried completely (about an hour).

3 If you already know what size you want the text panel to be, cut out a few pieces of this size from the cover stock you have chosen. Make several versions of text so you will have options to choose from. Another approach is to write your text several times on a larger sheet of paper, leaving plenty of space in between, and decide the size of your panel based on the size of the text you have written. If you do it this way, use a clear grid ruler and pencil to lightly rule the lines for the edges of the panel.

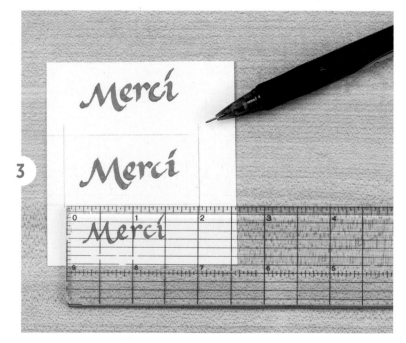

TIP If you are making multiple cards, interleave each card with a sheet of paper and stack the cards neatly under several books until dry.

4 Use a craft knife and steel-edge ruler to cut out the text panel, and then glue to the backing stock you have chosen. Press for 15 minutes or until completely dried. For a thin border as shown, use a craft knife and a steel-edge ruler to trim ⅛" (3 mm) from the text panel. Or, as shown in variations below, you might use a scissors to cut out a backing panel shape that is freeform. Remove the paper backing from one side of each self-adhesive foam dot and affix to the back of the text panel

5 Remove the paper backing from the other side of the foam dots and affix to the front panel of your card.

Variations

The shapes and colors you see in various decorative papers can provide inspiration and ideas for the shapes and colors of your floating panels.

Tiny Artist's Book

Tell a little story or joke, write a poem or a song . . . but keep it brief! This small book has only four panels. Here's your chance to be as fun and funky as you like—that's what an artist's book is all about.

WHAT YOU'LL LEARN

- How to plan spacing on book pages
- How to bind a paper book

WHAT YOU'LL NEED

- one sheet decorated cover stock
- several sheets of 110 lb (165.5 gsm; medium thick) text-weight paper
- black calligraphy ink
- 12" (30.5 cm) length of thin ribbon or cord for binding
- 2-mm calligraphy fountain pen
- pencil
- grid ruler
- steel-edge ruler
- bone folder
- craft knife
- bookbinder's awl (or corsage pin)
- two large paperclips
- cutting mat

TIP See Resources to find hand-held scoring wheels and table-top scoring machines.

Let's Begin

1 On a sheet of text paper, write out your text quickly and casually, breaking it up roughly into four similar-sized panels. Include illustrations if you feel like it. Rather than trying to fit your writing into a predetermined page size, just see how your four blocks of text shape up. Do this a few times if necessary, trying out different letter sizes, page breaks, and writing styles.

2 Decide the size of the folded page. Based on the way this story shaped up, the live area (area covered by writing) was determined to be 2⅜" wide × 3" high (6 × 7.6 cm), with a trimmed page size of 3⅛" wide × 3½" high (7.9 × 8.9 cm). An extra ¼" (6 mm) is added to all sides but the folded side, and will be trimmed away later. (Note how block of text is placed slightly to the left of the page so that it will appear centered when the book is trimmed.)

(step 2 shown on next page)

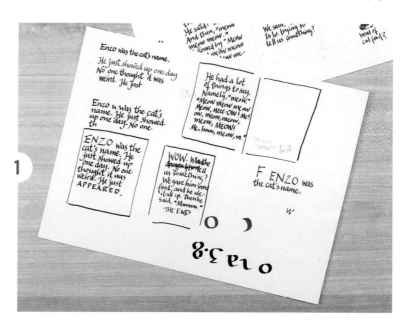

Tiny Artist's Book

3 Cut two pieces of text-weight paper and one piece of *cover stock* 6¾" wide × 4" high (17.2 × 10.2 cm). When cutting cover stock, be sure to cut so the fold runs the same direction as the grain of the paper (page 63). Fold the two text pieces in half, using a bone folder to get a crisp edge. Nestle the two folded pages one inside the other, and use a pencil to lightly number the odd-numbered pages in the lower right corners. Use scrap card stock to cut a rectangle the size of your live area (in this case, 2⅜" wide × 3" high [6 × 7.6 cm]) and use as a template to lightly outline in pencil where the live area will be on each of the odd-numbered pages. Remember to position the live area closer to the fold than to the right side, since ¼" (6 mm) will be trimmed from the right side of the page in the end.

4 Lightly pencil in your text based on your rough layouts. Or try it without pencil guidelines and see what happens. Make sure your hands are free of ink spots and your work surface is *clean*. Have a scrap of the same paper you are using for the pages handy to try the pen before you begin a line. Use a small piece of vellum positioned under your writing hand so that your skin does not come into contact with the paper. Once you've finished a panel, allow plenty of time for the ink to dry before working on the panel on the opposite side of the page.

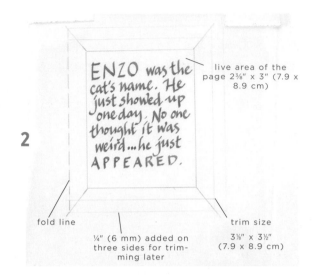

2

ENZO was the cat's name. He just showed up one day. No one thought it was weird ...he just APPEARED.

live area of the page 2⅜" x 3" (7.9 x 8.9 cm)

fold line

¼" (6 mm) added on three sides for trimming later

trim size
3⅛" x 3½"
(7.9 x 8.9 cm)

3

4

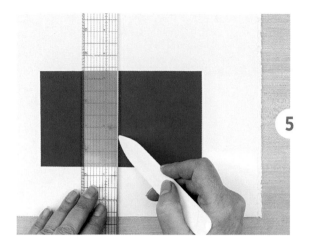

5 On the inside of the cover, pencil a line exactly down the middle where you want the fold to be. Place facedown on a clean surface that has some give, such as a cutting pad or several sheets of blotter paper. Position a steel-edge ruler just next to the pencil line (not directly on top of it) and draw the tip of the bone folder along the edge of the ruler and over the pencil line. It is important to hold the ruler firmly and press fairly hard with the bone folder. You may need to repeat this a few times to obtain a deep score, especially on very heavy stocks. Fold the cover, then smooth over the fold with the bone folder.

6 After your pages have thoroughly dried, use a kneaded rubber eraser to remove any pencil marks from your lettering. For removing pencil marks from where there is no ink, use a white rubber eraser, which actually removes microscopic bits of the paper surface, and will erase calligraphy ink too, so handle with care! Smooth over the folds with the bone folder for crispness. Position your pages (in the correct order) inside your cover, using paper clips to ensure that the folds of the paper are positioned tightly against the cover fold. Use a bookbinder's awl or corsage pin to poke holes through the folded layers about ½" (1.3 cm) from the top and bottom edges. Cut a 12" (30.5 cm) length of your chosen binding material and thread through the holes so that both ends come out on the outside of the book.

7 Tie cord and trim off excess. Position book on a cutting mat and use a straight-edge ruler and craft knife to trim ¼" (6 mm) from top, bottom, and right sides. Be sure to hold the ruler very firmly while doing this, cutting slowly and cleanly. Don't rush or push hard; you will need to make several light, even cuts to get through all the layers of paper.

Let it hereby be known that:

SUPER-FRIEND AWA

has been awarded to

E·R·I·K

for being a really super

This 7th day of August, 2009

X Jeaneen Gauthier

Proportion, Color, and Ornament

In addition to making well-formed letters, the art of calligraphy also involves skillfully proportioning those letters in relation to one another and arranging lines and blocks of text to form a balanced, attractive composition. Building on the basics of Foundational Hand shown on pages 52–58, this section will show you the skills and techniques that will help you fine-tune the size and spacing of your letters. We will also explore fun ways of using color and ornament to liven up your text and add accent and interest to your work.

Ruled Lines and Ladders

In calligraphy, a simple system of measurement based on the width of the nib you are using and ruled lines (straight lines lightly drawn with a pencil and ruler, which are later erased) is used to establish the appropriate letter size. To set up ruled lines that are correctly proportioned to the size nib you are using, make what is called a "ladder."

How to Make a Ladder

1 Choose the size nib you want (in this example, a 2-mm nib is used). Start by ruling a single pencil line across a page. At the far left of the line, use a set square or grid ruler to rule a 90° vertical line about 1" (2.5 cm) high, creating a corner.

2 *Turn the paper 90° clockwise,* and with your pen nib lined up straight against the vertical line, make a square mark that sits exactly in the corner of the two pencil lines. Make sure not to angle the pen nib—you want to position the nib straight against the vertical pencil line so that your mark is exactly one full nib width. Next, move the pen one nib width down and over, and draw another square that just touches the corner of the first square. For the third square, move the pen up and back, again making a square that touches the corner of the last square.

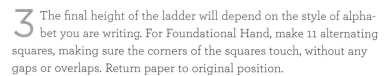

3 The final height of the ladder will depend on the style of alphabet you are writing. For Foundational Hand, make 11 alternating squares, making sure the corners of the squares touch, without any gaps or overlaps. Return paper to original position.

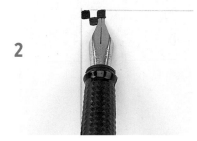

4 Use the ladder and horizontal pencil line to rule lines as shown, making sure your ruler lines are positioned precisely on the top of the squares: one line 3 nib widths from the bottom line, one line 5 nib widths up from the second line, one line 2 nib widths up from the third line, and one line 1 nib width up from the fourth line. A clear grid ruler will help you keep the lines straight.

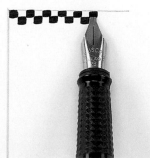

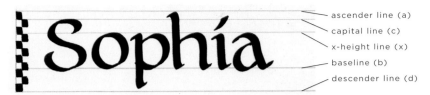

ascender line (a)
capital line (c)
x-height line (x)
baseline (b)
descender line (d)

Using the 11 nib-width ladder and ruled lines, you have set up the guidelines for properly proportioned Foundational Hand letters.

Some points to take note of as you practice:

- The body of each lowercase letter should rest between the baseline and x-line—this width is referred to as the "x-height" or "body height" of an alphabet.
- The Foundational Hand alphabet is generally written with an x-height of 5 or 4 nib widths, with ascenders and descenders of 3 nib widths.
- Capital letters sit on the base line and reach to the capital line—1 nib width short of the ascender line. Take care when writing capital letters not to make them too large.

Ladders for Various Alphabets

Calligraphy alphabets have traditionally been written using established nib width to x-height proportions. The relationship between the width of the nib used and the size of the letters, along with the pen angle used, is what gives each alphabet its distinctive look. Often a graphic symbol of nib width and pen angle is used to visually convey the information needed for writing an alphabet in its proper proportion. For example, the graphic information for Foundational Hand looks like this:

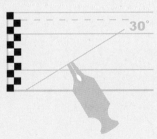

30°

This graphic shows at a glance what the proportion of capitals, x-height, ascenders, and descenders of the alphabet should be. To write the alphabet in a larger size, simply build a ladder the same number of nib widths using a larger nib, then rule out the guidelines accordingly. The result will be larger letters, but with the same proportions.

As each new alphabet is introduced, refer to the graphic symbol that appears with examples of the letters and indicates the nib width to x-height ratio and pen angle used. With this information you will be able to re-create the proportions of that alphabet using any nib size.

Ruling Lines for Practice and Projects

The best way to develop your skills for letter proportions and spacing is to practice writing full lines of text on paper that has been ruled specifically for the size and style of alphabet you want to write. Calligraphy practice pads are readily available and can be helpful for this, but one big drawback is that the ruled lines may not correspond to the nib size and alphabet you want to practice. A quick and easy way to rule out pages according to your specific needs is to make a ruling gauge.

How to Make a Ruling Gauge

1 Decide on the nib size and alphabet style you want to use. In this example we will make a ruling gauge for a 2.5-mm nib writing in Foundational Hand with an x-height of 5 nib widths. Cut a piece of sturdy card stock measuring about 3" (7.6 cm) square and use a T-square and a fine-tip pen to rule a vertical line ¾" (1.9 cm) in from the left side of the paper, running all the way from the top to bottom. Next rule a horizontal line that intersects at a right angle with the vertical line and runs all the way from the left side to the right side.

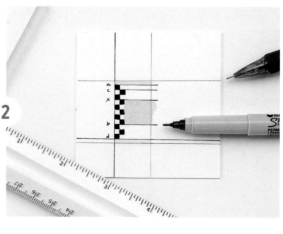

2 Starting in the very corner where the two lines meet, use a 2.5-mm nib to create a ladder of square marks 11 nib widths high. Use the fine-tip pen to rule the rest of the guidelines: 3 nib widths for descenders, 5 nib widths for x-height, 3 nib widths for ascenders, and 7 nib widths from the baseline for capital height. These lines need only extend about ½" (1.3 cm) or so from the ladder squares. Rule pencil lines for trimming 1⁄16" (1.6 mm) from the ascender and descender lines and about ½" (1.3 cm) from the ladder and ends of the ruled lines. A light-colored pencil can be used to color in the top- and bottommost margins, and another light color can be used to fill in the area between the baseline and x-line.

3 Use a steel-edge ruler and a craft knife to trim. For reference you can write the size of the nib used to make the ladder in the left margin. You have now created a ruling gauge designed for ruling lines for Foundational Hand with an x-height of 5 nib widths to be written with a 2.5-mm nib. With this gauge, the spaces between the lines of text will be ⅛" (3 mm); that is, the sum of the 1/16" (1.6 mm) space at the top and bottom of the gauge.

How to Use Your Ruling Gauge

1 Position the right edge of the gauge flush against the left-hand edge of the paper. Use a fine-tip pencil to mark where your ruled lines will go. Use dots to mark the outermost spacing lines and capital line, and dashes to mark the baseline, x-height line, ascender line, and descender line.

2 Match the top edge of the gauge to the bottom dot and continue making marks down the page.

3 Align a T-square to the dash marks you made with the gauge and use a fine-tip pencil to rule the lines. For the dots that mark the spacing between lines, draw a small *x*. It is not necessary to rule the capital line, just use the dot you've marked as a visual reference.

TIP Make a ruling gauge for each of your frequently used nib sizes and alphabets. Especially when you are trying out a new nib size or alphabet, a ruling gauge will help you get started writing letters that are properly proportioned.

Skill Builders
PRACTICING BLOCKS OF TEXT

Practicing lines and blocks of text on ruled paper is the best way to learn to make well-proportioned letters. You can use paper you have ruled for a specific nib size, or you may find *graph paper* or notebook paper that is ruled in increments that suit your purposes. Choose a paragraph of text, a poem, song lyrics, or any text you find interesting, and write it out on a sheet of ruled or graph paper in Foundational Hand, keeping in mind the following:

- Letter spacing: spacing between letters should be compact, but not too tight. Rounded letters like lowercase *e* and *o* need closer spacing, whereas verticals like lowercase *i* and *l* benefit from having a little extra space around them so they don't get lost. Learn to scan your letters with an eye for how the shapes fit together rather than the meaning of the text.
- Letter widths: allow yourself to write letters at their natural widths, especially *m* and *w*, and avoid the inclination to compress letters to get them to fit into a space. Foundational Hand letters tend toward being wide and round, so when in doubt, err on the side of making letters too wide rather than too narrow.
- Interlinear spacing: allow enough spacing between lines so that the ascenders and descenders do not bump into each other. On the other hand, too much spacing between lines can make lines look lost. Get into the habit of scanning your text without reading it, instead keeping an eye out for uncomfortable gaps and spaces between lines and letters.

> Qui totiens socios, totiens exterruit hostes, Creditur annosum pertim-uisse senem.

> 'm' and 'w' are the widest letters— allow them a lot of room.

> Quo me fixit Amor, quo me violentius ussit, Hoc melior facti vulneris ultor ero: Non ego, Phoebe, datas a te mihi mentiar artes, Nec nos ariae voce ...

QUICK REFERENCE

Graph paper. Graph paper ruled with 10 squares to the inch (2.5 cm) is very handy for practicing letters with a 2.5-mm nib because each square of the grid is approximately 2.5 mm wide.

Color

Color can be used in small amounts to add accent and interest to your work, or in larger amounts to make a bold creative statement. Ink, gouache, and watercolor can all be used for pen, brush, and background work, with ink being the easiest starting point for beginners.

Ink

With the primary colors of red, blue, and yellow calligraphy ink, you can mix almost any color you need. White and black ink can also be used to lighten or darken ink colors as needed. It is a good idea to purchase the same brands of these basic colors, since ink formulas vary between brands and do not always mix well. If you plan to work a lot in purple and green, it is also helpful to purchase those colors as premixed inks. Look for ink that is specifically labeled as "calligraphy ink." There are many colored inks on the market, many of which are formulated for fountain pens and tend to be too watery and transparent for calligraphy.

The color wheel provides a visual guide to mixing colors: mixing red and yellow ink will make orange, blue and yellow will make green, and red and blue will make purple. Be aware, however, that mixing calligraphy ink is not the same as mixing paint—for example, equal amounts of red and yellow calligraphy ink will not add up to orange, but rather just a slightly brighter red. The reason for this is that calligraphy inks, being water-based, are more transparent than paints, so the stronger pigment in a mix will dominate, sometimes to the extreme. When you are mixing ink, start with the lighter color (like yellow or white) and then add the stronger color (like black, red, or blue) in very small amounts until you have your desired color.

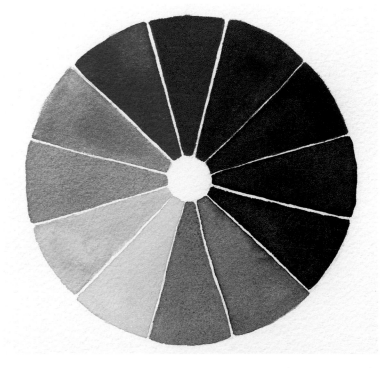

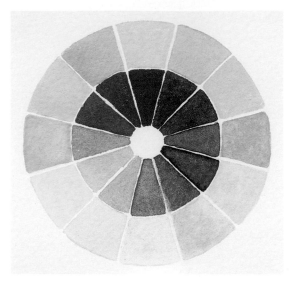

You can also add a very small amount of a mixed color to opaque white ink, creating a lighter tint, or small amount of black to create a darker shade. Use black ink sparingly; sometimes only a tiny amount on the mixing brush (less than a drop) is needed.

Test out your color with a clean, dry nib on a sheet of paper rather than trying to judge the color by the way it looks in liquid form. Transparent colors like yellow or light blue look much lighter on paper than they do as ink. You can add a small amount of opaque white to reduce transparency.

Tube watercolors can be mixed to an inklike consistency and used with a dipping pen, although many colors tend to be transparent and thus don't show up well when used for writing smaller letters. A fun way to use tube watercolors is for filling in letters, shapes, or borders, and for building up layers of transparent color. Watercolors can also be used to create a background wash, although some inks applied over watercolor washes may bleed.

TIP When working with acrylic ink or gouache, use only a dipping pen, never a calligraphy fountain pen, which can become clogged when filled with anything other than non-waterproof ink. Clean nibs well after using gouache or acrylic ink, using a stiff-bristle brush to remove any dried clumps of pigment.

Acrylic inks are available in a wide range of colors that are opaque and generally nonbleeding on any surface. Because it is waterproof, acrylic ink is useful for layering one color on top another without the danger of the two colors combining. Pearlescent acrylic inks are nice for borders and backgrounds, but can be a little too thick for use with a nib—you may need to add a little water. Acrylic inks dry very quickly, so make sure to rinse and wipe your nib often when using them.

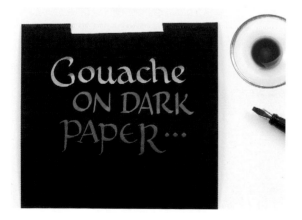

Gouache dries to a flat finish and usually somewhat darker than the mixed color. You can get very interesting effects by mixing pale tints to use on darker papers.

Calligraphy gouache can be mixed with water to an inklike consistency and used with a nib, giving a flat, opaque color. Load up the nib with a brush dipped in gouache and test the consistency, adding more water if needed, drop by drop, until the gouache flows smoothly from the nib.

Ways to Use Color

Color can be used sparingly or generously, depending on the look you want to create. Avoid using too many colors on a single page, which can distract the eye and make the piece look busy. Contrasting colors—colors positioned directly across from one another on the color wheel, such as red and green—used together will draw attention and give a bold, energetic look to a piece; whereas analogous colors—colors that sit next to each other on the color wheel, such as blue and purple—used together will create more harmonious, subdued effects.

Examples

![L·l·L·l calligraphy on dark background]

Calligraphy gouache can be used to lay down opaque color that will show up on a dark background.

♡ D'AMORS qui m'a tolu a moi⌁ N'a soi ne me viaut retenir ✥ me plaing

Ornaments done in a different color can liven up blocks of text.

When inking a dipping pen, alternating between two colors, such as yellow and green, gives you graduated shades of both.

THERE ONCE WAS a shoemaker, who, through no fault of his own, became so poor that at last he had nothing left but just enough leather to make one pair of shoes. ~~~~~~~

Traditional calligraphy often uses red for an opening initial or line.

ARUM MACULATUM · ANEMONE CORONARIA
BRYONIA DIOICA · CENTAUREA CYANUS
DIGITALIS PURPUREA · HEDERA HELIX·
MYOSOTIS SYLVATICA · MORUS NIGRA
ALTHEA ROSA · LONICERA CAPRIFOLIUM
BELLIS PERENNIS · LAURUS NOBILIS·
SILENE LATIFOLIA · VITIS VINIFERA·

In this example, analogous colors are used to create subdued contrast between words.

Fun with Color

Wet-on-Wet Wash Background

1 Tape all four sides of a sheet of heavy-weight (75 lb or 300 gsm) watercolor or printmaking paper to your work surface. Use a large, soft-bristle brush to saturate the paper, partially or entirely, with water.

2 Pick a few colors of acrylic ink, used full-strength or diluted with water, and use a soft brush to blot, swirl, or splatter the ink onto the wet paper. (Artists' acrylic paints thinned with water can also be used.) You'll notice interesting bleeding and patterns forming as the pigment flows into the moistened areas of paper. (Note: working with lighter colors will make it easier to go over with ink in the end.) Allow the paper to dry thoroughly before removing tape. It helps to press the semi-dried sheet between two sheets of paper under heavy books so that it dries completely flat.

3 When the sheet is dry, write on it with water-proof calligraphy ink or acrylic inks.

Pastel-Shaded Letter Fills

1 Write your text fairly large on a rough-surfaced watercolor or drawing paper. Unwrap some of the paper from a pastel crayon, and use a craft knife to scrape a fine layer of pastel over the work.

2 With a cotton swab, rub the pastel dust into the open areas you wish to fill in. For areas where you don't want pastel color to stick, blow the particles into a trashcan or sink (not onto your work surface or into the open air). You can remove unwanted color using a kneadable eraser, but make sure you don't accidentally erase color from the areas where you want it.

Watercolor Pencil Fills

You can use watercolor pencils to fill in spaces inside of letters, as well as the insides of outlined letters or borders. They are easy to use and a lot more forgiving than regular watercolor paints.

1 Use a watercolor pencil to lightly fill in the inside of a letter or border. The pencil tip should not be too sharp. Use a regular back-and-forth movement so the color is evenly distributed.

2 Use a small brush dipped in water to spread the color around. Once the first layer of color has dried, you can go back and add additional layers.

Freehand Gouache or Watercolor Borders

1 Mix two analogous colors of watercolor or gouache to inklike consistency—it should be more watery than thick. Examples of analogous colors are: yellow + green; purple + red; blue + green; and orange + yellow.

2 Use a pencil to lightly outline where your paper will be trimmed. Tape all four edges of the paper to your work surface and use a wide, soft-bristle brush about ½" (1.3 cm) wide to quickly paint a loose, flowing border that extends inside as well as outside of your pencil lines. Work quickly, keeping your brush strokes fast and fluid.

3 When the first layer of paint is dry, use the brush to apply the second layer. Don't repeat exactly what you did the first time, but instead try to have the colors overlap in places and stand alone in others. When ink is dry, untape the paper and trim to size following your penciled guidelines.

Ornament

Ornament plays a vital role in calligraphy, by adding style and decoration to a page, dividing up space graphically, or balancing a composition or line by filling in gaps. An ornament can be something as simple as a few dots placed in a row to a complex pattern of interlaced arabesques. Almost any graphic mark you make can be stylized and refined into an ornament, and combined with lines, borders, or other ornaments in many ways.

Try out some of these historic calligraphic ornaments to liven up your text. It helps to practice drawing the ornament out first in pencil before going over it in ink.

Ways to Use Ornament

Lo duca e io
per quel cammio ascoso
intramma ritornar
ne chiaro mondo
e sanza cura
aver d'alcun riposa
sallimmo sú,
el primo e io secondo,
tanto ch'i' vidi
de le cose belle
che porta 'l ciel,
per un pertugio tondo.
E quindi uscimmo
a riveder le stelle.

Ornaments at the bottom of the page give a sense of completion to the piece.

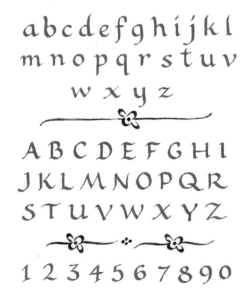

You can combine ornaments with lines to divide areas of text.

VET✤DU✤VAR VAR✤GLAD

Ornaments on each side of a word or phrase showcase it.

Groups of ornament can be combined to form patterns or borders.

Non enim illa, quae futura sunt, subito existunt, sed est, quasi rudentis ex plicato, sic traductio temporis nihil novi efficientis et primum quidque replicantus ✤✤✤

Ornaments or flourishes can be used to fill up blank space at the end of a line of text.

Adding Details with Small Nibs and Brushes

Using a small nib to add narrow lines to letters, borders, and ornaments can add extra visual interest to a piece. Try using a nib that is about one-third the width of your regular nib for outlining or adding small details.

Brushes are very useful for filling in borders—try lightly ruling two pencil lines and using a small brush (for example, a size 1 or 2 round) to fill the space in between with ink, gouache, or watercolor. You can build up the border by adding more details with a narrow nib.

Decorative Spice Labels

Although these labels are designed with spice jars in mind, you can easily make them into labels for storage boxes, folders, packages, or just about anything that needs a label.

WHAT YOU'LL LEARN

- How to make and use a template to create several uniformly shaped labels
- How to plan spacing of different words within the same shape
- How to enliven a project with a watercolor border

WHAT YOU'LL NEED

- crack-and-peel label stock with a woven or matte finish (glossy label stock may not take the ink well)
- calligraphy ink and watercolor in assorted colors
- 2 mm nib for lettering
- small nib (about 1 mm) for adding details
- ⅛" (3 mm) flat brush
- pencil
- ruler
- T-square
- craft knife
- spice jars or containers

Let's begin

1 To figure out what size label to make, cut a small strip of paper and wrap it around the front of your jar—usually about halfway or a little less around is the right size for a label. Fold the strip to mark the point where the label should end, and use that as a guide for the label size.

(continued)

TIP Check the back of your label stock to see in which direction the crack-and-peel lines run, and then position your template on the paper so that the crack-and-peel lines run vertically from the top and bottom of your piece. This will make it a lot easier to remove the label backing.

Decorative Spice Labels

2 Measure your guide strip and rule out a template of that size on sturdy card stock. Use a steel-edge ruler and craft knife to cut out the template, making sure that your cuts are straight. Use your template to make light outlines on a small sheet of label stock. Keep plenty of space between each outline, or if you wish, you can cut the label stock even smaller so that it is about 1" (2.5 cm) bigger than the template on all sides.

3 Use a clear ruler and pencil to lightly rule lines ⅛" (3 mm) in from the template outlines. This will be the area used for the border.

4 Choose the size nib you want to use. It is helpful to make a small ruling gauge (just a ladder of the x-height with lines for baseline and x-height) and use that for ruling your writing lines. Doing a trial run on paper will also give you an idea of the width of the different words, so you can easily center them when you're writing them on the labels.

5 Ink in your letters. After the ink is dry, if you wish, you can cut the paper into quarters (leave some space around each label) to work on each label individually.

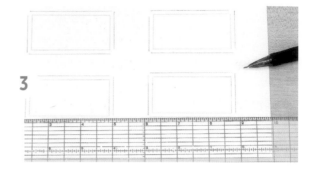

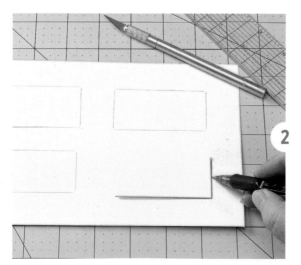

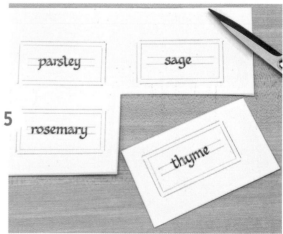

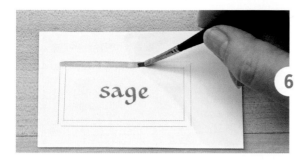

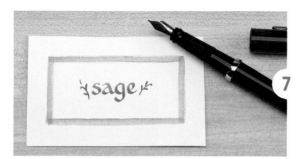

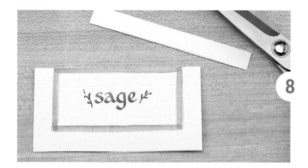

6 To paint the borders, apply a small amount of watercolor to the brush, keeping it as "dry" as possible. Start at a corner of the border and draw the brush in one smooth continuous stroke. Add additional thin layers of color if desired.

7 Use a small nib to add details.

8 Use a sharp scissors to trim the labels, cutting off just a tiny bit of the colored border.

9 Apply the labels to your spice jars.

Variations

Use the techniques you've learned to make gift tags, nameplates, and labels for lots of items around the house.

Let it hereby be known that the

SUPER-FRIEND AWARD

has been awarded to

E·R·I·K

for being a really super friend!

This 7th day of August, 2009

X Jeaneen Gauthier

Seal of Approval

Award Certificate

Everybody deserves recognition for something, right? You can put your developing calligraphy skills to use by creating certificates awarding your friends and family for just about anything.

WHAT YOU'LL LEARN

- How to use a rough layout to design a complex project
- How to rule lines for a complex project
- What order to work when making a multicolor project

WHAT YOU'LL NEED

- 8½" x 11" (21.6 x 27.9 cm) parchment paper
- pencil
- kneaded eraser
- ruler
- color calligraphy markers
- calligraphy nibs in 3 sizes (2, 3.5, and 5 mm)
- calligraphy inks
- ⅛" (3 mm) flat brush
- crack-and-peel label stock
- pinking shears
- red acrylic ink
- ribbon to make the seal

Let's Begin

1 Use calligraphy markers to do a rough layout.

(continued)

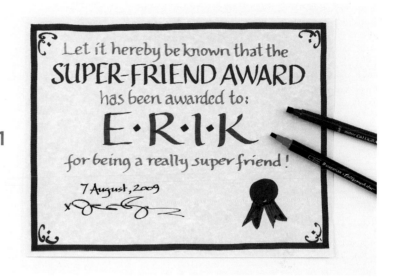

1

Award Certificate

2 Referring to your rough layout for letter heights and line widths, rule guidelines in pencil on a sheet of parchment paper and practice writing the individual lines of text. When you get a line you are satisfied with, measure it with a ruler, marking vertical lines at each end of the line as well as in the center. Trim to a narrow strip and continue this process for each line of text.

3 Use a pencil and T-square to lightly rule out the border of the certificate. Lightly rule a vertical line through the center of the entire page.

4 Line up your letter strips on the ruled sheet, aligning the vertical lines of the strips to the vertical line on the center of the sheet. When you are happy with the placement of each line, stick each strip into position with a little rolled piece of artist's tape or masking tape on the back of each strip. Use a pencil to mark small dots showing where each line of text begins and ends.

5 Remove the strips of stuck-on text. With a T-square aligned against the left edge of the paper, use pencil to lightly rule guidelines for writing. Start with the left-hand dot, and stop the line when you reach the right-hand dot. Note: it's okay if the dots don't line up perfectly—just keep your T-square aligned to your paper edge and draw your guidelines that are the same length as indicated by the dots.

2

3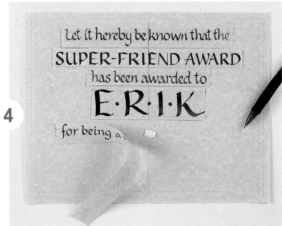

4

5

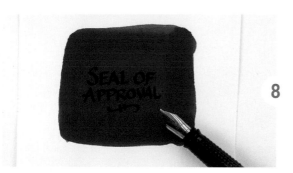

6 Do lines of all one color first rather than changing colors at each line. Remember to use a guard sheet under your hand to protect the paper.

7 Do the other text colors, and then use the ⅛" (3 mm) flat brush and red ink to fill in the borders. Try to keep your brush strokes as smooth as possible, drawing your arm down the page rather than moving your fingers.

8 To make the seal, use a brush and red acrylic ink to paint a 2" × 2" (5.1 × 5.1 cm) square on crack-and-peel label stock. Apply the ink in several layers so the paper is densely coated with ink. When the ink is thoroughly dry, use a compass or a round object to lightly trace a circle on the painted square. Use black ink and a small nib to write or draw inside the seal.

9 Cut lengths of ribbon about 2" (5.1 cm) long. Use pinking shears to trim around the circle, then peel off the label backing and stick the two ends of the ribbon diagonally against the back of the label, making sure the ribbon lies flat. Stick this to the certificate and trim the ribbon ends with sharp scissors.

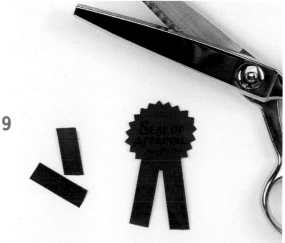

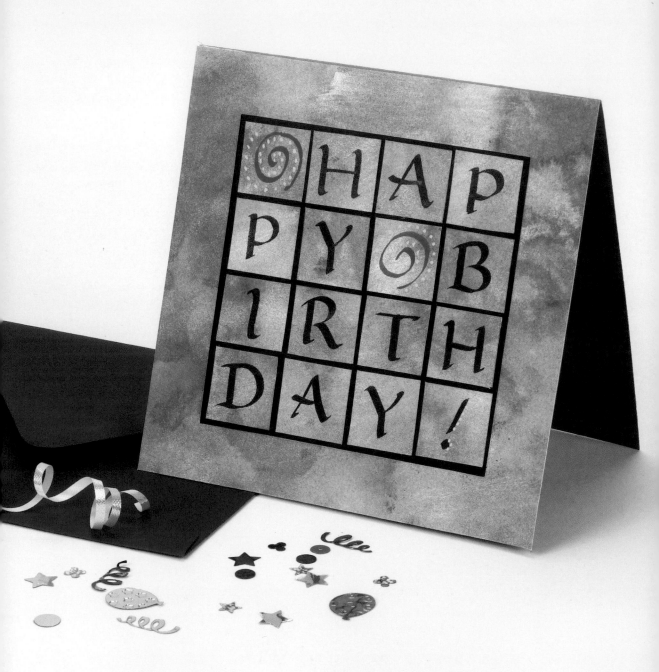

Mosaic-Style Greeting Card

For this project you will use acrylic inks and a wet-on-wet wash technique to create a colorful, swirling background for your letters. The instructions for this design make a 5½" (14 cm) square top-folding note card with spaces for sixteen letters for the greeting.

WHAT YOU'LL LEARN

- How to make colorful background paper for calligraphy using a wet-on-wet method
- How to cut small squares with precision
- How to glue small pieces in a precise grid pattern

WHAT YOU'LL NEED

- 140-lb (300 gsm) hot-pressed printmaking paper
- wide brush with soft bristles
- medium-sized brush with soft bristles
- three colors of acrylic inks (or acrylic paint)
- water in a spray bottle
- paper towels
- masking/artist's tape
- newsprint or scrap paper
- black calligraphy ink
- 2-mm nib
- scoring tool or bone folder
- pencil
- T-square
- ruler
- craft knife
- cutting mat
- 5" x 5" (12.7 x 12.7 cm) piece of colored card stock for backing sheet
- 5½" x 11" (14 x 27.9 cm) colored card stock for card base
- envelope

Let's Begin

(Note: cover your tabletop or work surface with newsprint or scrap paper for the wet-on-wet wash part of this project, which can be a little messy.)

1 Start with a piece of hot-pressed printmaking or watercolor paper (page 19), cut to about 7" × 10" (17.8 × 25.4 cm) in size. Place several sheets of newsprint or scrap paper underneath and tape down all four sides of the paper to a flat surface using masking tape or artist's tape. With a large, soft-bristle brush, thoroughly saturate the taped-down paper with water. Use a large brush to drop a few blobs of acrylic ink (or acrylic paint mixed with water to a creamy consistency) onto the wet surface of the paper.

(continued)

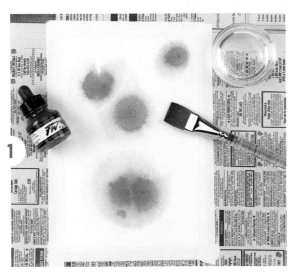

Mosaic-Style Greeting Card

2 Let the ink blobs spread for a few moments, then drop random blobs of your second color of acrylic ink or paint.

3 Allow some time for the second color blobs to spread out, then use a medium-sized brush to splatter a third color of acrylic ink or paint onto the paper. After these blobs have spread out a little, use a large slightly damp soft-bristle brush to blend the colors until there is no white space showing. You can keep adding blobs of colors if you like, mist the paper slightly if needed.

4 When the paper has dried completely flat (allow several hours for this) remove the tape and use a T-square and pencil to lightly rule a grid of squares measuring approximately 1" (2.5 cm). Start at the top of the sheet and rule six squares across, and four down, for a total of 24 squares. Do not rule the remaining paper—instead, trim it off— it will be used later in the project.

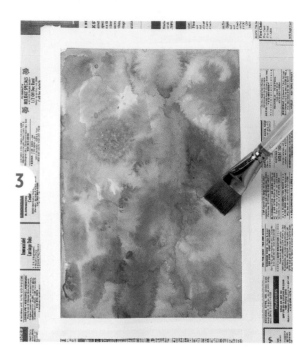

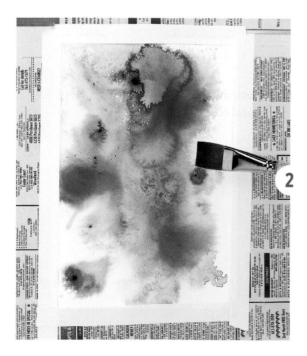

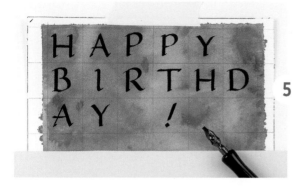

5

6

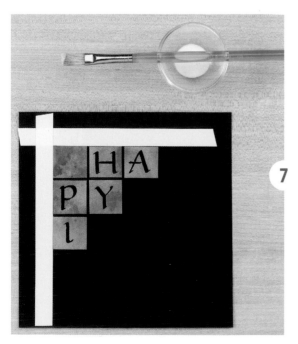

7

5 Use a dipping pen and ink to write the letters of your greeting in all capitals, taking care to center each letter inside its square. (Note: if your greeting has less than sixteen characters, you can also leave some of the squares blank, or fill them with ornaments.)

6 Working on a cutting mat, use a clear steel-edge ruler and a craft knife to trim each square approximately ¹⁄₁₆" (1.6 mm) in from each of the pencil grid lines. You can calculate this distance by eye while holding the edge of the ruler against the pencil line, and then moving it in toward the lettering. Trim each square this way, including any blank squares you intend to use.

7 To glue letter squares to backing sheet, start by sticking down two lengths of artist's tape along the upper and left edges of the backing sheet, forming a 90° angle. Use a brush to apply a thin layer of glue to the back of the squares, placing into position. Press down gently with wax paper to make sure the square is fully glued down. To ensure nice, even spacing between the squares, glue the first two squares of the first line, followed by the first two squares of the second line, and work outward from there, alternately gluing horizontal and vertical squares.

(continued)

Mosaic-Style Greeting Card

8 Remove tape and use a steel-edge rule and craft knife to trim the backing sheet approximately ¼" (6 mm) from the letter blocks. Use another ink to add ornaments.

9 Trim your leftover piece of printmaking wet-on-wet wash paper to 5½" × 5½" (14 × 14 cm). Measure the area covered by your grid of mounted letters and use a craft knife and steel-edge rule to cut a window in the 5½" × 5½" (14 × 14 cm) sheet just slightly larger than this measurement.

10 Fold 5½" × 11" (14 × 27.9 cm) card stock to 5½" × 5½" (14 × 14 cm) and glue the trimmed the sheet with letters to the center of the card.

9

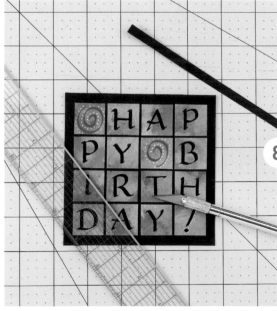

8

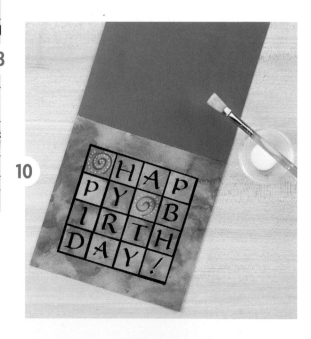

10

Variations

A simple, easy greeting.

A block of text cut up into squares becomes an abstract collage.

Uncial Hand and Illumination

Uncial Hand (from the Latin word "inch") is a script with a rich history that still holds an appeal for calligraphers today. It was developed around the fourth century AD as a style of lettering used by scribes of Christian manuscripts and became the standard "book hand" of the early Middle Ages. Uncial letters are generally written large and fairly quickly, and easily lend themselves to decoration. The Book of Kells, created by Irish scribes of the early ninth century, contains some of the most famous examples of Uncial hand text combined with profusely decorated letters and Celtic ornamentation, and provides some of the inspiration for the projects in this chapter.

The Uncial Alphabet

A a B c D e E

F C Z h i J k

l L M n N o p

q R S C T u v

w u x y Y z &

1 2 3 4 5 6 7

8 9 0 ! ? ., ß

á æ ç è î í ø

Uncial Hand Key Points

- Uncial Hand letters are upright and extremely rotund, characterized by the arched form of the letters *d*, *h*, *m*, *t*, *u*, and *w*. Keep the spacing between letters loose to provide "breathing room."

- There are no capital letters in the Uncial alphabet. All of the letters are the same height, except for the letters *p*, *q*, *y*, *d*, *h*, and *k*, which have very short descenders and ascenders (no more than 2 nib widths in length).

- Uncial hand can be written with a 30° pen angle, or if you choose you can use an angle of 20° or less. Historic Uncial scripts were written with a pen angle of 10° or 15°, creating their signature "fat and flat" look. If you choose to use a flatter pen angle, is very helpful to keep a separate nib or pen that you use only for writing Uncial Hand. The flatter writing angle will cause the edge of the nib to wear down differently, and over time will make it easier to write at the lower angle (and more difficult to use for other scripts that call for a steeper pen angle).

- The traditional x-height for Uncial letters is 3½ nib widths, but heights of 4 or 5 nib widths are also acceptable, as well as being easier to manage when it comes to ruling out lines.

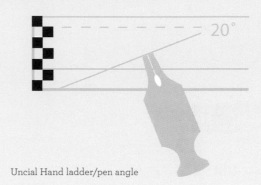

Uncial Hand ladder/pen angle

Skill Builders
Exercise 1: PRACTICING LETTER GROUPS

In this exercise, you will practice groups of letters that share common strokes, shapes, and proportions. Start by ruling one pencil line on a sheet of paper. On the far left side of the page, use your calligraphy pen to make a ladder 4 nib widths high, positioning the first step of the ladder precisely on the pencil line. When the ink is dry, *rule another line* at the very top stroke of the ladder. Measure the width between the two pencil lines, and rule out the rest of the page using that measurement.

WHAT YOU'LL NEED
- 2-mm calligraphy fountain pen or marker
- writing paper
- pencil
- ruler

 1st stroke

 2nd stroke

 3rd stroke

4th stroke

Round letter group

Many Uncial letters are rounded in shape, with the o being slightly elliptical. If you are using a flatter pen angle, the thin strokes of curved letters should

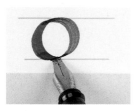

The Uncial O should be written as round as possible.

start at the top of the letter. The ascender of the *d* and the descenders of the *p* and *q* should be kept very short—no more than 2 nib widths in length.

There are several alternate versions of Uncial letterforms that can be used to add variety to your text.

Diagonal Letter Group

For diagonal lines, use a steeper pen angle—you want the diagonal strokes to be only slightly thicker than the upright strokes. Notice that the two upright strokes of the *n* are written using a steeper angle as well.

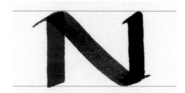

The two upright strokes are made first using a steeper pen angle; the diagonal stroke is written as a slightly curved swash.

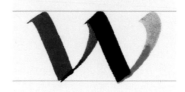

The first and second strokes of the *w* are written with a steeper pen angle, while the third and fourth strokes are slightly curved and swashlike.

Arched Letter Group

ƀhmɴʀuɯ

If you are using a flatter pen angle, the thin part of the arch will be at the top of the letter, but take care that these strokes are not made too thin. Arches should be wide and generous, echoing the proportions of the letter o.

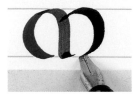

The first stroke is the same as for the letter o, and the arches are spaced equally.

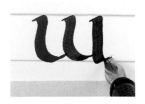

The alternate w has a very different feel from its diagonal version.

Straight Letter Group

ıȷꜰꞁᴛ

A pen angle that is less than 30° will add width to the vertical strokes. Practice making a gently curving upward movement of the pen to create rounded serifs at the start of the vertical stroke.

The letter f has a crossbar that should sit just above the baseline, and a short descender, like the letters p and q.

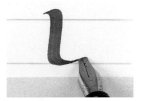

The first stroke of the l rises slightly above the headline (similar to h and k). A flatter pen angle gives a thinner line to the second stroke.

QUICK REFERENCE

Rule another line. Because Uncial Hand has only a few ascenders and descenders, it is not necessary to rule guidelines for them. However, if you would like to do it, rule descender and ascender lines 2 nib widths apart from the baseline and headline.

Versal Letters

Versal letters are large capitals used to mark the start of a paragraph or line, and are an excellent way to add decoration to your text. They are referred to as "built-up letters" because the technique used to make them is to draw the letter line by line, creating an outline. The letter can be left in outlined form, or it can be filled in and decorated. Lombardic Versals borrow letterforms from both Roman and Uncial alphabets. They were widely used to decorate pages of medieval manuscripts, and combine very nicely with Uncial Hand.

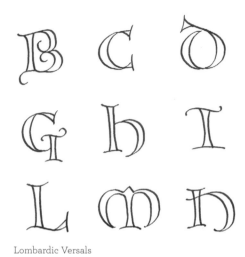

Lombardic Versals

Lombardic Versals Key Points

- Use a small nib to outline. The exact width of the nib will depend on how large you want to make the letter. A general rule is that the white space inside the vertical strokes should be about twice the width as the nib you use to make the outlines.

- It helps to sketch out the letter lightly in pencil before you start so that the angles and proportions will be correct. The inner strokes of the letters are made first so that the counters (the spaces enclosed either entirely or partly by the lines of the letters) are well-proportioned. The outer edges of curved strokes are added next, followed by serifs and decorative flourishes.

- A calligraphy pen with a fine-tip nib is very useful for free-hand drawing and embellishing—let the decorations flow!

Here a 1-mm nib was used to draw the outlines for a letter measuring 1" (2.5 cm) in height, with the white space inside the stem that is about 2 nib widths wide. Notice how the two vertical strokes are slightly "waisted," narrower at the center than at the ends.

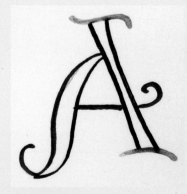

Starting with the inner strokes ensures adequate white space inside the letters. In this example, black strokes are drawn first, followed by red and green.

Skill Builders
VERSAL SKETCHING

Any style of letter can be developed into a Versal letter, and often sketching with pencil will yield unexpected and exciting ideas for Versals. Take some time with a pencil and paper to sketch out letters, using the technique of building up by outlines. It helps to draw the letters large and loosely, sketching over and adding details as you go. You could choose one particular alphabet to sketch, or just draw the letters any way you like and see what you come up with. When you've sketched a letter you really like, try out a version in ink: use a narrow nib to build your outlines, then fill in with ink or paint. Keep adding as much decoration as you like, allowing the ink or paint time to dry thoroughly before adding a new round of details. Save your sketches and finished letters for inspiration and future projects.

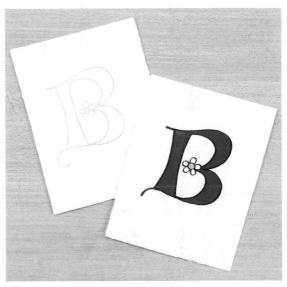

Various sketched letters and inked-in versions

Illumination

The history of calligraphy is rich with examples of precious metals and pigments used to lavishly decorate and illustrate texts. In the past, the term "illumination" referred to manuscript decorations made from gold leaf polished to a high shine, and to be the owner of an illuminated manuscript was a sign of status and wealth. Today the term is used more broadly to mean decoration in gold and other colors.

Tools and Supplies for Illumination

For the projects in this section, you will learn to use metallic gouaches and pigments that create the rich effect of shiny gold and are more affordable and easier to use than gold leaf. (For projects with gold leaf, see "Brushwork and Gilding," page 191.) You will also learn to use gouache, watercolors, technical pens, and acrylic inks to add color to your work. Here are some basic facts you'll need to know about these materials:

Metallic Pigments

These are sold in powdered form and are made from pulverized metal or minerals (usually bronze or mica) and a binding agent. When mixed with water to the right consistency, they can be used with a dipping pen or brush to create the effect of writing or painting with gold. Schminke Tro Col Dry Gouache Bronze Powder is an excellent brand, the Rich Gold color being a near-identical match to the color of real 24-k gold. To mix, add distilled water gradually, a few drops at a time, stirring with a brush until the powder is completely absorbed by the water. Mix only small amounts, just prior to use, as the consistency of the mix changes with prolonged exposure to air. A drop or two of gum arabic will help if you find the metallic particles separate from the water.

Metallic Watercolors

These are also sold in powdered form and mixed with water for use. Not all brands are ground fine enough for use with a dipping pen, and must be used with a brush. Avoid using metallic watercolors in tube or cake form, because they usually lack the density needed to produce rich metallic tones.

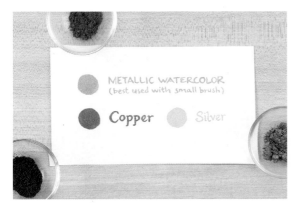

Calligraphy Gouache

This extremely dense gouache is sold in tubes and remains opaque when mixed with water to an inklike consistency. The Schminke Calligraphy Gouache is a very good brand, available in many colors as well as in a non-tarnishing metallic gold (gold pearl) that looks really shiny. If calligraphy gouache is not readily available, try designer's gouache, which is similar. Gouache dries to a flat finish, which may not always be desirable. Add a drop or two of gum arabic, or sugar dissolved

in distilled water to make it shiny. Designer's gouache is also available in metallic colors, which are useful for brushwork, but not all metallic gouaches perform well when mixed to the inklike consistency needed for writing with a nib.

Tube Watercolors

Like calligraphy gouache, watercolor paint in tubes can be mixed with water to an inklike consistency for writing with a nib. The colors tend to be somewhat transparent, which can be used to great advantage when you want to create rich, built-up layers of color. Conversely, you can mix a small amount of white into your watercolors to lighten your color somewhat but also to increase its opacity. Tube watercolors are ideal when used with a brush for illumination to create rich jewellike tones or built-up layers of delicate color.

Acrylic Inks

Many different brands and colors of acrylic inks have become available in recent years, many in pearlescent colors. They can be used with a brush or with a dipping pen, but be warned: acrylic inks dry very quickly, often right on the nib as you are writing! If you use acrylic ink with a dipping pen, you will have to rinse and wipe down the nib frequently to keep clumps of ink that can interfere with ink flow. A toothbrush is very useful for

(continued)

brushing ink off the nib in this case, as acrylic ink really tends to stick! The great advantage of acrylic inks is that they are waterproof, so you can layer one color over another without any bleeding. Some brands of pearlescent acrylic inks are a bit too thick for use with a nib—warning signs are if the serifs on your strokes come out consistently blobby (and you aren't overinking the nib) or you are seeing clumps of particle clinging to the nib. In this case, mix a few drops of distilled water to the ink, and if that doesn't help, try another brand of acrylic ink until you find one that flows well. Never use acrylic ink in a calligraphy fountain pen, as the ink will start to dry inside it as soon as the pen is not in use.

There are many brands of acrylic inks available, many of which vary in quality and suitability for use with nibs. Try out as many as you can.

Acrylic ink is useful for building up layers of colors that won't bleed into each other.

Safe Handling of Pigments and Paints

- When mixing pigment in powder form, wear a surgical mask or tie a kerchief over your nose and mouth to avoid inhaling the fine particles. Use a small palette knife or similar object to scoop small amounts of pigment from its container. Avoid dumping it out or making any motion that allows the pigment to become airborne.

- Do not eat or drink in the area where you are working with paints, inks, or pigments, and make sure to wash your hands and face after handling. When you are finished working, wipe down your work surface and tools with a damp cloth; water containers, brushes, and pens need to washed and rinsed well to remove all traces of metallic particles, which tend to cling.

- Take extra care to avoid ingesting or inhaling fumes from any paints containing cadmium, barium, or lead—these heavy metals can produce toxic side effects with prolonged exposure. If any art supply you are working with smells noxious or gives you a headache, ventilate your work area immediately and discontinue using the product.

Brushes

For illumination you will need various brushes for filling in colored areas, painting lines and borders, and adding details to letters and ornaments. When purchasing brushes, it helps to know what sort of marks you want to make, so you don't spend a lot of money on a brush that ends up being not what you really needed in the first place. Here are some tips:

- To make small dots: a short-handled brush with short bristles forming a rounded tip, usually labeled as "round" or "spotter." Look for small sizes—20/0 (very small), 10/0, 0, 1, 2—a number 2 round is the largest you are likely to need. The round bristle brush can also serve as a general all-purpose brush, used for filling in areas of color, drawing lines, shapes, etc.

- To paint leaves, stars, flower petals, swirls, or shapes having sharp corners or points: a short-handled brush with short bristles forming a pointed tip, usually labeled as "pointed round." Sizes 0 or 1 are good sizes to begin with. With this type of brush, a high-quality version is well worth the expense (look for sable bristles, often recommended as a watercolor brush) since inexpensive pointed rounds usually lose their shape very quickly. Take good care of your sable-bristle

brush (see Tips about Brushes on page 114) and it will last a long time.

- To make straight, blocky lines and borders use a short-handled brush with short to medium-long bristles and flat tip, usually labeled as "shader," "flat shader," or "lettering." The width of the brush should be slightly narrower than the width of the lines you intend to paint, because when you press down slightly on the brush, the bristles will expand to create a wider line. Keep in mind that you can also hold a flat-tipped brush at a 30° angle to paint letters using exactly the same kind of strokes you would use with a calligraphy pen.

(continued)

- To make long, skinny lines use a short-handled brush with long bristles ending in a point, usually labeled "script liner." The long bristles allow more ink to be taken up on the brush, creating long, flowing lines; 20/0 is a good size to start with. You will rarely need any size larger than 10/0 or 1.

Tips about Brushes

- Expensive isn't necessarily better. When starting out, steer clear of brushes made with sable, squirrel, or other animal fibers (except in the case of the pointed round brush). Synthetic bristles are generally preferable, as they are more durable, flexible, and readily replaceable. Be sure to check out any available "craft" or "hobby" brushes, which are often packaged in inexpensive assortments.

- That being said, for fine, detailed work, a well-made natural-fiber watercolor brush can be a real joy to use. Try out various synthetic-fiber brushes until you settle on a specific size and shape you really like, then treat yourself to a high-end version of it.

- Make it a habit to thoroughly wash the bristles of your brushes with dish soap after each use—especially if you have been working with metallic pigments, gouache, or acrylic inks, which tend to quickly gum up brush bristles. A soapy toothbrush is useful for combing out the particles that can collect in the bristles, especially where the bristles meet the ferrule (the metal collar that holds the bristles to the handle). After washing, apply a small amount of gum arabic to the tip of each brush, using your fingertips to shape the brush into its natural shape. Place washed brushes bristle-end up in a jar or brush holder to dry, making sure that the bristles aren't touching anything that might cause them to dry into a distorted shape.

Papers

The paper you choose for illumination projects should be thick enough to hold paint and ink without buckling, and smooth enough so that you can write clean lines with the nib. Ideally it should be archival (often labeled "100% cotton," "rag," "cotton rag," or "pH neutral"), which means the paper will not discolor or fade over time. Smooth-finish Bristol or hot-pressed cotton printmaking paper are good choices, and can be purchased in single full-size sheets as well as in smaller pads or blocks. You might also want to experiment with watercolor papers, which are very thick (and thus can absorb a lot of water and pigment) with a textured finish. Textured finishes can be tricky to write on with a nib, but you may find one that works for you. Often a textured surface is ideal for pieces intended to have a more rustic or arts-and-crafts look.

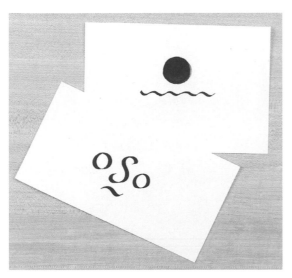

Bristol offers one of the smoothest writing surfaces with good absorption of ink.

Watercolor and cold-pressed papers have textured surfaces, which can create a rustic or more hand-touched look to you work.

Hot-pressed printmaking papers have a luxurious weight and texture and absorb ink well, although certain inks may bleed slightly on certain papers.

TIP Many of the best-quality art papers are sold only as individual full-size sheets, and many of the best brands (Arches, Fabriano, Strathmore, Canson) offer individual full-size sheets as well as smaller-size pads. Get to know what kind of papers your local art supply store sells by the sheet and try out various sheets before you invest in an expensive pad or block of watercolor or hot-pressed paper—especially when you're not sure how the paper will perform with your inks, nibs, and paint.

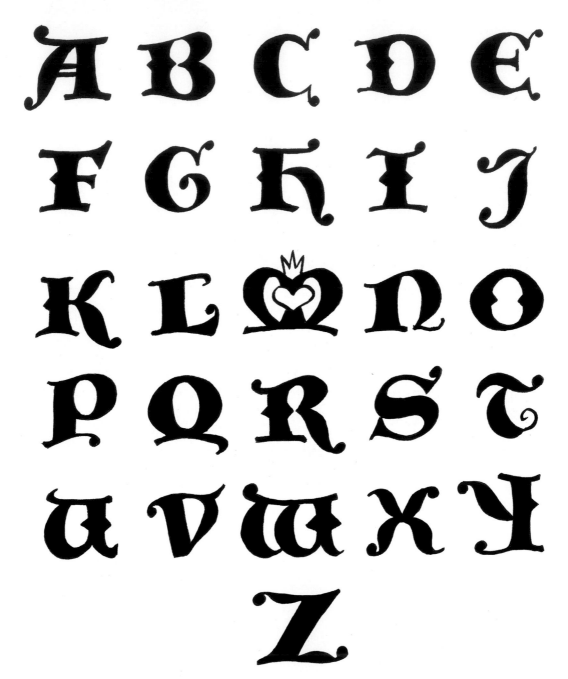

Blocky Lomardic Versals for Illuminating

WHAT YOU'LL NEED

- paper
- pencil
- ink
- paint

1 Choose a letter from this Versal alphabet, and build up an outline. First sketch the outline in pencil, and then use a narrow nib to draw the outline in ink. (You can also design your own Versal letter. Make sure to leave a lot of space between the pen outlines so there is room for color and decoration.)

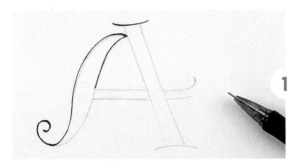

2 Fill in the outlines with ink or paint, using solid fields of color, patterns, shapes, or anything else that comes to mind. After the ink or paint has dried, you can go back and add more decoration. Note: you will have more success layering color on color if you use waterproof or acrylic inks instead of regular calligraphy ink.

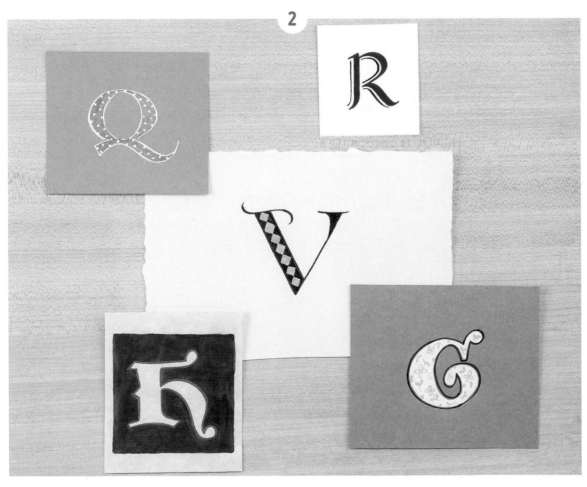

Illuminated Holiday Card

This simple design makes use of red, gold, and white inks on luxurious cotton paper to create a sumptuous holiday effect.

WHAT YOU'LL LEARN

- How to illuminate letters with calligraphy gouache
- How to layer papers together with ribbon

WHAT YOU'LL NEED

- 100% cotton hot-pressed printmaking paper or card stock
- matching envelope
- red card stock or heavy-weight text paper for backing sheet
- red calligraphy ink
- metallic gold gouache
- white gouache
- red gouache
- 6" to 12" (15.2 to 30.5 cm) of ⅜" (1 cm) red ribbon
- 3-mm round-hand nib
- small round-tip/spotter brush
- ⅛" (3 mm) hole punch
- optional: photo corners, decorative-edge scissors, additional gouache colors

Let's Begin

1 If you are not using precut card stock, cut or use a steel-edge ruler to tear a rectangle of cotton printmaking paper to a size that is ⅛" (3 mm) smaller on each side than your envelope. Using a T-square and pencil, lightly draw rectangles, measuring 1" wide by ⅞" tall (2.5 × 2.2 cm), spaced about ⅛" (3 mm) apart for each illuminated letter.

(continued)

Illuminated Holiday Card

2 Use a 3-mm nib and red ink to write letters in Uncial Hand that are centered in each square.

3 When ink has dried, mix gold gouache to a creamy consistency and fill in the squares. Start by outlining the edge of a square and filling in the blank area until you come right up to the edge of the letter. Try not to overlap the gouache onto the letter itself—a little white space between the gouache and letter is preferable and will make the red letters "pop." Turn your work in any direction needed that allows you to apply the gouache most easily. Work as quickly as you can, and try not to pile up layers of gouache, which can tend to clump. Stir the gouache with the brush from time to time to keep it at a uniform consistency.

4 When the gold gouache has dried, mix white gouache to a creamy consistency and use the round brush to add details as desired. For dots, swirl the brush in a small circle, avoiding laying down so much gouache that it forms a bump.

5 Mix red gouache to a creamy consistency and add a second layer of detail after the first layer has dried.

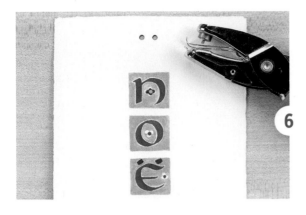

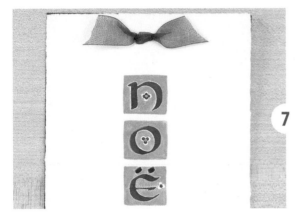

6 Add more gold or white gouache details as needed. Cut a sheet of red paper to the same size as the top card, but add an additional ¼" (6 mm) to the bottom of the red sheet. Line up the top card and red sheet and use the hole punch to punch two holes, spaced ¼" (6 mm) apart, at either the top or the top left corner of the two sheets.

7 Cut ribbon—a large bow will require 10" to 12" (25.4 to 30.5 cm) of ribbon, whereas a smaller bowtie-style bow will need only about 6" (15.2 cm). Thread ribbon through the holes of both top and bottom sheets, and use sharp scissors to trim the ribbon ends. If desired, use a decorative-edge scissors to trim the lower ¼" (6 mm) of the red backing sheet.

8 You can also affix photo corners to the red sheet to add a photo, and use a smaller nib to write a greeting.

Variations

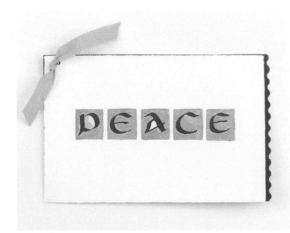

This illuminated card can be done vertically or horizontally. You can experiment with different ways to illuminate the letters of your greeting with color to reflect the season.

Broadside

As a calligrapher, you will be called upon to create a broadside—a single page of display text, often a well-loved, poem, saying, or quote, suitable for framing.

WHAT YOU'LL LEARN

- How to create an attractive broadside
- How to make ornamental opening initials
- How to make interesting decorative elements
- How to produce well-spaced text

WHAT YOU'LL NEED

- 10" x 8" (25.4 x 20.3 cm) piece of 100% cotton heavy-weight printmaking or watercolor paper
- sheets of practice paper
- assorted calligraphy inks
- 3-mm pen nib
- metallic pigments or watercolors
- small round-tip brush
- pencil
- ruler
- T-square

Let's Begin

1 Use a T-square and pencil to lightly rule out margins on your 10" × 8" (25.4 × 20.3 cm) sheet as follows: 2" (5.1 cm) on the right, left, and bottom, and 1½" (3.8 cm) at the top. The inside space will be your "live area" for writing text, providing ample room for matting and framing. Rule out a few sheets of practice paper in the same way.

(continued)

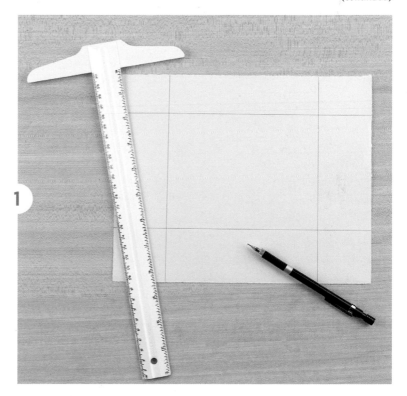

Broadside

2 Do a few trial runs of your text on the practice sheets. As with the Award Certificate project (page 93), it is often helpful to trim out strips of your best lines of text and paste them up in a layout that looks good to you. Pay special attention to your opening initial: if you make it larger, or in Versal style, proportion it so that it is large enough to stand out, but not overly large in relation to the other letters.

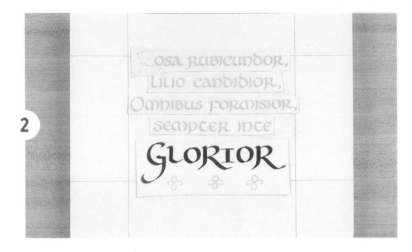

3 Take measurements from this layout and use them to rule guidelines on your final sheet.

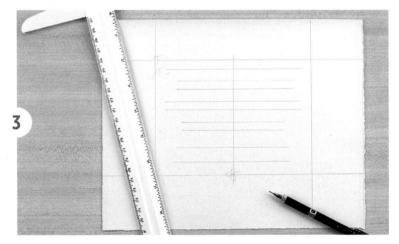

4 When writing text, remember to keep letters large and well-spaced. The idea is for the words to be easily readable, drawing the eye from a distance.

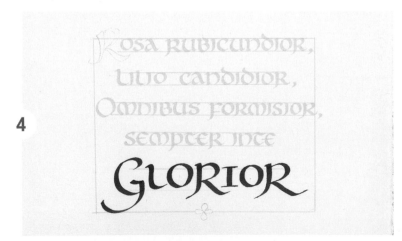

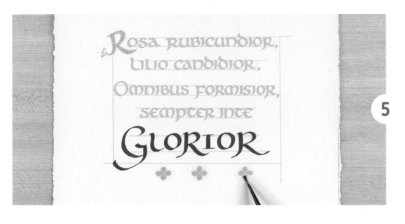

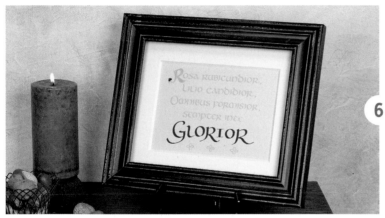

5 Add ornaments and other decorative elements to the initials at the end, as needed. It helps to first pencil in the areas for illumination and then use a small brush to fill in with color or pigment.

6 If your piece is going to be matted or framed, a border is not generally necessary, because a mat and frame will serve as borders to the piece.

Variations

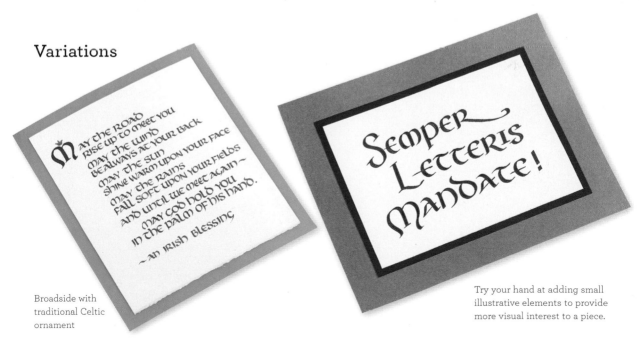

Broadside with traditional Celtic ornament

Try your hand at adding small illustrative elements to provide more visual interest to a piece.

Illuminated Initial Medallion

Illuminated lettering can be really lovely when paired with jewelry, transforming your calligraphy into wearable art. Look for blank medallion pendants and dimensional adhesive at local bead and jewelry suppliers or online—be sure to get a glaze that will adhere to metal.

WHAT YOU'LL LEARN

- How to make jewelry with calligraphy letters
- How to make a curve-shaped template using tissue paper
- How to use diamond glaze

WHAT YOU'LL NEED

- medallion pendant
- water-based dimensional adhesive (often called diamond glaze)
- smooth-finish text-weight (or thinner) paper
- tissue paper
- heavy vellum
- bone folder
- glue
- acrylic inks
- metallic powdered pigment
- calligraphy ink and nibs
- small brushes
- small scissors

Let's Begin

1 If the inside area of the medallion is not a square or rectangle that can easily be measured, make a template as follows: apply a tiny smear of glue to the center of the medallion and allow it to dry almost completely. Cut a piece of tissue paper and press the center of the paper onto the glue spot. Use a bone folder to very gently rub the tissue flat, gradually working your way to the edges. When you get to curved or irregular edges, gently use the point of the bone folder to work the tissue along the edges, smoothing flat any folds. Be careful not to poke holes in the tissue with the bone folder.

(continued)

Illuminated Initial Medallion

2 Use a pencil to trace along the inner edges of the medallion that you have shaped with tissue.

3 Gently remove the tissue and smooth flat. Lay a piece of heavy vellum over the tissue and use a fine-tip pen to trace the pencil outlines. Use small scissors to cut out the lines you've traced on the vellum. Place this piece inside the medallion to see how it fits. Redraw the template if necessary.

4 Use acrylic ink and a smooth brush to apply an area of ink larger than your medallion to a sheet of smooth, light-weight paper. Apply the ink thickly so that the paper is thoroughly covered. When completely dry, use a pencil to lightly trace the outline of your template onto the inked area.

5 Lightly pencil in the outline for your initial letter and other ornamental details. Use a small brush or nib to fill in areas with acrylic ink.

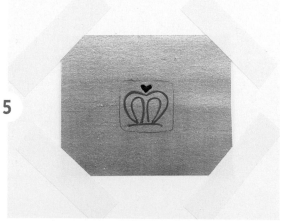

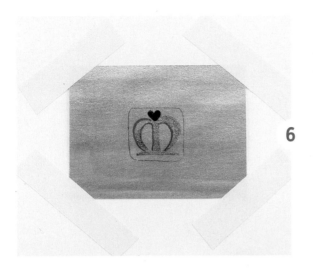

6 When ink is dry, mix a small amount of metallic pigment with distilled water, adding water drop by drop and stirring well with a brush until the mixture becomes creamy. Test the mix out on paper to make sure it is not too thin or too thick. Use a brush or nib to apply the metallic pigment. If you use a thin brush you can build up areas by carefully going over lines more than once. Note how metallic outlines do not have to follow every edge of the letter but can just appear here and there as accents.

7 Allow to dry thoroughly (several hours is recommended). Following the manufacturer's instructions on the diamond glaze, pour or squeeze out the glaze onto the artwork until the glaze fills the inside of the medallion and comes just up to the edge. Be careful not to let it flow over onto the frame!

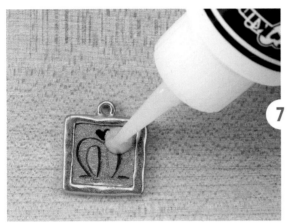

8 Allow it to dry flat for 24 hours. A bowl placed over the work will keep any wayward bits of dust from settling on the glaze. When completely dry, attach to a chain or cord.

Variation

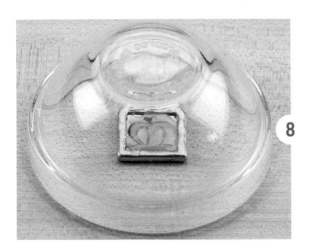

Multiple medallions on a charm bracelet—letters, symbols, tiny writing, even beads and small gems can be encapsulated under the glaze.

Zodiac Accordion Book

The accordion book (also called a "concertina book") is a traditional book-artist's format that is one of the easiest kinds of books to construct. You will need a paper sheet that measures at least 32" wide and 20" high (76.2 × 50.8 cm). Take care to handle the long sheets gently so they don't get scuffed or dented.

WHAT YOU'LL LEARN

- How to make mountain and valley folds
- Basic instructions for making an accordion book
- How to protect finished pages while working
- How to make illuminated designs for all the signs of the zodiac

WHAT YOU'LL NEED

- medium-weight text paper or 100% cotton artist's printmaking paper, 80 to 110 lb (131 to 161 gsm)
- long metal T-square or tear-bar
- metal-edge ruler
- bone folder
- craft knife
- two pieces of book board cut to 5¼" (13.3 cm) square
- 80- to 100-lb (131 to 150.5 gsm) text-weight colored paper for cover
- artist's tape
- pearlescent blue acrylic ink
- red, blue, olive green, sky blue, and aqua calligraphy inks
- white calligraphy gouache
- medium-size soft bristle brush
- soft-bristle ¼" (6 mm) flat brush
- #0 pointed round brush
- 1- and 2-mm round-hand calligraphy nibs
- polyvinyl adhesive (PVA glue)
- 1" (2.5 cm) foam brush or soft bristle brush for applying glue
- 24" (61 cm) length of ¼" (6 mm) or ⅜" (1 cm) ribbon
- scissors

(continued)

Zodiac Accordion Book

Let's Begin

1 On a large work surface, position your paper so that the widest edge faces the top and refer to the diagram below. Cut (or use a long T-square or tear-bar to tear) three sheets that measure 31" × 5" (78.7 × 12.7 cm). Use a T-square and pencil to lightly rule vertical lines where the diagram shows light-gray dashed lines: the first line is ruled ½" (1.3 cm) from the left edge of the paper, followed by six lines ruled 5" (12.7 cm) apart, and ending with a final line rule ½" (1.3 cm) from the right edge.

2 Refer to the diagram below for how to fold each section. Heavy dashed lines represent "mountain folds," where the fold points up toward you; light dashed lines represent "valley folds," where the fold points away from you. Use a bone folder to fold all three sheets in this pattern.

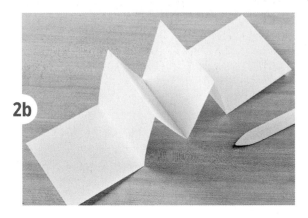

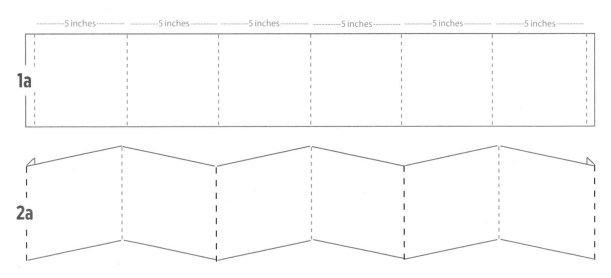

---------5 inches--------- ---------5 inches--------- ---------5 inches--------- ---------5 inches--------- ---------5 inches--------- ---------5 inches---------

1a

2a

3 For inking in the pages, work on two open panels at a time, keeping remaining panels folded together and loosely tucked into an envelope. Use artist's tape to secure the tops and bottoms of the panels you are working onto your work surface. In this example, panel 1 remains blank. For panel 2, use the ¼" (6 mm) flat brush to paint a square of pearlescent blue acrylic ink and allow to dry. Do the lettering next, and when that has dried, use white calligraphy gouache and the #0 brush to paint the stars. When dry, remove the tape, slip a piece of paper in between the two panels to act as a guard sheet, then flip and turn to the next two panels.

4 The next two panels follow the same sequence: tape down edges, paint the blue pearlescent ink square, follow with calligraphy inks, then do the white gouache stars. When ink is dry, insert guard sheet, fold the page, and tuck into envelope with previously finished panels.

5 When you finish the last two panels of the first section, fold up the entire page and press lightly under a book until you are ready to attach all the pages together.

(continued)

Zodiac Accordion Book

6 For the rest of the book you will follow the same sequence, creating different text on each page. The fourth panel is where you can write your dedication, signature, date, or any other special marks of your own.

7 To assemble the three individual sections of the book do the following: with the first section folded and facedown, place a sheet of scrap paper underneath the ½" (1.3 cm) folded strip at the far left and coat the strip with a light layer of PVA or craft glue, making sure to get all the way to the edges, but not going over the fold line on the left. Remove the scrap paper from underneath, and lay the first ½" (1.3 cm) flap of the second section, folded under, on top of the glue, lining up the two sections evenly. Cover with a sheet of wax paper and press under a book until dry.

6a

6b

6c

6d

6e

7

8

9

8 Flip over the glued-together sections and glue down the strip to the back of one of the pages. To glue the strips between the end of section two and the beginning of section three, repeat steps 7 and 8.

9 Trim two pieces of book board to 5¼" (13.3 cm) square and cut two sheets of colored cover paper to a 6½" (16.5 cm) square. Use the foam brush or 1" (2.5 cm)-wide brush to cover the front of the one piece of book board with a thin layer of PVA glue.

(continued)

Zodiac Accordion Book

10 Lay a cut sheet of cover paper facedown on your work surface, and place the book board, glue-side-down, onto the paper, making sure it is centered on the sheet. Flip the board over so it is faceup, and use a bone folder to smooth over the cover paper, working from the center outward, making sure the paper is glued down flat.

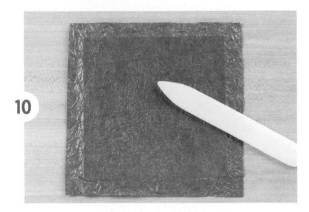

11 Trim off the corners of the decorative paper diagonally, about ¼" (6 mm) from the corners of the board. Flip the board over and, working one side at a time, apply PVA to a flap of cover paper and fold it up and over the edge of the board, using the bone folder to press the paper firmly against the edge of the board. Use the pointed tip of the bone folder to press the little corner folds of paper tightly against the edges of the board. Repeat steps 9 to 11 to make the cover and place the two glued boards between sheets of wax paper and press under several heavy books for at least 8 hours (overnight is best).

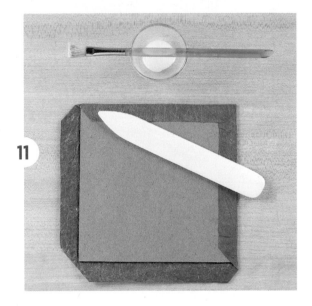

12 To mount the pages to the covers, first trim away the ½" (1.3 cm) strips from the very left of the first panel and from the very right of the last panel. Place the page facedown on the table and lay a clean sheet of scrap paper beneath the first panel. Use a foam brush and PVA glue to quickly apply a thin but thorough layer of glue to the back of the first panel.

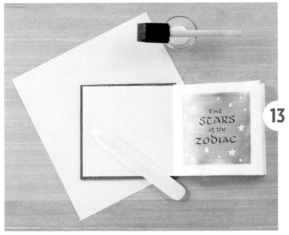

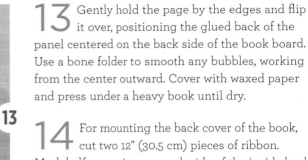

13 Gently hold the page by the edges and flip it over, positioning the glued back of the panel centered on the back side of the book board. Use a bone folder to smooth any bubbles, working from the center outward. Cover with waxed paper and press under a heavy book until dry.

14 For mounting the back cover of the book, cut two 12" (30.5 cm) pieces of ribbon. Mark halfway points on each side of the inside back cover, and use a few drops of PVA to glue each end of the ribbon to the sides of the book. Cover with wax paper and press until dry, then follow the same procedure described in step 12 to mount the last panel of the pages to the back cover. Press the entire book between two layers of wax papers under several heavy books and allow to dry overnight. When dry, tie the ribbons in a bow at the front of the book and trim the ends diagonally.

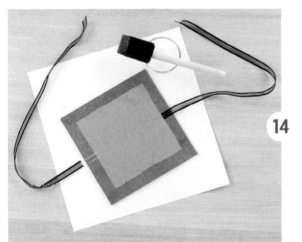

Now it had come to pass that the king ordained a festival that should last for three days, and to whic all the young women of that country were bidden, so that the king's son might choose a bride from among them. When the two stepdaughters heard that they, too, were bidden to appear, they felt very pleased; and they called Aschenputtel, and said:

"Comb our hair, brush our shoes, and make our buckles fast; we are going to the wedding-feast at the king's castle."

Gothic Hand

Many fascinating calligraphy styles evolved during the Gothic era (1100 to 1500 AD) as the production of handwritten manuscripts proliferated. While there is no one Gothic hand, the alphabets of this time all share dense, angular letterforms and compact spacing of letters. The pointed arches and elaborate ornament we see in Gothic alphabets reflect the architectural style of the Middle Ages, as seen in Gothic cathedrals.

Lowercase Blackletter Alphabet

This particular Gothic alphabet is known as "Blackletter" due to its broad, heavy strokes and overall dark appearance. Notice how in some of the letters (such as d, h, and k) you can see remnants of the Uncial style.

Pen angle for Blackletter alphabet

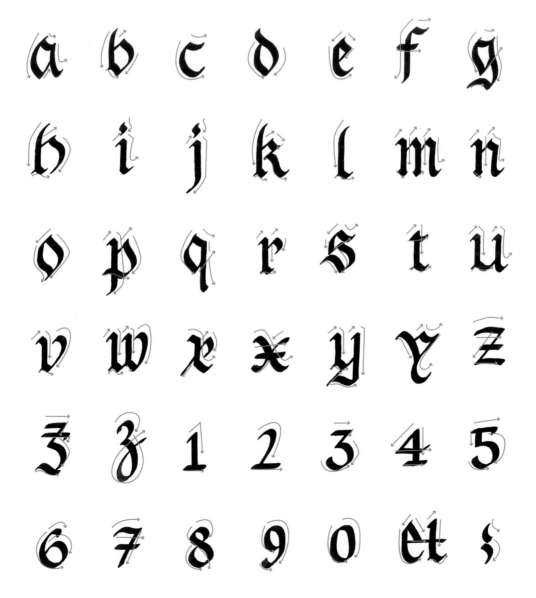

Gothic Alphabet Key Points

- Gothic scripts stand upright, with strong, thick vertical strokes. A broad pen is used, with a pen angle of 30° to 40°. Generally the x-height for Gothic script is 5 nib widths, with a capital height of 7 nib widths.
- Gothic script has an overall heavy and dense appearance; one characteristic of this is that usually the amount of white space between vertical strokes (as in the letter *m*) is equal to the width of the vertical strokes.
- Curves and arches in Gothic script have a distinctly angular shape; serifs are either square or have a small curved "foot."
- Ascenders and descenders tend to be short, usually no more than 2 nib widths in height.

1ST STROKE

2ND STROKE

3RD STROKE

4TH STROKE

5TH STROKE

6TH STROKE

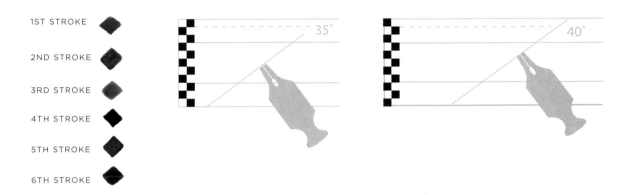

Letter Groups

Curved Group

a c e o s

The letters in this group are contained within the baseline, although a fine line extends slightly above the letters *a*, *e*, and *o*. Notice how letters are narrow with distinctively pointed arches.

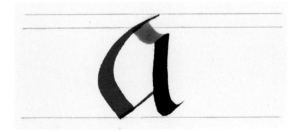

The first stroke of the lowercase *a* extends 1 nib width above the x-height line.

The lowercase *s* also extends 1 nib height above the x-height line.

Arched with Ascenders/Descenders

The letters in this group combine arches, which are kept narrow and pointed, with ascenders or descenders, which are relatively short in length.

The pointed arch of this letter brings to mind the arched windows of a Gothic cathedral.

It will take a bit of practice to get the shape of this letter correct—think of it as constructing an arched oval rather than a circular letter *o*.

Arched Group

m n u v w

The letters in this group have a solid, rectangular quality. Counters (the white space in between strokes) are kept narrow.

Each color shows the change in pen direction for this stroke.

The *m* is comprised of many strokes, the first one starting with a slight upward movement.

This letter, as do many in this group, starts with the same multi-directional stroke shown for the letter *m*.

Vertical Group

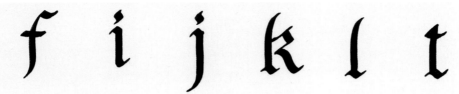

The vertical group has relatively short ascenders and descenders. Cross-strokes on the *f* and *t* appear on the top edge of the baseline.

For the crossbar, turn your pen to a slightly steeper angle to keep the stroke from becoming too wide.

This letter also has many strokes, although you may find it possible to combine several strokes into one movement of the pen.

Miscellaneous Group

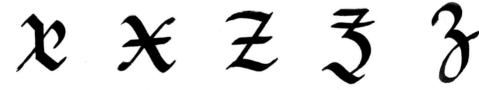

During the Gothic period several variation of the letters *x* and *z* evolved, no doubt due to the increase of scribes and manuscripts being produced during that time.

Uppercase Blackletter Alphabet

Originally no capitals existed in Gothic alphabets; instead a decorative Versal or Uncial letter would be used. This can still be a good option in your work. Avoid using all Gothic capitals in a word, as legibility becomes an issue. The little flags appearing on the stems of the letters, as well as the fine vertical lines, are added as the last strokes of a letter.

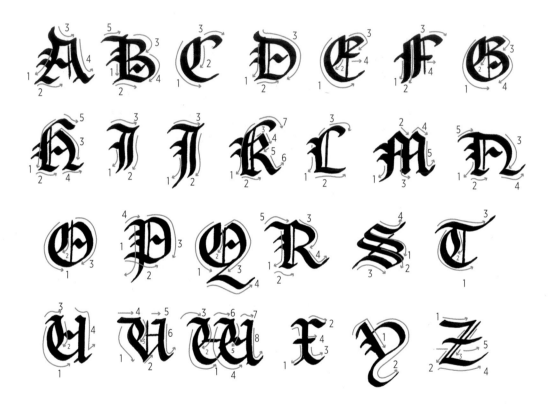

Skill Builders
COPY A PARAGRAPH

Using Gothic Hand, copy out a paragraph or two from an old book (I am very partial to fairy tales, so the sample here is from "Ashenputtel" by the Brothers Grimm), using the smallest nib you are comfortable with and aiming to create dense, compact spacing, just the way you might see the story printed in a book of long ago. Old Bibles and nineteenth-century children's books can also provide calligraphic inspiration, since many of these were printed in exquisite Blackletter typefaces.

> Now it had come to pass that the king ordained a festival that should last for three days, and to whic all the young women of that country were bidden, so that the king's son might choose a bride from among them. When the two stepdaughters heard that they, too, were bidden to appear, they felt very pleased; and they called Aschenputtel, and said:
> "Comb our hair, brush our shoes, and make our buckles fast; we are going to the wedding-feast at the king's castle."

How to Do the Blackletter *S*

- The two strokes shown in red are done first, beginning with the uppermost one. The second red stroke is offset just slightly; the amount of white space between strokes should be the same width as the stroke width.

- The lower green stroke is done next, followed by the upper green. Notice how the tail of the upper green stroke does not extend too far—if it did, the letter would start to look off-balance.

- The thin green diagonal line is added last. Wait until the ink is dry, so no wet ink gets smeared or pulled into the thin stroke. Angle your pen at 45˚ or whatever angle will give you the thinnest possible line in the direction in which you are drawing.

While this letter looks complicated, it is really very simple—it's just a matter of stacking up the strokes evenly.

Magnetic Alphabet Set

Here is a fun project that pairs the serious look of the Blackletter alphabet with a splashy modern background. The process for making these magnetic letters is entertaining, and when you finish, you can play with them!

WHAT YOU'LL LEARN

- How to layer translucent colors in a background
- How to work with paintable vinyl magnetic sheet

WHAT YOU'LL NEED

- 12" x 24" (30.5 x 61 cm) paintable magnetic sheet (with a vinyl not a paper surface)
- steel baking or tea tray with a flat bottom, at least 6" x 6" (15.2 x 15.2 cm)
- T-square
- pencil
- scissors
- fine sandpaper, 220 grade
- yellow, black, and white acrylic inks
- metallic gold acrylic paint
- 1" (2.5 cm) wide soft bristle brush
- paper towels
- 2-mm chisel-tip calligraphy nib
- black calligraphy ink
- steel-edge ruler
- craft knife

- small spray-mist bottle
- #2 round brush
- small metal tin
- two self-adhesive circular magnets

Let's Begin

1 Use a T-square and pencil to measure the section of your magnetic sheet that will lay flat on the bottom of the tray. Mark lines with pencil, and trim with scissors (as close to 1" [2.5 cm] increments as possible). Use 220-grade fine sandpaper to sand each sheet, alternating between swirling and diagonal motions. Make sure not to press too hard, and to work all the way to the edges of the sheets. Wipe each sheet with a damp paper towel to remove any grit from the sandpaper. Mix yellow acrylic ink (add a small amount of black acrylic ink for more of a mustard color) and use a 1" (2.5 cm) brush to swirl slightly watered-down ink across the surface of the magnetic sheet. Let it sit for 5 minutes.

(continued)

Magnetic Alphabet Set

2 Blot the ink lightly with a paper towel, removing a little of the yellow, but not all. (If the ink has dried too quickly, mist the paper towel with water.) Allow to dry thoroughly. If you remove too much yellow, you can repeat this step. Repeat this process and steps 3 to 6 on all of the sanded magnetic sheets.

3 Mix gold acrylic paint to a watery wash consistency and use 1" (2.5 cm) brush to swirl it over the yellow layer. Wait about 5 to 10 minutes, then blot or swirl some more as desired. You can add as many smooth layers of color as you choose. Load a small brush with gray acrylic ink. Hold your outstretched index finger well above the work, and hit the brush firmly against your finger to spatter the ink. The higher up you hold your finger, the wider and finer the splatter will be. You can blot off the drops with paper towel to tone them down if necessary.

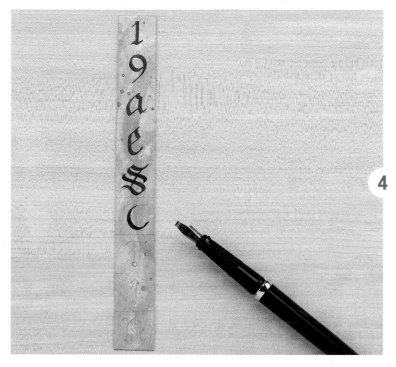

4 When sheets are completely dry, use a T-square and ruler to mark off ¾" × ¾" (1.9 × 1.9 cm) squares across the surface the sheets. Pencil in two complete lowercase alphabets, and two complete capital alphabets, using extra squares for vowels, punctuation marks, numerals, commonly used consonants, etc. Use a steel-edge ruler and craft knife to trim ¾" (1.9 cm) vertical strips from your sheets. Use the 2-mm broad nib and black calligraphy ink to write over your pencil marks.

5 Use sharp scissors to trim letters apart on the horizontal pencil lines.

6 If desired, put the letters in a metal tin with magnets affixed to the back and stick it to the fridge or other metal surface. Adults and children alike will have a lot of fun with this!

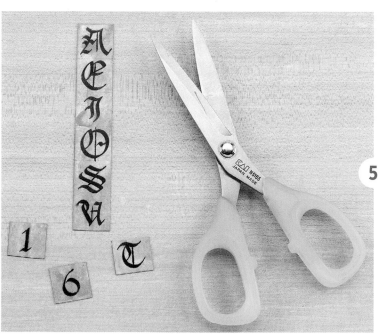

QUICK REFERENCE

Vertical strips. Working on a vertical strip will help you keeping each letter centered within its square.

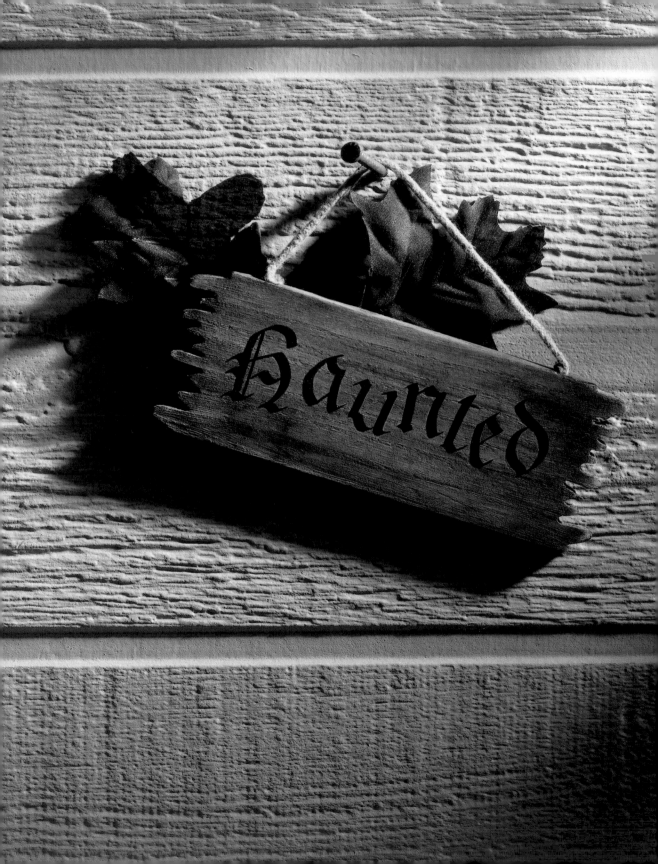

Spooky Signs

Every now and then you need a spooky sign for Halloween decorations, or just to lend a sense of darkness and foreboding wherever it's needed. A craft or hobby shop is a good place to find sign blanks that you can decorate with all kinds of spooky sayings.

WHAT YOU'LL LEARN

- How to "age" wood with coffee and tea
- How to apply calligraphy to a wood surface

WHAT YOU'LL NEED

- approximately 6" wide x 2" high (15.2 x 5.1 cm) ¼" (6 mm) plywood die-cut sign blank
- black tea
- brewed coffee
- brown water-based ink
- fine (220 grade) sandpaper
- acrylic matte medium
- 1" (2.5 cm) craft brush
- pencil
- eraser
- white Saral transfer paper
- 2 or 3mm calligraphy nib
- black calligraphy ink

Let's Begin

1 To give an aged look to your sign, brew a pot of strong black tea (5 or 6 teabags), steep well, then pour the tea into a bowl large enough to accommodate your blank sign. Next add several cups of very strong coffee. Submerse your sign in this mix, weighting with a heavy cup or bowl to keep it submerged for at least 4 hours.

(continued)

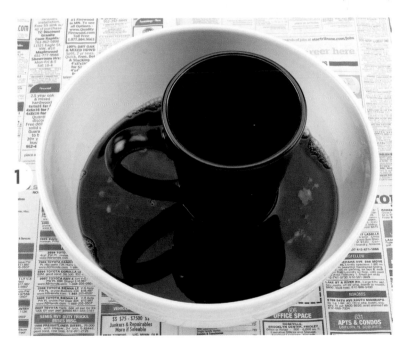

Spooky Sign

2 Remove sign blank and place it on a stack of newsprint; cover with another stack of newsprint and a heavy book until dry, about 24 hours. Once it has dried, remove and mix brown ink with a small amount of water and use a brush to add extra brown age marks around edges.

3 Use fine grade (#220) sandpaper to sand the surface of the sign and a 1" (2.5 cm) brush to apply three layers of acrylic matte medium, allowing at least 30 minutes in between applications for drying. After the last layer of matte medium is dry, either you can write your text freehand with a 2- or 3-mm calligraphy nib and black calligraphy ink or you can do a trial run of your text on paper and trace your results onto the sign using white Saral tracing paper.

4 Decorate with dead leaves or other creepy elements to add a nice Gothic touch.

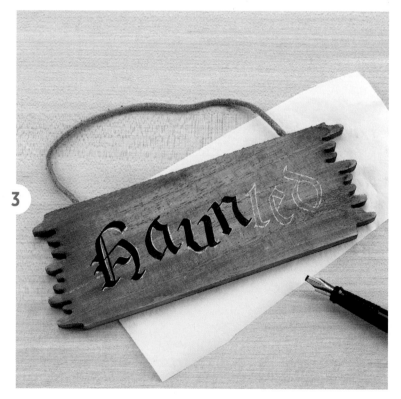

Variations

More creepy messages

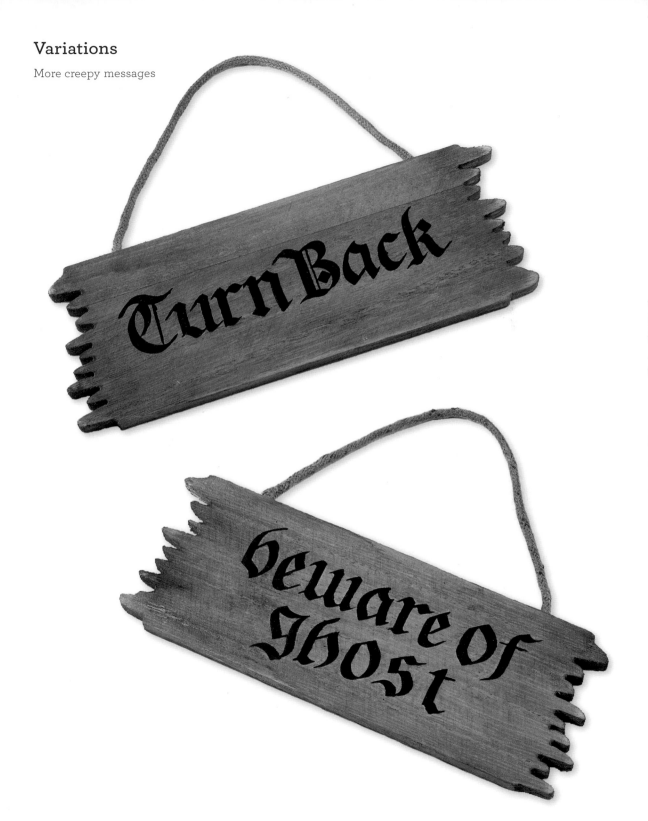

Vinnie
and the
Stardüsters

Band Logo T-Shirt

If you or some of your friends have a band, chances are you need a logo! Gothic script lends itself very well to the look and sound of many musical projects, and can be modified in countless ways to suit your tastes. In this project you will learn how to design a logo, and use it to make a band T-shirt.

WHAT YOU'LL LEARN

- How to design a logo
- How to adjust the logo size for different uses
- How to print a logo on a T-shirt

WHAT YOU'LL NEED

- sketchbook paper
- graph paper
- pencil
- large ⅛" (3 mm) round-hand nib
- black calligraphy ink
- scissors
- removable artist's tape
- glue stick
- smooth finish 100# white Bristol
- scanner or photocopier
- inkjet thermo transfer media
- T-shirt
- iron

Let's Begin

1 Sketch out some ideas on paper. They don't have to be in Gothic hand at this point; just focus on fitting the words together in an interesting way, experimenting with letter sizes, curves, position, and so on.

(continued)

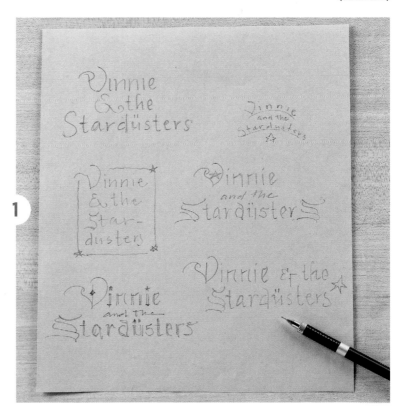

How to Design a Logo

2 When you come up with something you like, sketch a larger version of it on plain paper or graph paper and use the 3-mm nib and black ink to ink over the pencil lines in Gothic hand to see how it looks. Do as many variations as you like and, if needed, use a smaller nib for details or ornaments. Don't be surprised if you find the design evolving slightly (or a lot!) with each version.

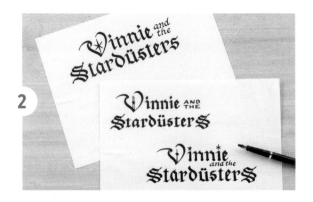

3 When you have a version you like, scan or make photocopies, printing out versions at 75%, 50%, and 25%. Check to see if anything looks odd at these reduced sizes. For example, if certain letters are hard to read at 50% then you may want redo those letters so they are larger and more open. You may also notice that the spacing between lines or letters needs adjustment.

4 If you need to make adjustments, cut the logo into individual lines (or letters, if necessary), lay the pieces on a sheet of graph paper, and use removable artist's tape to reposition the pieces as needed. If all the elements of your final version seem perfectly in place to you, then you can skip this step, but sometimes it's helpful to see if there are ways the layout can be improved. In this version, I re-lettered the capital *V* and *S* to make them easier to read, and slightly increased the spacing between lines.

5 If you have access to a scanner, you can scan your pasted-up sheet and save the file for future use. Otherwise, take measurements from your paste-up sheet, rule a sheet of white Bristol accordingly, and re-letter the logo. Rather than re-drawing the logo every time you need to use it, make several photocopies of your master version, at various sizes, and use these copies for future projects. This will ensure that you are always working with the same version of the logo at all times.

How to Print a T-Shirt

1 Scan your logo and set up to print an 11" × 8½" (27.9 × 21.6 cm; landscape) page from a laserjet printer. Follow the instructions included with your inkjet transfer paper, setting up print settings as recommended by the manufacturer.

2 Trim away unprinted transfer paper.

3 Peel off transfer paper backing. Making a slight fold and using a craft knife to separate the layers makes this easier.

4 Position transfer right side up on the T-shirt, and follow manufacturer's instructions for ironing. Most transfer papers come with a protective sheet that is placed on top of the transfer while ironing so the transfer won't be damaged by the heat.

Italic Hand

Italic script, with its gracefully angled letters and flowing curves, is our earliest form of cursive writing. It was developed in the early fifteenth century by Italian calligraphers (thus the name "Italic") as a form of script that could be written quickly. Flourishes and embellishments are often added to Italic letters, but the simple form is graceful and elegant on its own.

Italic Hand Alphabets

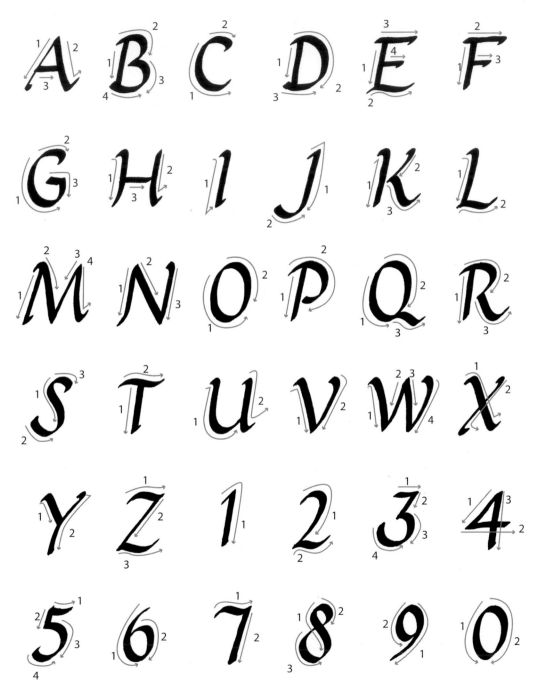

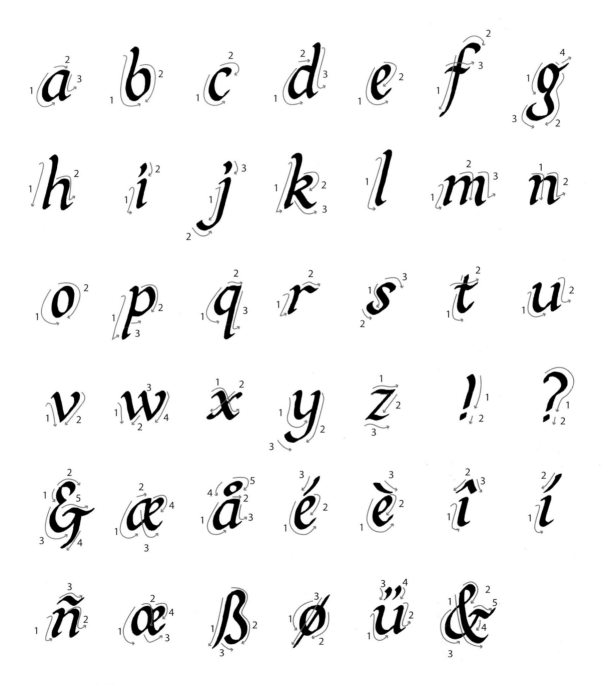

Lowercase Italic Alphabet

Skill Builders
Exercise 1: **PRACTICING LETTER SHAPES**

Practice writing the letters in groups that have common strokes, shapes, and proportions.

WHAT YOU'LL NEED

- 2-mm calligraphy fountain pen or marker
- writing paper

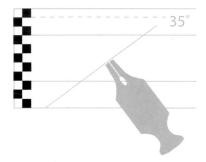 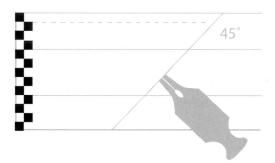

Top-Arched Group

The top arches start farther down the stem of the letter and move upward at angle. Holding the pen at a steeper angle (40° to 45°) results in narrower stem strokes.

n m r h p b

Bottom-Arched Group

Lower arches also have the same upward angle of travel.

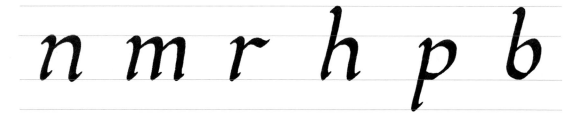

Round Letter Group

The arch at the bottom of these letters is not as steep as it is with the bottom-arched letters. These letters all fit between baseline and x-height line, and are the same width as the *o*. To make the letter *s*, it may be helpful to first sketch an italic *o* in pencil and then practice fitting the *s* into the oval of the *o*.

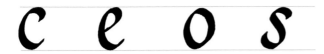

Diagonal Letter Group

As in Foundational Hand, the angle of the top-left to bottom-right diagonal slope should be steepened so that it doesn't become too heavy.

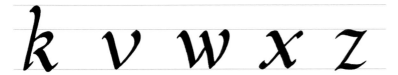

Vertical Letter Group

A steep pen angle keeps the vertical lines from becoming too thick. For the lowercase *t*, a small upward stroke is drawn first, which at the end blends with the crossbar.

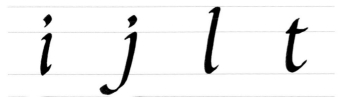

Italic Hand Key Points

- Italic letters are sloped—anywhere from 5° to 12° from vertical. A steep pen angle is used as well, usually 35° to 45°. A nib with an angled writing edge (often called as an Italic nib) can be used to create more steeply angled strokes and finer, crisper lines and serifs. Five nib widths is the standard x-height for Italic, with ascenders and decenders of 4 or 5 nib widths.

- Unlike other alphabet styles, Italic Hand is written with few pen lifts between strokes, with many of the letters and flourishes written in a single continuous pen movement.

- In Italic Hand the letter *O* takes the form of an ellipse rather than a circle. Curved and arched letters (*n*, *d*, *p*, *h*, etc.) are also elliptical in form and narrower than other alphabet styles.

- The ascenders and descenders of Italic letters are longer than in other scripts, usually 3 to 4 nib widths, and are frequently flourished or extended into graceful loops and curves.

- The serifs at the bottom of letter strokes are often elongated so that they flow into the adjoining letter, connecting the letters in a way that we think of as "script" or "cursive."

Exercise 2: PENCIL PRACTICE FOR ANGLE AND SPEED

Because many strokes of the Italic alphabet are done in one continuous movement, it can be helpful to practice them first with a pencil, which is easier to manipulate than a dipping pen and won't run out of ink. A mechanical pencil is especially good because the tip wears to an angled point and is easily renewed.

Practice writing lines of Italic text using a mechanical pencil (sizes 0.7 or 0.5 are good to start with) on regular lined notebook or graph paper. Concentrate on maintaining a consistent slope to your letters. Don't worry about doing the strokes perfectly; you'll find that once you can keep a constant slope to the letters, the shape of the strokes will become more consistent.

The main point of doing the Italic pencil practice is to get the feel for the Italic slope and the angular shapes of the letters. Don't worry too much about serifs or small details – the main thing to keep in mind is the slope of the lettering. Keep your letters spaced well apart so you can really see the shapes. Remember that letters that would be rounded, like "a" or "o" or "d" are oval in shape when written in Italic Hand.

You can also try practicing Italic Hand with a smaller pencil – this can give you a chance to do serifs and other small details and will help you immensely when you take up your pen.

Swashes and flourishes can also be practiced with a Pencil before trying them out in Ink

Italic Swash Capitals

Italic letters can be easily ornamented with swashes, especially the capitals. Try adding a swash capital letter to your text every so often, especially at the start of a paragraph. As you develop your skills with Italic Hand, you can develop your own swashes and make them as ornate as you please.

TIP A calligraphy fountain pen is very useful when learning how to do swash capitals, because it provides a constant ink flow and is especially easy to manipulate through curved or looped strokes.

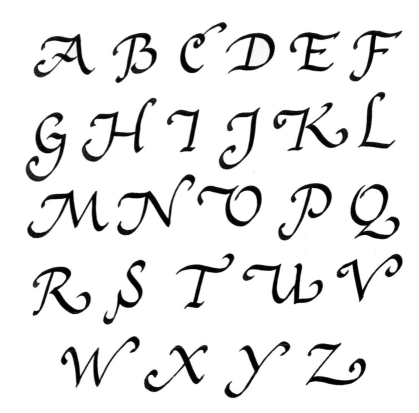

The Italic/Cursive Connection

Italic script is the forerunner of our present-day cursive handwriting. The quickly written, flowing qualities of Italic script can easily be adapted to everyday writing tasks. A good way to practice your Italic script is make a point to use Italics as often as you can in your everyday writing—for filling out forms, addressing envelopes, writing letters and notes, signing your name, and so on. This will provide you with plenty of opportunities to develop your skills for writing Italic letters, and it also makes a nice surprise for the person on the receiving end of your communications!

Please join
NICK
&
SHANNON
for
cocktails & dinner
in celebration
of their

FIRST
WEDDING
ANNIVERSARY

Sunday, October 18th
7:30 PM
Tracks Bar & Grill

RSVP
(123) 456-7890

Informal Invitation

Here's a simple project that uses just one size of Italic lettering that is understated and perfect for a casual get-together.

WHAT YOU'LL LEARN

- How to plan and lay out the text on a long, narrow invitation
- How to ink text in more than one color
- How to mount a text panel using slot and tab method

WHAT YOU'LL NEED

- warm white text-weight paper
- light-gray 80-lb (218 gsm) cover stock
- dark-gray 80-lb (218 gsm) cover stock
- matching gray #10 (4⅛" × 9½" [10.5 x 24.1 cm]) envelope
- gray and green calligraphy ink
- 1-mm Italic nib
- ruler
- T-square
- pencil
- eraser
- scissors
- craft knife
- glue
- wax paper
- optional: white label stock, decorative paper

Let's Begin

1 Cut two pieces of text paper to 3⅛" × 10½" (7.9 × 26.9 cm). For each piece, use a bone folder and ruler to fold a 1" (2.5 cm) flap on each of the 3⅛" (7.9 cm) sides. Use scissors to snip corners, starting at the fold line and angling in, on each corner of the sheet.

(continued)

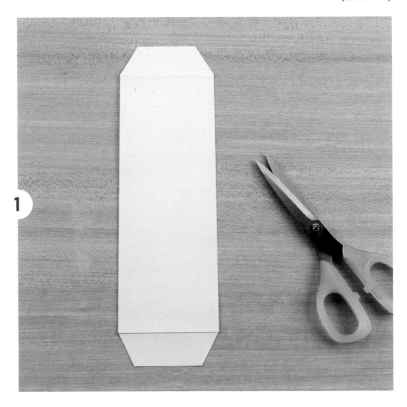

Informal Invitation

2 Use a piece of text paper to work out your line widths and spacing in pencil. Allow about ½" (1.3 cm) of blank space below the fold lines at the top and bottom of the sheet. Once you're happy with your layout, use a ruler and pencil to lightly rule lines on the second sheet of text paper.

3 Use gray calligraphy ink and a 1-mm nib to do the gray lettering first, following with green for capitalized lines and flourishes. When inks are thoroughly dry, erase your pencil marks.

4 Cut decorative paper to 3¾" × 9⅛" (9.5 × 23.2 cm). Center your top sheet, flaps folded under, on top of the decorative paper sheet, making sure all the margins are equal. On the lower sheet, make small dots marking the position of the corners of the top sheet.

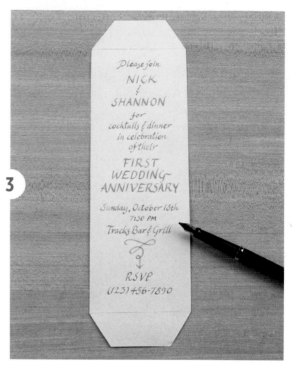

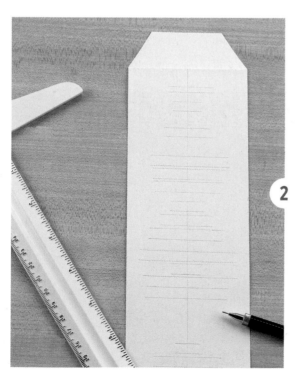

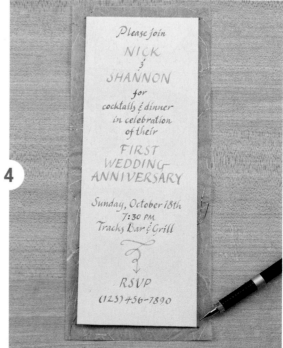

5 Following the dots you marked as a guide, align a steel-edge ruler between the top two dots and use a craft knife to cut a slit between the two dots. Repeat for the bottom two dots.

6 Slip the folded flaps of the top sheet into the slits cut into the decorated paper. Apply a dot of glue under each of the flaps and press down.

7 Turn faceup and use a steel-edge clear grid ruler to trim the edges of the decorated paper down to ⅛" (3 mm) wide on all four sides.

8 Cut base paper to 3⅞" × 9¼" (9.9 × 23.6 cm). Turn upper panel facedown and apply a few small dots of glue to the top, bottom, and side edges of the decorated paper. Then turn faceup and place carefully on top of base sheet, cover with wax paper, and press until dry.

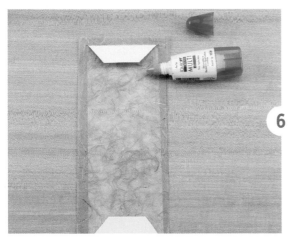

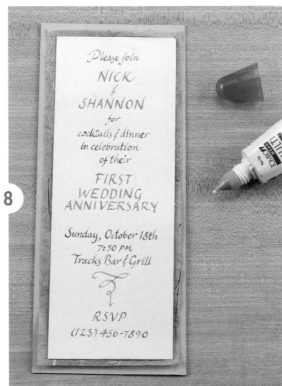

Stationery with Cross-Writing Borders and Lined Envelopes

Back in the days when people corresponded solely by writing letters, "cross-writing" was often used as a way to fit as much information on a sheet of paper as possible. This project uses cross-writing as an ornamental pattern for a border and envelope liner.

WHAT YOU'LL LEARN

- A fun way to use calligraphy as a design element
- How to make a calligraphy-embellished envelope liner
- How to make truly personal stationery

WHAT YOU'LL NEED

- A6 (6½" x 4¾" [16.5 x 12.1 cm]) envelopes
- several sheets of matching 9" x 12" (22.9 x 30.5 cm) text-weight paper
- palette knife
- one 11" x 14" (27.9 x 35.6 cm) sheet of heavy-weight vellum
- pencil
- eraser
- drafting tape
- grid ruler
- craft knife
- glue stick
- bone folder
- two colors of calligraphy ink
- metallic gold gouache
- small (approximately 1 mm) italic nib
- #0 round brush
- ⅛" (3 mm) flat brush or #1 script liner

Let's Begin

1 To deconstruct your envelope to take measurements for the liner, place the envelope on a flat surface and slip the blade of a palette knife, letter opener, or similar thin flat object under the lower corner of the envelope's glued flap. Use a gentle back-and-forth sawing motion, keeping the blade flat against the envelope.

(continued)

Lined Envelope

2 Use drafting tape to tape the unfolded envelope to a flat surface (don't tape over the corners of the flaps, as you will need to see these to make your template). Use a clear grid ruler to mark lines as follows: ⅛" (3 mm) below the glue line on the top flap, ⅜" (1 cm) in from other flap edges. For the side flaps, have the two lines meet in a gentle curve. For the corners of the envelope, draw a gentle concave curve as shown.

3 Trim along the pencil lines and use as a template, tracing the outlines onto a sheet of 11" × 14" (27.9 × 35.6 cm) text-weight paper. Align your grid ruler along the angle of the flap and lightly rule pencil lines that follow this angle at ¼" (6 mm) intervals until the template is covered. (Note: Extend the lines only about ¼" [6 mm] beyond the template outline.)

4 Use the guideline to fill the template with text in the first color. Leave gaps from time to time where gold ornaments will be drawn later.

5 When the ink is dry, align your ruler to the opposite side of the top flap and rule lines ¼" (6 mm) apart across the template, creating a lattice pattern of lines. Ink in text using your second color, making sure to leave open the gaps you left

when writing the first color. Also leave a gap when you reach the end of a sentence or phrase—these gaps will later be filled in with gold ornaments.

6 Use a fine-tip pen to outline the template edges of your sheet, then erase all pencil lines. Mix gold gouache to a creamy consistency and use a #0 round brush to paint gold ornaments in the gaps. Paint borders about ⅛" (3 mm) wide along the edge of the top flat.

7 Trim just inside the penned-in template outlines. Center the envelope liner on top of the envelope you took apart and use a bone folder and ruler to score folds, lining the ruler up just inside the folds of the envelope.

8 Fold in all but the top flap and gently slide into the envelope. When the liner is about halfway in, apply a dab of glue to the side and lower flaps. Use the flat end of a ruler to push the liner the rest of the way in, then apply glue stick sparingly to the back of the top flap and press until dry.

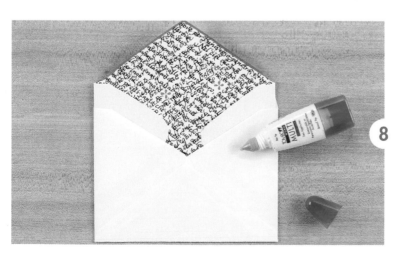

How to Letter a Border on Paper <small>1 Use a T-square and pencil</small>

to rule 2⅛"(5.3 cm) margins on each side of a 9" × 12" (22.9 × 30.5 cm) sheet of text-weight paper. Next, rule ¾" (1.9 cm) margins on each side of the sheet. Align a ruler with the upper left- and lower right-hand corners of the inner rectangle and draw diagonal lines spaced ¼" (6 mm) apart throughout the middle margin area (don't rule lines inside the inner box).

2 Use drafting tape to mask the inner border of the inside box. Cut the ends of the tape neatly so they line up with your pencil lines. Start in the upper right corner, writing lines of text in red. You can write on the tape to finish a word if you want, but be sure not to write in the inner box area.

3 Align ruler with the lower left- and upper right-hand corners of the inside box, rule lines ¼" (6 mm) apart, and add second color of text.

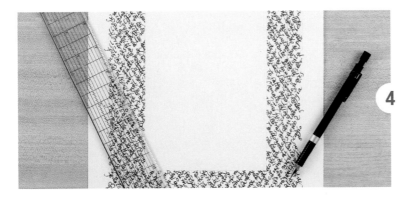

4 Erase your pencil lines, then carefully remove the drafting tape. Use a pencil and grid ruler to rule lines ¾" (1.9 cm) out from the edge of the inner box on all four sides. These will be your final trim lines. Double-check your measurements; the trimmed size of the sheet should be 6¼" wide by 9" high (15.9 × 22.9 cm).

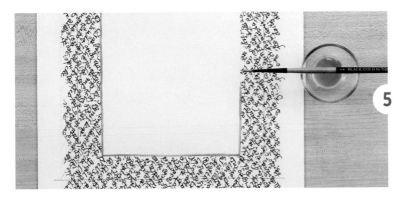

5 Use gold calligraphy gouache and a #1 round brush to paint borders along the inside edges of the box. Keep your strokes long and even, and focus your eyes on the point where you want the line to end.

6 Use a #0 round to paint ornaments in the corners with gouache. When the gouache is dry, use a steel-edge ruler and a craft knife to trim.

TIP If you are planning to produce multiple copies of envelope liners and lettered paper, prepare one liner and one letter sheet, omitting the gold gouache. These can be scanned and printed, or taken to a printer, and gold gouache can be added by hand later.

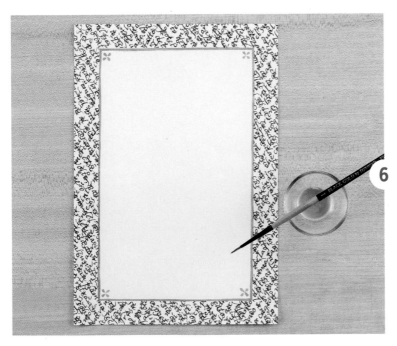

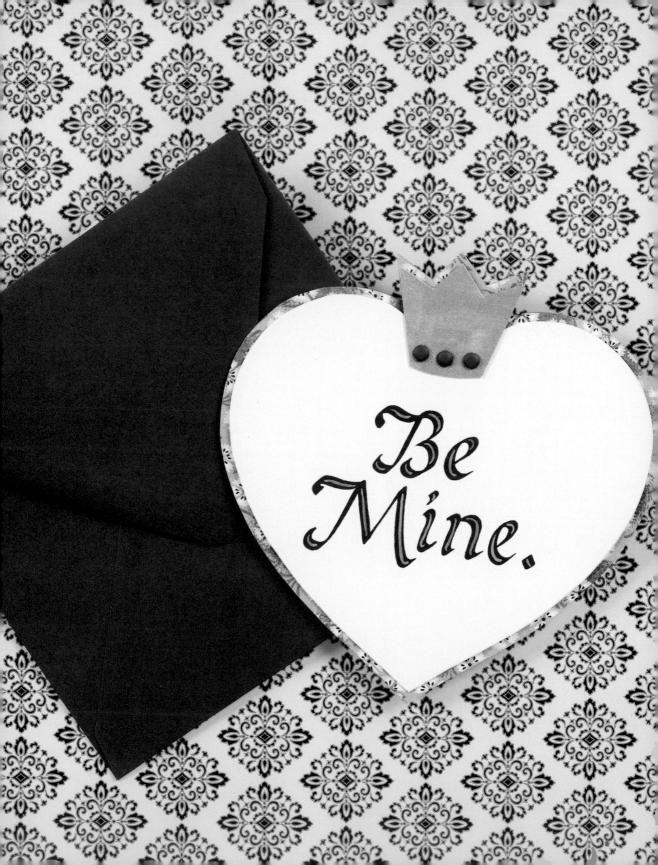

Layered Heart Valentine

This valentine looks fancy, but is very easy to make, and can be adapted to any shape you can imagine.

WHAT YOU'LL LEARN

- Successful method for gluing two paper sheets together
- How to add details to letters

WHAT YOU'LL NEED

- red card stock
- heavy-weight (100 lb [260 gsm]) white Bristol or hot-pressed cotton paper
- decorative paper
- wax paper
- PVA or white glue
- foam brush for applying glue
- gold metallic gouache
- #2 round brush
- red and white acrylic ink
- metallic gold ink or gouache
- medium-sized Italic nib
- small brass paper brads
- 1/16" (1.6 mm) hole punch or awl
- pencil
- ruler
- scissors
- 5¾" x 5¾" (14.6 x 14.6 cm) envelope

Let's Begin

1 To make the backing sheet, cut red card stock to approximately 6½" × 6½" (16.5 × 16.5 cm), and decorative paper to 6" × 6" (15.2 × 15.2 cm). Lay the red paper facedown on a sheet of scrap paper. On another sheet of scrap paper, turn decorative paper facedown and use foam brush to apply PVA across the entire back of the sheet. Keep the layer of glue as thin as you can (don't saturate), and make sure glue covers the paper all the way to the edges.

(continued)

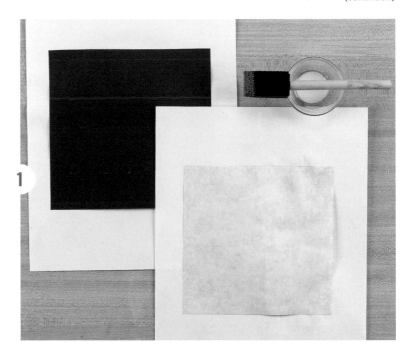

Layered Heart Valentine

2 Pick up glued sheet by the edges and lay it down on top of the red sheet. Cover with wax paper and smooth with a bone folder, working from the center to the edges, making sure there are no bubbles or wrinkles. Press with a heavy book until thoroughly dry (about 1 hour).

3 Trace the templates (opposite) and cut them out. Print them on card stock, and trim. Trace the outlines of the Outer Heart template onto the backing sheet and trim.

4 Trace the outlines of the Inner Heart template onto Bristol or cotton card stock and lightly the rule pencil lines for your greeting. Do the large lettering first.

(continued)

2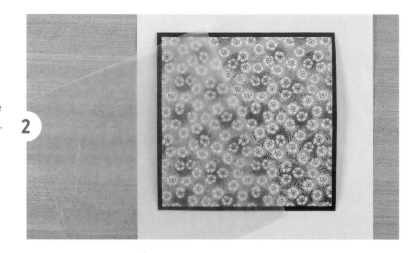

3

4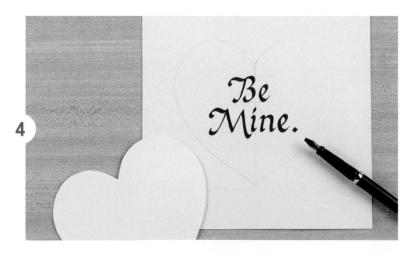

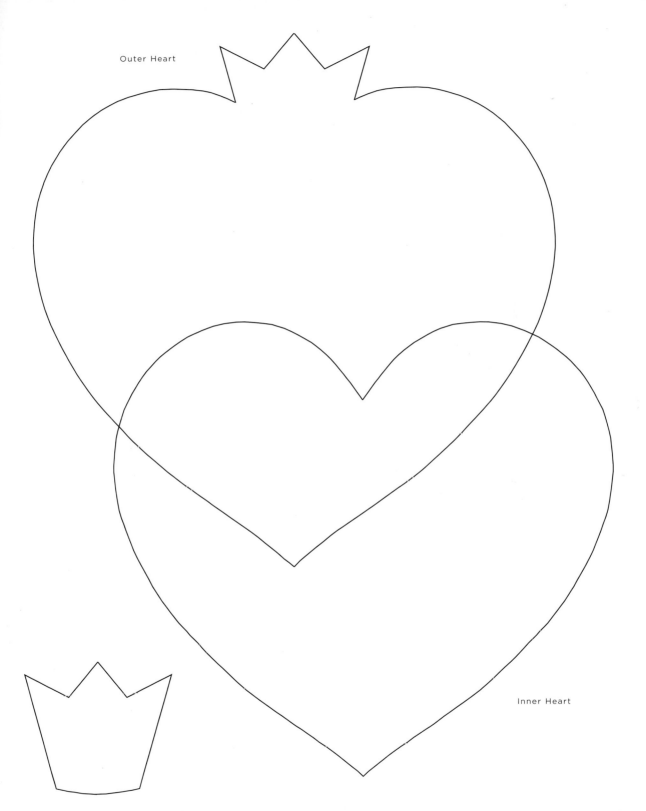

Outer Heart

Inner Heart

Layered Heart Valentine

5 Add a small amount of red ink to white to make a pale pink, and use a #0 pointed round brush to add details after the first ink color is thoroughly dry. Trim.

6 Use gold ink or gouache to paint a 2" × 2" (5.1 × 5.1 cm) square on Bristol or cotton cover stock. When dry, trace the outlines of the Crown template on it and trim. Use an awl or hole punch to punch three holes evenly spaced ⅛" (3 mm) from the bottom of the crown.

7 Use a few dots of glue to attach the lettered panel to the backing panel, and a few more dots of glue for the crown. Use the awl to poke through the holes of the crown, going through all the layers. Poke the brads through the holes and fasten.

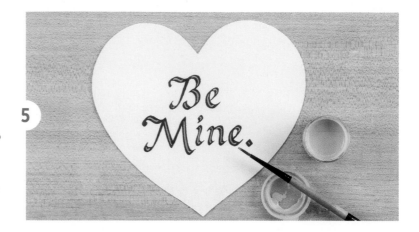

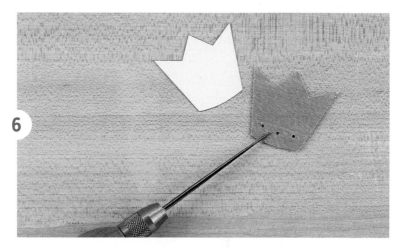

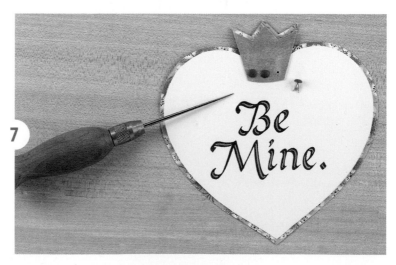

Variations

More Valentine ideas

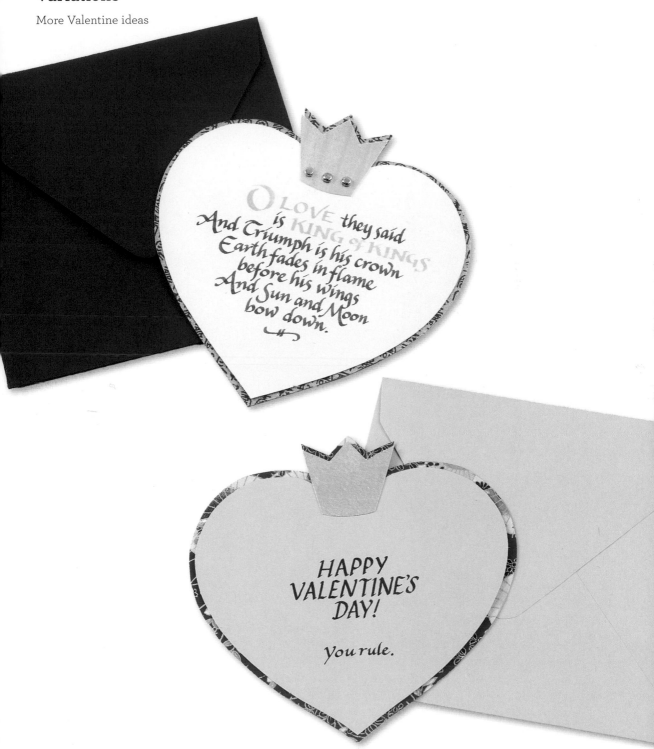

O LOVE they said
is KING of KINGS
And Triumph is his crown
Earth fades in flame
before his wings
And Sun and Moon
bow down.

HAPPY
VALENTINE'S
DAY!

You rule.

Mom & Uncle Larry
at the cabin
Summer, 1989

Graduation
Univ. of Minnesota
May, 1991

April, 1999

December, 1968
with Jeaneen, Chrissy & Bobby

Faux-Vintage Scrapbook Pages

Scrapbooking is a lot of fun, especially when you create uniquely personal elements for your scrapbook pages rather than purchasing them. This project shows you how to give your scrapbook pages an old-timey nostalgic look. There is also a template included for making your own old-fashioned style paper photo corners.

WHAT YOU'LL LEARN

- Archival techniques for scrapbooking
- How to make your own photo corners
- The best way to position photos accurately on a page
- How to apply glue dots

WHAT YOU'LL NEED

- two 12" x 24" (30.5 x 61 cm) sheets of 70 lb (105 gsm) black text-weight paper
- T-square
- ruler
- pencil
- craft knife
- white chalk pencil
- one or more styles of decorative-edge scissors
- glue dots
- paper memorabilia for scanning or collaging
- prints of personal photos
- photo corners
- scissors
- eraser
- craft glue
- opaque white calligraphy ink
- small (1 mm) Italic calligraphy nib
- optional: white acrylic ink, white calligraphy gouache, scanner/printer/color copier, laserjet printer and photo paper, one large sheet vellum or decorative glassine paper, decorative paper for making photo corners

Let's Begin

1 Fold each large sheet of black text-weight paper in half along grain direction, then use a T-square, ruler, and craft knife to measure and trim to 12" × 12" (30.5 × 30.5 cm). With a white chalk pencil, lightly rule a 1½" (3.8 cm) margin on the non-folded edge of each page. This marks the area that will be punched with holes and bound into your scrapbook.

(continued)

Faux-Vintage Scrapbook Page

2 Print out (or make color copies) of the photos and other materials you want to use, experimenting with the reduction and enlargement setting to make different-sized versions the images. Leave white space around your prints so you can try out different kinds of borders using decorative-edge scissors to trim. You can also experiment with printing photos or other elements onto colored papers. This can be especially interesting when a black-and-white photo is printed on a colored paper stock. In this example, vintage clip-art frames and handwritten letters were scanned and printed on parchment and different colored paper stocks.

3 Choosing from the various prints you made, decide which pieces you want to use and print out final versions, trimming and cropping as needed. For trimming with decorative-edge scissors, make sure to position the scissor blade correctly so the next cut of the scissors matches with the previous patterned line cut.

4 For pictures that will be mounted under paper frames, trim windows in the frames carefully with a craft knife. Place the frame on top of the photo, and use a fine-tip pen to mark the edges where photo will be trimmed so it fits exactly under the frame. Trim photo just inside pen lines, apply craft glue to the back edges of the frame—make sure not to get the glue too close to the window edge where it can ooze out onto the photo—and place frame directly on top of the photo. Press under wax paper until dry, about 30 minutes.

5 Lay out your page by positioning your prints and other items on a test page with removable artist's tape or masking tape to hold them in place. Remember to leave plenty of space for captions. If you plan to use photo corners, position them on the corners of the photos, but don't glue or stick them down. Use a white charcoal pencil to rough in the captions.

(continued)

Faux-Vintage Scrapbook Page

6 Test your white ink and calligraphy nib on a scrap sheet of the same black paper used for the scrapbook page. If regular white calligraphy ink doesn't appear opaque enough, try acrylic white ink or white calligraphy gouache.

7 Remove the first photo to have a caption from your test page, and position it into the same place on the actual scrapbook sheet. Lay a sheet of paper underneath your writing hand to keep skin oils from marking the scrapbook page. As you write your caption, refer to your test version for size and spacing. If you like, you can experiment with connecting the Italic strokes and developing an old-time handwriting.

8 Continue adding captions, working from the top to the bottom of the page, placing one photo at a time on the sheet as you write the caption.

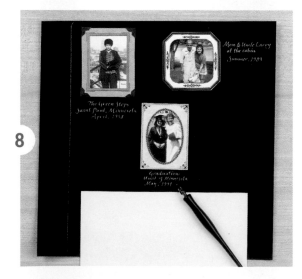

9 After the ink for the captions has dried, remove all the photos and prepare to mount them. To mount a photo using photo corners, place a photo corner so it fits snugly on the upper left corner of your photo. (And remember, if your scrapbook page has any layered images, you'll want to mount the bottommost layers first.) Moisten, apply glue, or remove backing from photo corner depending on the type of photo corner. Stick the upper left corner to the page, and once you are sure the photo is straight, press your finger down on the photo corner until it is stuck firmly. Once this photo corner is on, you can easily add the others, and the photo will remain in position.

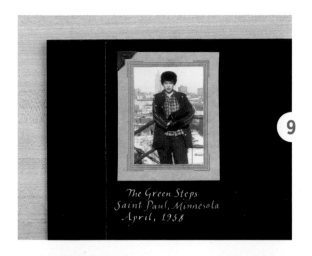

The Green Steps
Saint Paul, Minnesota
April, 1958

10 For items not using photo corners, glue dots are recommended (rather than glue) because they are easy to apply and allow the future option of removing the photo from the page if necessary. To properly apply glue dots, turn the piece to be mounted facedown, cut a short strip of dots from the roll, turn the strip so the first glue dot is positioned in the place you want it to stick, press on the dot with your finger, and then lift the strip. The glue dot will be attached to the back of your artwork in the place that you pressed it on.

11 When you have applied as many dots as you need, turn the artwork over, place it where you want it to be mounted, lay a sheet of paper or wax paper over the artwork, and press firmly. Items stuck on with glue dots can be removed if necessary, but will usually take a bit of the page they were mounted on with them, so make sure to position your artwork accurately the first time.

12 A sheet of decorative glassine or vellum bound into the scrapbook as an overlay

QUICK REFERENCE

First photo to have a caption. If you are right-handed, this should be a photo from the upper left part of the page, and if you are left-handed, this should be from the upper right part of the page. In this order, you won't have to rest your hand on parts of the page that you've already finished.

One photo at a time. Photos can be set in place without masking tape if you wish—the idea is not to let the photos get in the way of your writing—they can always be repositioned later.

How to Make Photo Corners

You can make your own vintage-style photo corners by tracing the template below on decorated text-weight paper. For the scrapbook page in this project, I scanned and printed out a letter in my mother's handwriting on colored papers, reducing the template to 50% of its original size.

1 Print the template onto card stock, cut out, and use and pencil to trace it on text-weight paper.

2 Use sharp scissors or a craft knife to trim the straight sides of the tracing first.

3 Fold the smaller inner flap first.

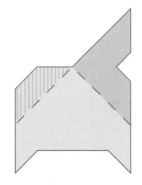

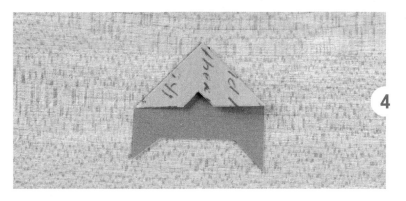

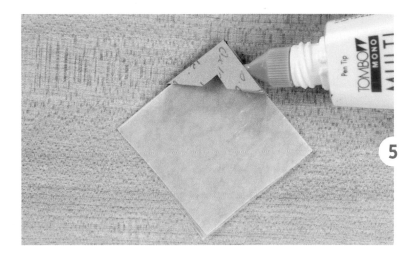

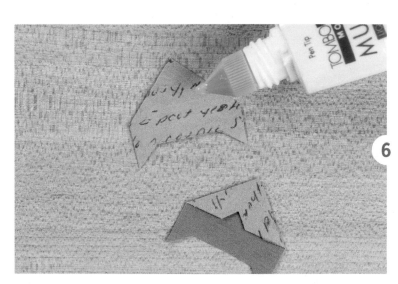

4 Turn the photo corner so the front faces you and fold over the left-hand flap, gently pulling it so that the right corner lines up with the folded inner flap.

5 Fold a small piece of wax paper into a square and tuck inside the photo corner. Use glue stick to apply a small amount of glue to the inner flap and pinch the outer flap between your thumb and finger to make sure the glue sticks, then remove the wax paper.

6 Apply glue stick or craft glue to the backs of your photo corners when you are ready to use them.

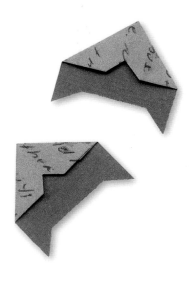

Brushwork and Gilding

Brush lettering has its origins in the Roman alphabet, as well as in ancient Chinese and Egyptian writing. It is interesting to look at Roman inscriptions in stone and realize that the serifs, sheared lines, and terminals we see originated from the attempt to reproduce the original lettering designs that were done with a brush.

Although the connection between calligraphy and brushwork may not be obvious at first, we have seen throughout the chapters of this book that brushwork does indeed play an important role in calligraphy. You will find that a stiff-bristle flat brush can be used in just the same way as a calligraphy nib, as well as in other even more expressive ways.

Beginner Brush Lettering

Italic Hand is one of the easiest to learn to write with a brush. For this script, use a small (⅛" [3 mm] wide) flat brush with firm bristles, held in the same way as you would hold a calligraphy pen.

You can work in ink or gouache, but either way, make sure you don't overload the brush. It helps to keep a folded paper towel on hand to blot off extra ink or paint until the brush is nearly dry (i.e., having just a minimal amount of paint on it). Practice "writing" Italics with the brush, following the same stroke order as you would with a pen, until you get a sense of how much ink or paint is the right amount. It also helps to use a thick paper with a soft finish, such as a 100% cotton printmaking paper, which will absorb the ink or paint well.

Italic Brush Letter Samples

Advanced Brush Lettering

Once you get a feel for writing with the brush, you can try your hand at the more traditional form of brush lettering, where the brush is held nearly perpendicular to the paper. Although it takes some getting used to, once you learn you'll find you can use the brush very expressively.

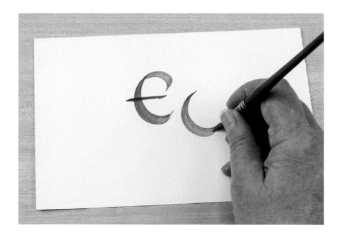

Informal Roman Capital Brush Alphabet

ABCDEFGHIJ
KLMNOPQRS
TUVWXYZ

Key Points for Brush Lettering

- One important characteristic of brush lettering is that the brush is held perpendicular to the paper, with your fingers gripping the ferrule (the metal collar of the brush). Your pinky finger should extend down to lightly touch the paper, providing a means of support.

- For starting out, use a wide flat-tip brush about ⅜" to ½" (1 to 1.3 cm) in width. Keep the brush very lightly inked, almost dry. Don't worry if you run out of ink mid-stroke; for now just concentrate on getting used to making the stroke shapes.

- Pan watercolors can be very useful for brushwork, since they lend themselves well to a dry-brush technique. Dip your brush in water and stroke the surface of the watercolor until the brush is just lightly covered.

- For this alphabet, the height of the capitals is about 7 brush widths. You will have a lot of control over how wide your strokes are depending on how hard you bear down on the brush, which you can use to your advantage to give your brush lettering a more dynamic, freeform look.

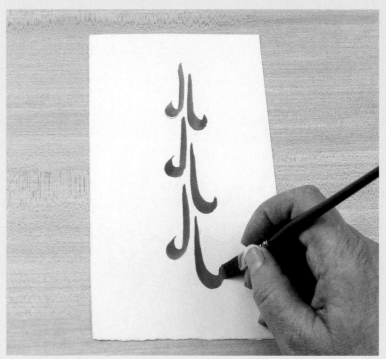

- You can also twist the brush slightly (or a lot) at the end of a stroke for an interesting effect (at right).

- If you have more than one variety of brush on hand, try them out to see how they write. You'll probably find that there is one specific brush that works really well for you.

Skill Builders
GETTING THE FEEL FOR THE BRUSH

Because a brush is much more flexible than a calligraphy nib, it can feel much harder to control brush strokes at first. The key is to not try to control the brush, but to learn how to let the brush make the marks it is designed to make. The best way to learn how to do this is simply by doodling and playing around with different brushes, much the way you did with the calligraphy pen.

Assemble of few different sizes and types of brushes, along with a few different colors of ink in small containers. On a large piece of Bristol or other thick stock, ink up a brush, and just play around making marks—loops, squiggles, waves, whatever. Notice which strokes are easy to make and which ones tend to break apart or feel unstable. Change colors each time you change brushes, and write which brush you used for each set of marks. This practice will help you work with your brushes instead of trying to control them.

These are the brushes used for this sample: orange, ⅛" flat; green, #4 flat shader; red, #1 round; blue, #1 script liner; and black, ⅜" flat.

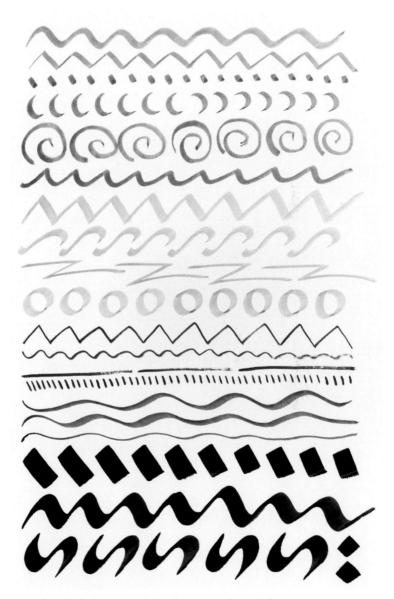

Notice how the flat brushes work best for creating the kind of strokes used for calligraphy.

Experimenting with Different Brushes

There are brushes of many more shapes and sizes besides the ones introduced so far in this book, and you can have a lot of fun experimenting with them to create decorative paint effects. Here are just a few to try out:

- Chinese writing brush (maobi)

The long, soft fibers of the Chinese writing brush allow it to be pushed, pulled, or swirled in any direction.

- Squirrel hair brush

Similar to a Chinese brush, the squirrel hair brush is extremely soft and flexible, and especially useful for soft washes and natural shapes like flower petals and leaves.

- Fan and angled shading brushes

Brushes with angled edges can be used for filling in areas with texture or making repeating patterns.

- Color shaper

Not really a brush but more like a small rubber stamp on a brush handle; a color shaper can be used to make lines or patterns.

Painting Tips

- Ink, gouache, watercolor, and acrylic paints all perform somewhat differently when used with a brush, and the best thing you can do is to experiment with each and see what happens. Don't just assume that a brush will make the same marks with whatever medium is used. For example, lettering done with acrylic paint and a ¼" (6 mm) brush will come out much larger than the same lettering done with a ¼" (6 mm) brush and ink.

- If possible, try to have separate brushes of the same size for each type of medium. For example, have one ¼" (6 mm) flat brush you use only with ink, and another identical brush used only for gouache, and so on. At the very least, use different brushes for gouache and acrylic work, because these paints tend to wear out a brush more quickly.

- Most inks will stain the fibers of your brushes to some degree, so if you are using white ink or paint, make sure to use brush that is absolutely clean.

- Keep a large container of water—2 pints (1 liter) at the very least, and a liter or more is ideal—for rinsing brushes, and change this water often. To really rinse a brush well as you are working with it, immerse it as far as you can in a large container of water and shake the brush back and forth vigorously in the water for a good thirty seconds. Don't squish the bristles of the brush against the bottom of the container, because this is bad for the fibers and just puts the color sludge back onto the brush. Blot the brush dry on clean paper towel or rag.

- When you are done using a brush, rinse it well under running water and use dish soap or brush cleaner and your fingers to gently lather up the bristles. Use a very fine-tooth comb or toothbrush to loosen the clumps of pigment that tend to stick up at the base of the brush ferrule. When done washing, shape the bristles back into their original shape while still wet and let the brush dry standing upright or lying over a table edge so the bristles aren't touching any surfaces. If you really want your brushes to maintain their shape, wash them well after use and dip into liquid gum arabic (available at art supply stores) while still wet, then re-shape with your fingers. The gum arabic will keep the bristles dried in position and can be rinsed away with water when the brush is used again.

- Always keep paint tubes tightly sealed, stored away from heat or cold, and out of the reach of pets or young children.

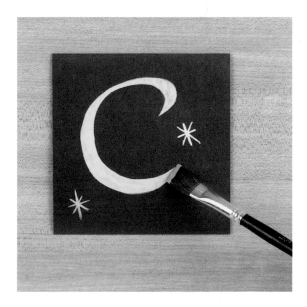

About Gold and Silver Leaf

Working with gold or silver leaf can be challenging at first. It is important to start out with small, modest projects that are easy to do and designed to yield successful results. It also helps to understand the physical components of the gilding process.

First, a substance called sizing is painted onto paper or whatever surface is to receive the metal leaf. Although sizing is generally water soluble, it has a stickiness that makes it different from working with ink or paint. It is very much like painting with glue, and one of the downsides is that any re-working you do to the sizing you have painted will result in ridges or blobs that can be seen under the metal leaf. Therefore, learning to work skillfully with sizing is the first step to achieving good results with gold and silver leaf.

After sizing is painted on a surface and allowed to become tacky (usually within 30 minutes or so), pieces of metal leaf are laid down and gently rubbed onto the sticky area. The excess leaf (that which doesn't stick to the sized areas) can be gently rubbed off with a brush right away. If you want to be more careful, you can wait 24 hours (the length of time for sizing to dry completely) before brushing away any excess leaf.

The final step in the gilding process is to gently rub the gilded areas with a hematite or agate burnisher (a highly polished stone with small rounded tip for reaching small areas) to increase shininess in the metal leaf. Unless you are working with pure gold or silver leaf, this process is optional. With pure metals, the rubbing motion of the burnisher will actually cause the metal to melt slightly and take on a lustrous, liquid finish. With aluminum- and copper-based metal leaf material (which is more commonly used and what we will use in the projects that follow), the burnishing process may cause the metal leaf to separate from the sizing.

 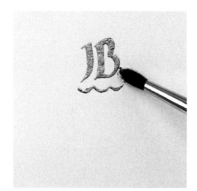

Gilding Tips

- For gilding on paper, make sure your paper is relatively smooth and free of dust, grit, dirt, etc. Have plenty of scrap paper on hand to place below each piece of paper to which you are applying sizing, and renew the scrap sheet each time any of the sticky sizing gets on it.

- Wooden surfaces should be well sanded with fine sandpaper and wiped clean with a damp cloth.

- Working with sizing is very much like working with quick-drying glue, so it is very important to lay down the amount of sizing you want in single layers. Overlapping and re-working should always be avoided, since this will result in ridges that show up beneath the metal surface of the leaf. It is useful to use a brush that it exactly the size of the stroke you want to make so you don't have to go back and add an extra layer of sizing to anything you have painted.

- Start with small brushes, doing projects with small lines and narrow borders, because thicker areas tend to be more difficult to cover in one go. As you learn to work with sizing, you will develop a sense of how to cover large areas evenly in one layer.

- Many kinds of sizing will set up within 30 minutes and remain tacky for 24 hours, so it is possible to apply sizing to a project and then go back and apply the leaf later. If you do this, make sure to store your sized pieces somewhere well away from dust, pet fur, breezes, or anything that might cause unwanted material to stick to the sizing.

Thanks
a
Bunch!

Script Notes on Pearlescent Paper

This project makes use of pearlescent cover stock, which is available in a wide range of colors (see Resources). Be sure to test your inks on a scrap of pearlescent paper before starting, because certain inks do not absorb well into the coated surface of the paper (calligraphy gouache works the best on this type of paper).

WHAT YOU'LL LEARN

- How to apply letters and designs with brush strokes
- How best to work with pearlescent cover stock

WHAT YOU'LL NEED

- cover stock
- pencil
- watercolor pencils
- ⅛" (3 mm) flat brush
- white acrylic ink
- scrap paper for practice
- #0 round brush
- pearlescent white acrylic ink
- #0 pointed round brush
- #00 pointed round brush
- red acrylic ink
- #2 round brush
- script liner
- scoring wheel or bone folder
- ruler
- text-weight pearlescent white paper
- glue

Let's Begin

1 Find the grain direction and cut cover stock to 5½" × 8½" (14 × 21.6 cm), with the grain running in the direction of the shorter side. Lightly rule a pencil line exactly halfway through the longer side. On the same side, pencil in the design with watercolor pencils or other soft pencil (too sharp a pencil point will leave dents in the pearlescent stock).

(continued)

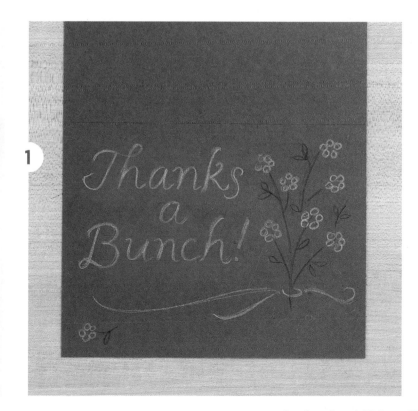

Script Notes on Pearlescent Paper

2 Use a flat ⅛" (3 mm) brush and white acrylic ink to paint lettering, being careful not to overload the brush. It helps to have a practice sheet of the same paper nearby to try out your strokes on.

3 Use a #0 round brush to paint dots for flowers. With a circling motion, start from the outer edge of the dot and swirl inward.

4 When white ink has dried, use pearlescent white acrylic ink and a #0 pointed round brush to add accent strokes to the wide parts of the letters. When you come to the widest part of a stroke, push down slightly on the brush so the bristles flare out a little.

5 Use a #00 pointed round brush and red acrylic ink to paint the stems. Work in single, long continuous strokes. When the stem lines are dry, paint the leaves, starting at the leaf tip and making a graceful swoop that meets the stem.

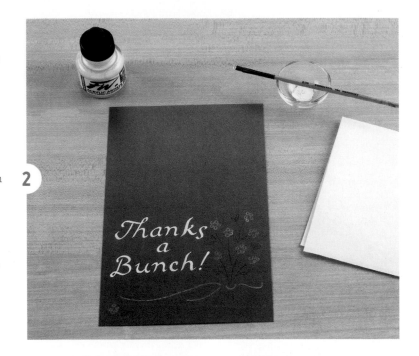

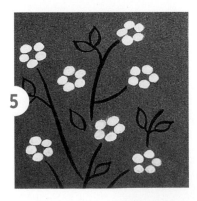

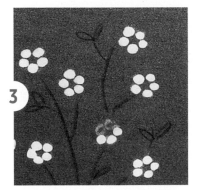

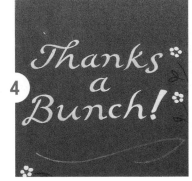

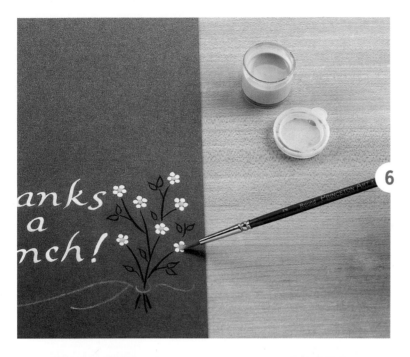

6 Mix pearlescent white acrylic ink a touch of red to make light pink. Use a #2 round brush to paint dots for the flower centers. To build up a raised flower center, re-ink the dot several times, allowing to dry completely each time.

7 Use a script liner to paint the ribbon with white acrylic ink, and then use pearlescent white acrylic ink and a #2/0 pointed round brush to do the ribbon details.

8 When gouache is thoroughly dry, use a scoring wheel or a bone folder and ruler to score the fold marked earlier in pencil on the front side of the card.

9 A sheet of text-weight pearlescent white paper, cut to 5¼" × 8¼" (13.3 × 21 cm) and folded, can be glued in to create a lighter surface for writing on. Just use a few dots of glue on the fold and a dot on each corner.

10 Re-create a simplified version of the flowers on the back flap of the envelope if you wish.

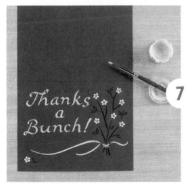

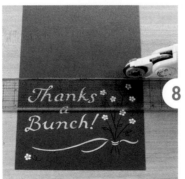

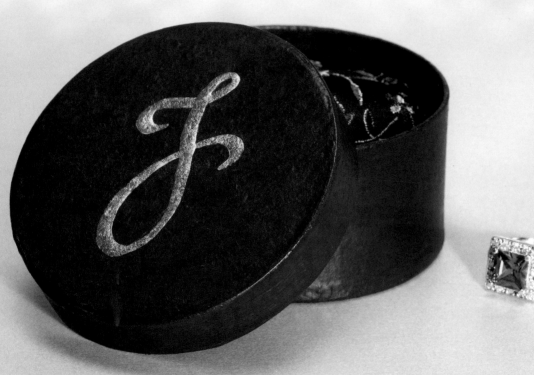

Gold Leaf Treasure Box

Once you get the hang of gold leaf, you'll find you can apply it to almost any surface, provided it is flat and prepared properly. You could try this project on a wood or metal box.

WHAT YOU'LL LEARN

- How to transfer a calligraphy design to a small box lid

- How to reproduce your calligraphy in gold leaf

WHAT YOU'LL NEED

- small wood or cardboard box with removable lid
- acrylic paint (any color)
- ½" (1.3 cm) soft brush
- three or four large cotton balls
- 7" × 7" (17.8 × 17.8 cm) square patterned silk or fabric to match paint
- one piece of cover stock
- compass
- pencil
- ruler
- scissors
- hot glue gun
- tracing paper
- one sheet artificial gold leaf
- water-based gold leaf sizing liquid
- #0 round brush
- #2 round bush
- 3-mm flat brush
- hematite or agate burnisher
- optional: Saral brand white transfer paper

Let's Begin

1 Mix acrylic paint with water to a thick consistency and use a 1" (2.5 cm) brush to paint the surface of the box beginning with the inside of box lid. Then paint the inside of box, all the way down to the base, but don't paint the base itself. When the paint has dried, paint the outside edges of the box and lid, and when these have dried, use a smaller brush to paint the narrow rims of the lid and box top. Repeat the entire process if you see thin areas of paint after it has dried.

(continued)

Gold Leaf Treasure Box

2 Measure the diameter of the base of your box (the box in this example measures 2¾" [7 cm] across) and use a compass to draw a circle that has little over twice this diameter on card stock (in this case, 6½" [16.5 cm]). Trim the template with scissors; trace the template onto fabric and cut the fabric to size.

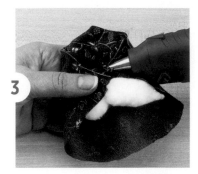

3 Pull three or four cotton balls apart slightly and fit them into the base of your box so they fill the box about halfway. Remove the cotton mound, and place on the facedown fabric circle. Wrap the margins of the fabric over the cotton, small sections at a time, and glue in place with a hot glue gun. (Note: be careful to never touch either the hot glue or the tip of the glue gun when it is plugged in.)

4 Add hot glue to the inside base of the box and set the cushion inside.

5 Trace the outer edge of the box lid on tracing paper and use a pencil to work out the initial design you want to do in gold leaf. Remember, this can be a simple ornament or initial, rather than a complicated scheme of letters.

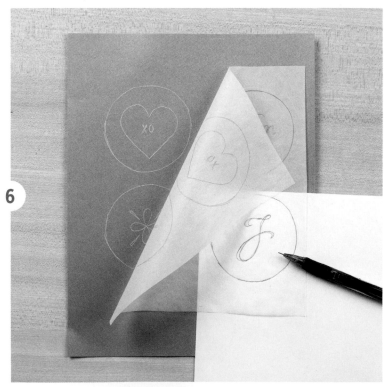

6 If you want, you can do a test run of your chosen design by tracing the design

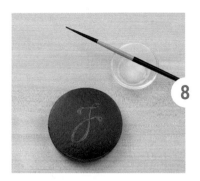

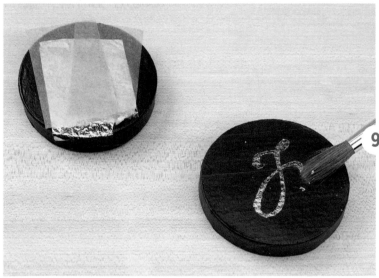

onto a darker-colored piece of paper through a layer of white Saral transfer paper, which will not leave grooves or imprints in the final surface and can be easily erased. Use your Saral tracings as an opportunity to practice using different kinds of brushes with your gold leaf size and applying gold leaf.

7 When you have settled on a design and particular brush and technique to use, transfer your tracing paper design through a layer of the Saral transfer paper onto the box lid. (Note: because tracing lines tend to come out rather thick, it helps to first erase them slightly with a kneadable eraser so you have only very fine lines to follow.)

8 Use your selected brush to apply sizing, without allowing layers of sizing to overlap, and let it set for 30 minutes or according to manufacturer's instructions.

9 Apply gold leaf (see page 198): cut a small amount of leaf to cover area, gently rub with orange protective sheet, then move on to the next area. When all areas have been covered with leaf, use a small brush to remove excess.

Variations

Make small gift boxes in different shapes and colors to suit the recipient and the occasion. Apply imaginative gilded designs you've created with calligraphy.

Brush-Lettered Name Plaque

This simple project makes use of bright colors of acrylic paint and simple craft plywood shapes. Because acrylic paints are generally opaque, you can add color details over other color layers. Decorate and embellish with paint as much as you like!

WHAT YOU'LL LEARN

- How to apply brush letters in acrylic paint
- Cute and clever ways to decorate a child's name plaque

WHAT YOU'LL NEED

- 4" × 12" (10.2 × 30.5 cm) plywood sheet, ⅛" (3 mm) thick
- acrylic paints in titanium white, cadmium yellow light, cadmium orange, brilliant yellow green, permanent light green, turquoise blue, medium magenta, and brilliant blue
- fine (#220 grade) sandpaper
- plastic paint palette (or old plate)
- large jar for water
- ¼" (6 mm) wide flat brush
- ½" (1.3 cm) wide flat brush
- #8 pointed round brush
- #1 round brush
- die-cut wooden shapes
- white chalk pencil
- ruler
- wood glue or craft glue
- small coping saw
- 36" (91.4 cm) length of decorative ribbon
- stapler or staplegun with short-prong (⅛" [3 mm]) staples
- scissors
- optional: clear gloss polymer medium

Let's Begin

1 Use #220 grade sandpaper to lightly sand the edges, corners, and surfaces of the plywood sheet, then wipe away dust with a damp cloth. Squeeze out an approximately 2" (5.1 cm) of brilliant yellow green onto a palette or mixing plate, wet the ½" (1.3 cm) brush with water and continue to mix water into the paint until it is thick and creamy. Use the ½" (1.3 cm) brush to *paint the front and back* of the sanded plywood sheet. If you want more intense background color, add a second layer of green after the first layer has dried.

(continued)

QUICK REFERENCE

Paint the front and back. You do need to paint both sides of the board, otherwise it will warp.

Brush-Lettered Name Plaque

2 Add a small amount of permanent light green paint to the brilliant yellow green paint and mix together—it should be just a shade or two deeper than the green you painted on the plywood sheet. Make sure to add enough water to the paint so that it flows well from the brush. Use the #8 brush to paint a border on each side of the plywood sheet. Let the lines of your border be loose and curvy rather than perfectly straight. (Optional: after paint has dried, use the #8 brush to go over the border with clear gloss medium.)

3 When the border has dried, use a minimal amount of paint to paint the ⅛" (3 mm) edge of the wood—use a light, side-to-side movement of the brush so you just catch paint on the edge of the wood. Check the front border when you are finished and use the brush to blend in any paint that may have oozed over the edge.

4 Sand any rough edges of die-cut wood flowers and shapes and wipe clean. Paint them with the ½" (1.3 cm) brush using medium magenta, cadmium orange, and cadmium yellow light. When dry, paint the backs and edges. Make sure to change the water in your water jar and wash your brush well with each color change. This will keep the individual colors as bright as they can be. (Optional: after painted has dried, use the ½" [6 mm] brush to coat with clear gloss medium.)

5 Use the white charcoal pencil to sketch your letters onto the plywood sheet, leaving 1¾" (4.5 cm) margin on each side where flowers shapes will be glued on.

6 Add water to brilliant blue paint until it is loose enough to flow well from the brush. Use the ¼" (6 mm) flat brush to do the lettering, holding the brush at a 30° angle as you would a calligraphy pen. (Optional: when lettering is thoroughly

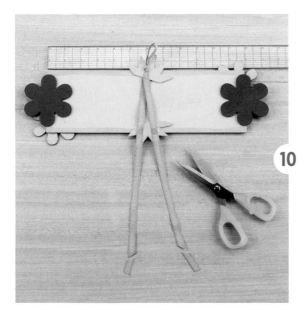

dry, use the ¼" [6 mm] flat brush to go over the lettering with clear gloss polymer medium.)

7 Turn the plaque facedown and use wood or craft glue to glue the die-cut shapes to the back of the plaque as shown. (Note: if necessary, use a coping saw to saw pieces in half, as was done here with the yellow star.)

8 Turn the plaque faceup and glue the orange die-cut flowers as shown.

9 Mix equal amounts of titanium white paint and brilliant blue paint with water so that it flows easily from the brush. Use the #1 brush to add detail lines to the edges of the lettering. If desired, use the #1 brush to continue to decorate the plaque. A small amount of titanium white mixed with other paint colors will help your details stand out on the colored surfaces.

10 Find the center point of the 36" (91.4 cm) length of ribbon and tie a knot to make a loop about 1" (2.5 cm) in height. Turn the plaque facedown and use a ruler to find the exact center of the top edge and mark this point with a chalk pencil line. Apply a generous dot of craft glue to the center line and press the knotted part of the ribbon against it; press with a heavy book until completely dry, about 1 hour. Use short-prong staples to staple the knot in place, making sure the points of the staples won't poke through to the front of the plaque. Pull the ribbon ends straight down and glue them to the lower cut-out shape with glue dots, as shown. Trim ribbon ends diagonally with sharp scissors.

The favor of a reply
is requested by
Friday, September 21, 2012

M_____
___ Accepts ___ Regrets
Number in party:

Josephine de Francis
&
Arthur L. Rusterholz
invite you to join them in
the celebration of their wedding.
Friday, December 21st, 2012
at two o'clock in the afternoon
St. Louis Cathedral
615 Père Antoine Aly
New Orleans

Ms. Versea Minnette
1664 Hague Avenue
Saint Paul, Minnesota
55104

Mrs. Henry de Francis
7 August Street
Saint Paul, Minnesota
55104

Wedding Invitation Suite

This invitation project combines calligraphy with simple decorative painting techniques to create a memorable piece for a memorable event.

WHAT YOU'LL LEARN

- How to design and make all the pieces necessary for wedding invitations
- How to embellish the invitation with a brush-stroke floral design

WHAT YOU'LL NEED

- aqua 80lb (218 gsm) cover stock
- white 80lb (218 gsm) cockle-finish cover stock
- white square petal-flap envelope
- brown calligraphy ink
- pearlescent white acrylic ink
- white acrylic ink
- titanium white acrylic paint
- 1-mm calligraphy nib
- #000 squirrel brush
- #0 pointed round brush
- green and blue calligraphy ink
- white sticker stock
- A8 (5¾" × 8¾" [14.6 × 22.2 cm]) aqua envelope
- craft glue
- wax paper
- pencil
- ruler
- T-square
- craft knife
- scissors

Let's Begin

1 Cut the top sheet to 5" × 8" (12.7 × 20.3 cm) high and do a trial layout with the text you want to use. Be sure to leave 1" to 1¼" (2.5 to 3.2 cm) of the left margin blank for the flower painting. Lightly sketch in flowers and stems with pencil.

(continued)

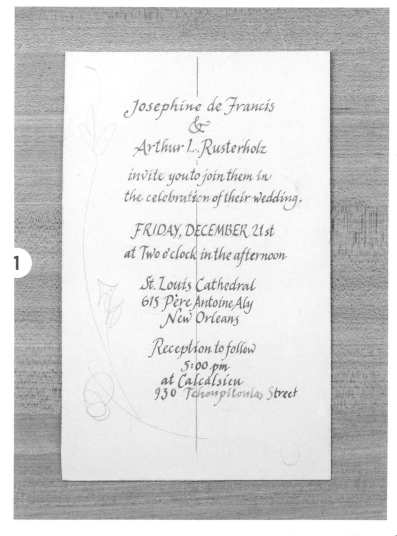

Wedding Invitation Suite

2 Taking measurements from your rough layout and making adjustments as needed, use a pencil to lightly rule lines for writing.

3 Use a narrow nib to do the main text. In this example a #4 (1 mm) Leonhardt nib was used for letters with an x-height of ⅛" (3 mm).

4 For a response card, make a similar rough layout and use those measurements to rule pencil lines.

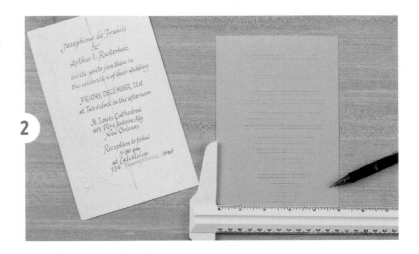

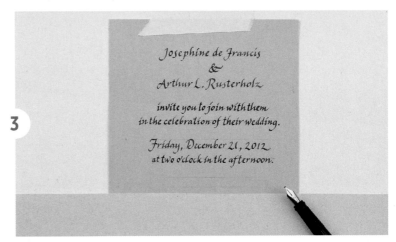

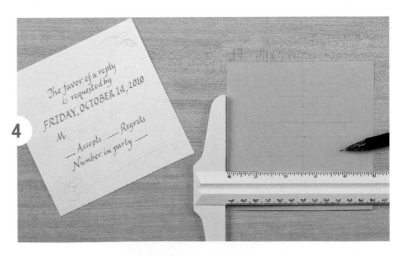

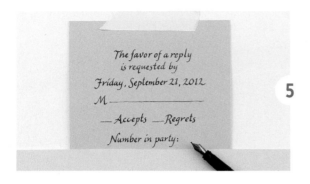

5 With the same size nib and ink color, ink in the lettering for the response card.

6 For the flower petals, mix equal amounts metallic white and white acrylic ink. Try out the consistency of the ink on a scrap of aqua paper with the squirrel brush, adding a small amount of titanium white acrylic paint to slightly thicken the ink if necessary. Do a practice version of the invitation and response card by penciling in stems and drawing the flower petal shapes. Push down on the brush to make the wide part of the petal, then flick the brush inward to make the point.

7 Lightly in pencil stem lines, leaving blank areas for flowers, and paint the petals.

(continued)

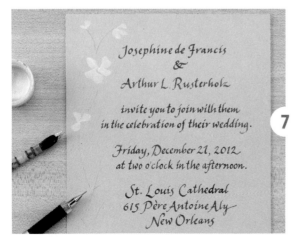

Wedding Invitation Suite

8 Pencil in the stem lines and paint petals for the response card.

9 To do stems, erase pencil marks on the invitation and response card. Add a drop or two of blue ink and green ink to white ink to make light aqua, and use the #0 pointed brush to make thin stem lines. Repeat the process for the response card.

10 To mount invitation, cut backing sheet card stock to 5½" wide × 8½" (14 × 21.6 cm) high. Use a brush to apply craft glue to the back of the invitation, making sure to go all the way to the edges. Place on backing sheet, smooth under wax paper, and press under a book until dry, about 30 minutes.

11 Follow same process to mount response card to petal envelope. You can make your own petal envelope by enlarging the template on page 238, tracing it onto card stock, and scoring the flaps on all four sides with a bone folder and ruler.

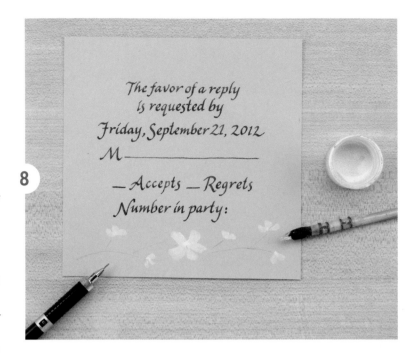

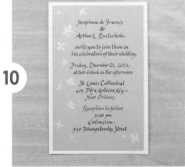

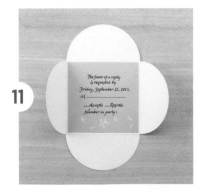

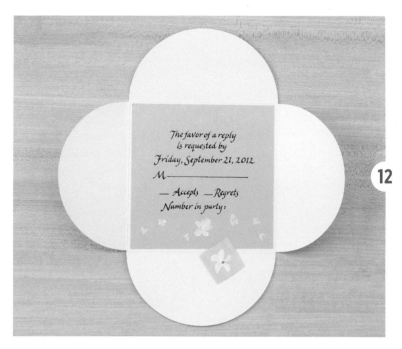

12 To make the sticker to seal the response card, paint a layer of the same ink used for the flower stems on a piece of sticker stock. When dry, paint the flower petal design in white and trim to a small square. Include this sticker with backing still on it inside the folded response card.

13 With the sticker inside the folded and unsealed response card, address the front of the petal envelope. In the United States, square envelopes require extra postage.

14 Use the same ink and nib to address A8 size envelope.

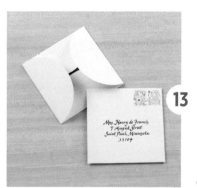

Calligraphy and Modern Methods of Copying

Calligraphy interfaces very well with digital-age technology. Unlike scribes of ancient times, who labored to reproduce the same pages again and again by hand, calligraphers of today can complete one piece and choose from several options for its reproduction. This chapter will show how you can use a personal computer, a photocopy machine, or the services of a professional printer to reproduce your work.

Reproducing Calligraphy on a Personal Computer

To reproduce your calligraphy on a computer, you will need a scanner and image-editing software, layout software, and an inkjet printer. Many computers are sold with basic image-editing applications that allow you to import scanned images and manipulate them, as well as a basic page-layout programs that allow you to place picture files.

If you are more graphically minded and willing to make the investment, you can purchase Photoshop software that will provide you with extensive image-editing capabilities. Page-layout programs such as InDesign and QuarkXpress are also useful, if you have the budget to purchase them.

Additionally, there are printers that have scanning, copying, and faxing capabilities; if you own or have access to one, consult the machine's specifications to see if you can scan at a resolution of at least 300 dpi (dots per inch) and whether you can copy a scanned image to a disk or flash drive, export it to your computer drive, or e-mail it. If any of these are options possible with your printer, then you can get by without having to purchase a separate scanner.

There are many types of reasonably priced scanners and inkjet printers available that are capable of delivering high-quality printed images; be sure not to buy anything fancier than you really need. Basic flatbed scanners at the time of this writing sell for around $100, and are capable of scanning in color or black-and-white, many also come with software applications that allow basic image editing.

TIP When scanning or photocopying your work, make sure that the copying surface is clean—wipe the surface with a lint-free cloth or, if necessary, use a small amount of glass cleaner sprayed on the cloth (not the scanning surface). It makes a difference!

Scanning and Inkjet Printing Your Calligraphy

In this project, we start with a 8½" × 11" (21.6 × 27.9 cm) page of calligraphy done with colored inks on light brown parchment paper, and use a scanner and some simple image-editing techniques to adjust the colors, export the image, and set up a page-layout file to print multiple smaller-sized copies from an inkjet printer.

1 Set up your scanner to scan in color/photo mode at 300 dpi. If your piece is very small, or you simply prefer higher-resolution images, use the 600-dpi setting. Some people use the higher resolution because it renders colors and fine details more accurately, although it also results in larger files that take longer to print. Make sure your piece lies flat on the scanning surface. Scan the image at full size (100%).

2 Often it is a good idea to increase the contrast slightly, especially when the ink and paper color are close in tone, or if you want a white paper background to appear truly white. In this example, the brightness/contrast setting was used to increase the contrast by 10%—just enough to make the color pop—and the image was saved as a jpg file.

3 Using a page-layout program, create a new document 11" wide × 8½" high (27.9 × 21.6 cm) place the jpg file and scale down to 35%. At this point it is a good idea to print out the page to see how it looks. Keep in mind that very fine lines can disappear if the piece is reduced too much in size.

4 A larger red box is placed behind the image (the eyedropper tool was used to sample the red color from the calligraphy) and another box with a yellow (the yellow color was also sampled from the image's paper color) is added.

(continued)

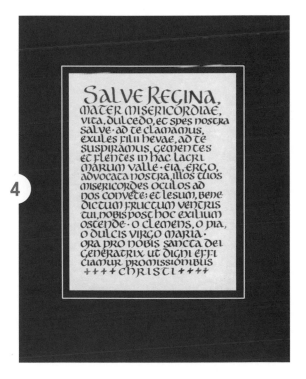

Scanning and Inkjet Printing Your Calligraphy

5 The red box, border, and yellow frame are grouped, duplicated, and placed on the second half of the page, using guidelines to assure they are lined up exactly. Guidelines are also used to set up the red crop mark lines that extend ⅛" (3 mm) in from the margins of each piece, indicating where the edges will be trimmed.

5

6 Use an inkjet printer to print multiple copies onto a slightly textured natural white paper.

7 Trim final pieces to size, following crop marks.

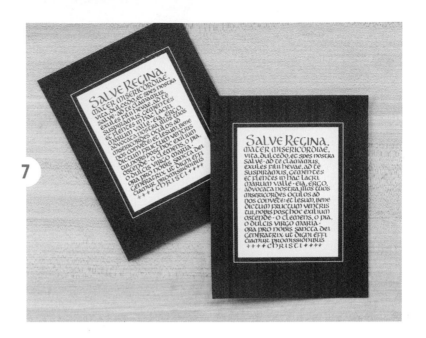

Helpful Hints for Inkjet Printing

A home inkjet printer is a great tool to have for easily reproducing your calligraphy. To make sure you are getting the best results from your printer, here are some tips:

- Use the best quality ink cartridges you can find. There can be a vast difference in quality between various ink cartridges brands, so shop around. Many drugstores and office supply stores offer ink cartridge refilling services, which is considerably less expensive than purchasing new cartridges. The drawback of this, however, is that sometimes the color from refilled cartridges can be quite dull or muddy looking. For special projects, consider purchasing new ink cartridges—these can be removed from your printer before they are used up and stored in a plastic bag until you are ready to use them again.

- Use papers suitable for inkjet printing. Most printers will handle a wide variety of papers, from text weight to cover stock, and uncoated to high-gloss photo paper. Take the time to check out the various paper and ink settings for your printer and use the ones that are appropriate for what you are printing. Papers with gloss or pearlescent coatings (especially in heavier weights) can present difficulties for inkjet printing, since the coating on the paper prevents the ink from being properly absorbed into the paper; if you find your ink is smearing on coated paper, try using a lighter-weight paper or adjusting your printer settings for glossy (photo paper) stock.

Tips for Photocopying and Laser Printing

- If you have black-and-white calligraphy that you want to print, black-and-white photocopying or laser printing is an easy and readily available option. For photocopying, it can be very useful to create your original piece slightly larger than the finished size you want, and then reduce the size when photocopying—reducing will give a crisper, more "tightened up" look to the lettering.

- Always do your original work in black ink on bright white paper, even if you plan to have the finished piece printed on a colored paper. For example, if you are planning to do something with black ink on green paper, it's helpful to do a version on green paper to see how it will look, but you will have a terrible time trying to make photocopies from it, since the copier will pick the color of the paper and print it as gray.

- Photocopiers and laser printers can print on many kinds of paper stock, including card stock, but there are limitations to the thickness and texture of the paper you can use. Often anything heavier than an 80-lb (218 gsm) cover stock will become jammed in the machine. Some photocopiers and laser printers also have problems with printing on textured cover stocks—the card stock will go through the machine just fine, but the black toner will be easily brushed or rubbed off the paper, or disappear altogether in places. This is an indication that the toner is not fusing properly to the paper because of its thickness or rough surface. In this case, try using a thinner or less textured paper. If you've printed a lot of copies of something, only to discover later that the toner is rubbing off, the undamaged copies can be sprayed with artist's fixative. Artist's fixative is available at art supply and craft stores and should be used only in a well-ventilated area.

- Color laser printing can be a very good option for reproducing calligraphy that is done in color—especially if you want to print your work on a pearlescent or coated cover stock. As with black-and-white laser printers and photocopiers, there are thickness and texture limitations to the types of cover stock you can use. Paper that is too thick or has a highly textured surface may not print well. If you are printing a digital scan of your calligraphy on a color laser printer, you will have better color if you save the scanned image in CMYK color mode instead of RGB.

- Color photocopying is not the best way to reproduce calligraphy, because the color photocopying process imparts a slightly grainy, screened look to the page, which can make lettering appear less readable. However, for some projects, this look might be just what you want. If you plan to reproduce a piece by making color copies, fit as many versions of the piece as you can onto a single 8½" × 11" (21.6 × 27.9 cm) or 11" × 17" (27.9 × 43.2 cm) page, so that you can get more than one copy per sheet.

QUICK REFERENCE

CMYK color mode instead of RGB. Computer monitors, scanners, and digital cameras use small bands of Red, Green and Blue (RGB) light to generate the images we see on a backlit screen. Printing presses, color laser printers and copiers, and most inkjet printers use Cyan, Magenta, Yellow and blacK (CMYK) inks to reproduce colors on paper. Often the very bright colors seen on an RGB monitor cannot be reproduced accurately on paper because paper does not have a light source streaming through the colors. A color image that is scanned in RGB will need to be converted to CMYK mode to print properly on paper. When an image is converted from RGB to CMYK, colors may shift a little or a lot; this can be corrected with image-editing software. On many home printers, the difference between RGB and CMYK isn't always discernible, but it's still a good idea to convert your color images to CMYK for printing at home—and absolutely necessary for images that will be printed on a printing press, where color shifts can be very pronounced.

Having Your Calligraphy Project Professionally Printed

For a project that you need to print in large quantities, taking your work to a professional printer may be a good option. Because there are many methods of printing used for very specific purposes, you will have to do some research to find the right print shop for your project. Have the answers to the following questions ready when you speak with the printer so they can accurately determine if they can provide the services you need.

1 How many copies do I need printed? Some print shops will not take on "short runs" (anything less than 500 pieces). Some print shops will, but the printing costs will be nearly the same as for a larger run. Take the time to find print shops that cater to individual clients and smaller print runs, and don't be hesitant to ask for a cost estimate, since prices can vary a lot.

2 Is my artwork in digital or hard-copy format? Most print shops work from digital files, which you e-mail directly to them. If you have a digital file of your artwork, it's important to find out in what form the printer needs the file so your work will look its best when printed. If your art is in hard copy form (an actual piece paper with calligraphy on it), it will almost always need to be done on white paper so that the printer can accurately scan or photograph it. The work should also be at the actual size at which you want it to be reproduced, or slightly larger, in which case you must tell the printer what you want the final size to be.

3 What kind of printing do I want? How much money do I want to spend? There are many kinds of professional printing available for reproducing calligraphic work, which can vary greatly in price.

Digital printing (sometimes called "online" printing) is readily available via the Internet and is usually the least expensive option. Digital printers generally offer "full color" (four-color process) printing, no minimum quantities, and a quick turnaround time. To use digital printing successfully, you need to make sure your file is set up correctly for the printer. Request a copy of their printing guidelines and follow them. Be sure to ask questions about any of the guidelines that you don't understand. You should also ask the printer if you will be sent a "proof" (a single sample that shows what the finished piece will look like), for which there may be an extra charge. If you have never worked with a digital printer before, it is helpful to find one in your area and show your artwork to him in person. This will help the printer see what he is being asked to do and hes will be able to give you better advice about setting up the work.

Offset printing may be an option, although many offset printers may not take on small print runs. Check the telephone book or the Internet for printers in your area, and find the ones that offer invitations or stationery printing, because these are the types of shops that are accustomed to working with individuals on smaller projects. Again, a personal visit with a sample of your artwork is a good idea, and will help the printer determine exactly

what you want done. If you don't have access to a scanner or computer, an offset printer can scan your work for you, and in some cases make printing plates directly from your original artwork. Make sure your work is on white paper, even if the finished product will be on colored paper. Printers will have swatchbooks of papers and ink colors for you to choose from.

Offset printing is a good choice if your work is going to be printed in only one color. Adding additional colors (spot colors) increases the price considerably. If your work contains many colors, a digital printing "full color" (four-color process) printing is a more affordable option. Be aware that prices can vary greatly between offset printers. Look for shops that specialize in printing for individual or retail customers, and get pricing from as many print shops as you can.

Thermography is a form of printing where the printed letters are raised up from the surface; many shops offering invitations and stationery printing also offer thermography. Your calligraphy should be in black ink on white paper; again, bring a sample of your artwork to a local thermographer and follow his guidelines for how he needs your artwork to be prepared. Be sure to ask the printer if your artwork is appropriate for thermography, since the process of printing the raised letters can slightly enlarge them, which may slightly alter the shape and spacing of your lettering.

Silkscreen is a printing method used for printing on fabric, paper, and other surfaces. It is fairly easy to find local shops and online printers who will silkscreen your design onto a t-shirt or other fabric item. All you need to provide is a black-and-white copy of your artwork—ideally the size at which you want it reproduced—either as a photocopy or digital file. Silkscreen is suitable for calligraphy with larger lettering, because fine lines and details tend to drop out or turn blobby when printed by this method. As with working with other forms of professional printing, it's always a good idea to show

your artwork in person to the printer to determine whether it will reproduce well, or if small changes need to be made. Look for silkscreen shops that specialize in gift and novelty printing for retail customers, as these types of shops tend to be more reasonably priced and have lower minimum quantities.

Letterpress printing and engraving are highly specialized forms of printing, usually used for very special projects such as wedding invitations. If there is a letterpress or engraving print shop in your area, it is well worth a visit to see how the printing is done and how it differs in texture from other kinds of printing. With letterpress printing, the lettering is pressed deeply into the paper, whereas with engraving, the inked letters are raised up from the surface of the paper and very finely detailed. Bring a sample of the artwork you are considering having printed by letterpress or engraving and ask the printer for his input on how it will reproduce.

Glossary

Acrylic ink. Ink that is not water-soluble once dry

Acrylic medium. A clear-drying adhesive, available in glossy and matte finishes, used for gold-leaf and for coating surfaces

Arch. The part of a letter that is attached to the stem of a letter and forms a curve, as in *h, m,* and *n*

Archival. A term used to describe materials such as paper, ink, or glue that have neutral pH; that is, they are non-acidic and will not discolor or degrade over time

Arm. A horizontal stroke that touches a letter at only one end, as in *E* or *F*

Ascender. The part of a lowercase letter that ascends above the x-height

Ascender line. The line that marks the height of a letter's ascender

Awl. A sharp, pointed tool used for poking holes

Baseline. A line (either imaginary or ruled) on which a line of writing sits

Blackletter. A term used to describe the dense, angular writing of the Gothic era

Bleed. A portion of artwork that extends (bleeds over) beyond the line where the paper will be trimmed

Body height. See "x-height"

Bone folder. A bladelike tool made of bone or horn, used for scoring and folding paper

Book Hand. Alphabet styles commonly used in book production before the age of printing, such as Uncial Hand

Bowl. The part of a letter formed where a curved stroke attaches to the stem of the letter, forming an enclosed white space, as in *R, P, a,* and *b*

Broadsheet. A calligraphic work contained on a single sheet of paper

Built-up letters. Letters formed by drawn outlines, which often have fills, ornaments, or other graphic details added to them

Burnisher. A polished piece of metal or stone that is used to rub gold or silver leaf to a high shine

Capitals. Large letters, originating from the letters of ancient Roman inscriptions; also called "upper case" and "majuscule"

Capital line (capline, headline). The line that marks the height of a capital letter, often slightly lower than the ascender line

Cartridge. A sealed plastic tube of ink that is inserted in a fountain pen and disposed of when emptied

Coated paper. Paper that is manufactured with a coating of clay, varnish, or other substance that prevents ink from being absorbed; the terms glossy, matte, velvet, and pearlescent all refer to different types of coating used on paper

Cold-pressed paper. Paper made with a medium-textured surface, generally of cotton or rag content, often used for watercolor painting

Copperplate. A very delicate and slanted writing style, engraved on copper plates that are used for etched and engraved print processes

Counter. The fully or partially enclosed space inside a letter, such as the white space inside the letters *b, d, p, s,* and *c*

Crop marks. Small cross-bars positioned at the margins of a page and used to indicate where the page will be trimmed

Crossbar (or bar). A horizontal stroke as on the letter *t, e, A,* or *H*

Cursive. Handwriting where letters are continuously joined without lifting the pen

Descender. The tail of a lowercase letter that descends below the baseline

Descender line. The line on which a letter's descender should rest

Ear. The small stroke to the right of the lowercase *g*

Edge off. The technique of gradually lifting the edge of the brush from the writing surface, beginning with the right corner of the brush and lifting the left corner last

Edge on. The technique of placing a brush onto a surface gradually, beginning with the right corner of the brush

Finish. The texture of paper, for example, smooth, wove, rough, laid, cockled, vellum, etc.

Flourish. An extended pen stroke used to decorate a letter

Gilding. The application of gold or other metallic leaf to an adhesive base applied to paper or similar surface

Gouache. A particular type of watercolor paint, sold in tubes, which dries to an opaque, flat, and dense color

Gothic. Several different styles of angular and heavy writing that developed in the late medieval period

Grain direction. The direction in which manufactured paper folds most easily

Guidelines. Lines drawn lightly in pencil to indicate the spacing, position, and height of letters

Gum arabic. An organic substance used to help pigment bind with water or to add shine to ink or paint

Hand. A style of writing, script, or alphabet that is written by hand

Hot-pressed paper. Paper made with a smooth-textured surface, generally of cotton or rag content, often used for printmaking

Illumination. Originally used to describe decoration with gold, now used more generally to mean the decoration of letters and manuscripts with metallics and colors

Interlinear spacing. The space between two lines of text

Ladder. A graphic device made up of an alternating row of squares 1 nib width wide, used to calculate the correct proportion of letters in relation to the size of nib being used

Lowercase. Small letters as distinct from capitals; the terms uppercase and lowercase derive from the age of metal type, when capital letters were stored in the top of a wooden type case and small letters stored in the lower part of the case

Majuscule. See "capitals"

Miniscule. See "lowercase"

Parchment. In the past, parchment was a writing surface made from the inner layer of sheepskin; today it is a cellulose-based paper with a slightly mottled texture and subtle variation of color designed look like historic parchment

Paste-up. Preparing artwork for printing by attaching written material to a surface, often a grid

PVA (polyvinyl acetate). An archival, water-based adhesive used for paper crafts, bookbinding, and gilding

Rag (or rag paper). Paper containing cotton content derived from recycling of cotton fabric

Reservoir. 1. A removable tubelike device that fits in a fountain pen and can be filled with ink and used over and over again; 2. A small metal flap that fits over or under a calligraphy nib, allowing the nib to hold a small amount of extra ink in reserve

Rule. To draw lines, usually lightly with a pencil, to indicate placement of lines of lettering, margins, or spacing

(continued)

Score. To draw a thin, hard object (like a bone folder or metal wheel) across paper, usually using a ruler as a guide, to prepare the paper for being folded

Serif. A small stroke that finishes the main stroke of a letter; can be flat, rounded, square, or pointed

Stem. The main vertical stroke of a letter; in diagonal letters like *n*, *o*, and *Z*, the diagonal line is considered the stem

Stroke. A line, either straight or curved, drawn with a pen or brush

Swash. A swash is a wavy, curved, looped or otherwise embellished stroke that forms part of a letter. It's an additional decorative stroke added to basic the letterform.

Tail. A diagonal or curved stroke that connects to a letter at one end, as in R, Q, and y

Terminal. The end of a stroke that does not end with in a serif

Uncoated (paper). Paper that is not varnished or coated with any substance

Uppercase. See "capitals"

Vellum. In the past, vellum was a writing surface made from the skin of a calf, and had a smooth, velvety texture; today it is a very smooth translucent paper

Versal. A large, decorative letter, often used at the beginning of a sentence or chapter

Weight (letter). The size and thickness of a letter, determined by the relation of nib width to letter height

Weight (paper). The thickness of a sheet of paper; in most countries this is measured by its weight in grams per square meter (gsm), in the United States it is measured by pounds per carton (lb)

X-height. The height of a lowercase letter, not including ascenders or descenders; also called body height

Waterproof. Ink or paint that is nonsoluble in water when dried

Anatomy of Letterforms

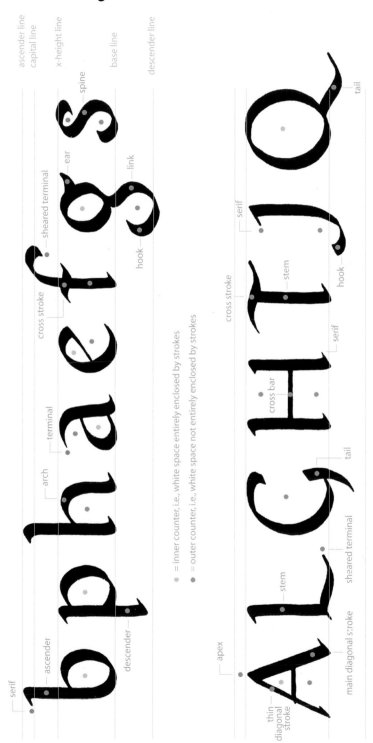

● = inner counter, i.e., white space entirely enclosed by strokes

● = outer counter, i.e., white space not entirely enclosed by strokes

Products Used

Pattern Bookmark

- Calligraphy paper: Pentalic Paper for Pens
- Backing paper: Canson cover, assorted colors

Passe-Partout Picture Frame

- Photo frame paper: Murano cover stock.
- Photo paper: HP Laserjet glossy photo paper
- Photo mounting paper: Arches hot-pressed 300-gsm printmaking paper

Two-Tone Place Cards

- Paper: Sorbet duplex cover, Legion paper
- Brads: EK Success

Floating-Layer Thank-You Notes

- Paper and envelopes: Rössler Papier Paperado line; Lime Green, Olive Green, Denim Blue, Cappuccino, White (available from www.roessler-dueren.com)
- Decorative Paper: Shizen

Tiny Artist's Book

- Paper for pages: Pentalic Paper for Pens
- Cover: Canson Mi-Teintes, 80-lb. cover, Poppy Red (available from www.canson-us.com)
- Leather Cord: Camp Hoochee Coochee by toner-plastics.com

Decorative Spice Labels

- Label stock: Strathmore Writing 70-lb label stock, soft white

Award Certificate

- Parchment: Panache beige parchment, Speedball Art Products
- Seal: Strathmore Writing 70-lb label stock, soft white

Mosaic-Style Greeting Card

- Color-washed paper: Medieovalis by C. M. Fabriano
- Backing sheet: Murano cover

Illuminated Holiday Card

- Paper and envelope: Mediovalis by C. M. Fabriano
- Backing paper: Savoir Faire red cover
- Ink: Winsor & Newton crimson calligraphy ink, Schmincke gold and white calligraphy gouache

Broadside

- Paper: Arches cold-press 300-gsm watercolor paper
- Ink: Schmincke calligraphy gouache, assorted colors

Illuminated Initial Medallion

- Vellum: Bee Paper 68-lb tracing vellum
- Acrylic Ink: Permanence liquid acrylic, moss green; Daler Rowney FW
- Acrylic Ink: Daler Rowney FW, emerald green
- Metallic Pigment: Schminke Tro-Col-Broze Dry Gouache Reichgold
- Diamond Glaze: Judi·Kins Diamond Glaze
- Medallion: Patera pendant finding by Nunn Design (available from www.nunndesign.com)

Zodiac Accordion Book

- Book pages: Arches (120 ssm) cold-press text
- Decorative paper for cover: Lama Li

Magnetic Alphabet Set

- Magnetic sheet: Paint·A·Mag paintable surface magnetic sheet by Magnetic Specialty Inc. (available from www.magspec.com)

Spooky Signs

- Craft plywood sign blanks: Michael's Crafts

Band Logo T-Shirt

- Inkjet thermal transfer paper: Papilio Light Color T-Shirt Transfer Media (available from www.papilio.com)

Informal Invitation

- Text paper: Crane 100% cotton 80-lb text
- Backing paper and envelope: Paper Source
- Decorative paper: Lohkta

Stationery with Cross-Writing Borders and Lined Envelope

- Paper: Bee Pen and Ink Sketcher Paper, 80-lb text
- Gold ornaments: Schminke calligraphy gouache

Layered Heart Valentine

- Backing paper: Paper Source 80 cover
- Bristol: Strathmore 100-lb smooth Bristol
- Brads: EK Success

Faux-Vintage Scrapbook Pages

- Paper: Savoir Faire, black French ribbed kraft paper
- Photo paper: HP laserjet photo paper, glossy
- White ink: Schmincke white calligraphy gouache
- Black photo corners: NuAce photo corners by Ace Art Company

Script Notes on Pearlescent Paper

- Paper: Stardream 80-lb cover
- Envelope: Stardream 70-lb text

Gold Leaf Treasure Box

- Round paperboard box: Michael's Crafts
- Gold leaf: Schlagmetal faux-gold leaf from Pen & Ink Arts
- Sizing: Rolco Labs Water-Based Aquasize
- Liner fabric: JoAnn Fabrics

Brush Lettered Name Plaque

- Craft plywood base and shapes: Michael's Crafts
- Lettering paints: Liquitex acrylics
- Gloss polymer medium: Golden Gloss Polymer Medium

Wedding Invitation Suite

- Backing sheet paper: Paper Source Luxe 80-lb cover
- Top sheet paper: Paper Source 80-lb cover
- Petal envelopes: Waste Not Luxe 80-lb cover petal envelopes
- Sticker stock: Strathmore writing 25% cotton label stock, soft white
- Envelopes: Waste Not 70-lb text
Scanning and Inkjet Printing Calligraphy
- Paper: Strathmore Pastelle 80-lb cover
- Inkjet printer: HP Deskjet 952C

Resources

Recommended Suppliers of Calligraphy Products

Following are three of the most knowledgeable, friendly, and well-stocked suppliers you'll ever find. Phones are answered by real people who are happy to take your order as well as supply useful advice.

Wet Paint, Inc.
1684 Grand Avenue
St. Paul, MN 55105
(651) 698-6431
www.wetpaintart.com
This company has an extensive selection of art supplies including inks, nibs, calligraphy pens, papers, and brushes as well as an extremely knowledgeable and helpful staff (most of whom are artists themselves).

Paper & Ink Arts
3 North Second Street
Woodsboro, MD 21798
(800) 736-7772
www.paperinkarts.com
The free mail-order catalog offers everything a calligrapher could dream of, plus plenty of tips and product recommendations.

John Neal Bookseller
1833 Spring Garden Street
Greensboro, NC 27403
(800) 369-9598
www.johnnealbooks.com
This company offers a calligrapher/bibliophile's dream selection of pens, papers, nibs, inks, books, and abundance of interesting miscellany; publisher of *Letter Arts Review* and *Bound & Lettered*.

Pens and Nibs

J. Herbin
www.jherbin.com/calligraphy_supplies.shtml

Sheaffer Pens
www.sheaffer.com

Speedball Art Products Company
www.speedballart.com

Brause Nibs
www.exaclairinc.com/brands_brause.shtml

William Mitchell Nibs
www.scribblers.co.uk/acatalog/William_Mitchell_Nibs.html

Wills Quills
www.willsquills.com.au

Pilot Parallel Pens
www.pilotpen.com

Calligraphy Markers

Staedtler
www.staedtler-usa.com

Itoya
www.itoya.com

Marvy-Uchida
www.marvy.com

Zig Markers
www.paperinkarts.com

Inks

Winsor & Newton
www.winsornewton.com

Daler Rowney
www.daler-rowney.com

Dr. Ph. Martin's
www.docmartins.com

Pelikan
www.pelikan.com

J. Herbin
www.jherbin.com/fountain_pen_inks.shtml

Gouaches, Pigments, Watercolors, and Acrylic Paints

Schminke
www.schmincke.de/produkte/gouache-vielfalt.html?L=1

Winsor & Newton
www.winsornewton.com

Holbein
www.holbeinhk.com

Liquitex
www.liquitex.com

Golden Paints
www.goldenpaints.com

Papers

Strathmore Artist Papers
www.strathmoreartist.com
Sketchbooks, art papers, inkjet papers, envelopes, label stock, and stationery paper

Pentalic
www.pentalic.com
Papers, books, sketchbooks, and paper for pens

Arches
www.arches-papers.com/en
High-quality cotton printmaking, watercolor, and drawing papers

Rives BFK
www.rivesbfk.com
High-quality cotton printmaking, watercolor, and drawing papers

Canson
www.canson-us.com
Papers, envelopes, scrapbooking, and craft supplies

Fabriano
www.cartieremilianifabriano.it/uk/_prodotti.html
High-quality cotton papers, envelopes, and stationery

Stardream Metallic and Pearlescent Papers (Legion Paper)
www.legionpaper.com/Our-Collection/By-Brand/Stardream.htm

Paper Source
www.paper-source.com
Commercial paper, stationery, and envelopes in a great range of colors, styles, and sizes

Art and Craft Supplies

Daniel Smith Art Products
www.DanielSmith.com

Arch-San Francisco
www.archsupplies.com

Dick Blick Art Materials
www.dickblick.com

Utrecht Art Supplies
www.utrechtart.com

Pearl Paint
www.pearlpaint.com

Art Materials
www.artmaterialsonline.com

Joann
www.joann.com
Fabric, books, and craft supplies

Michael's Crafts
www.michaels.com
Art and craft supplies, papers, mattes, frames, jewelry supplies

Bobby Bead
www.bobbybead.com

Organizations

Association for the Calligraphic Arts
www.calligraphicarts.org
International organization based in Rhode Island, United States

Society of Scribes (New York City)
www.societyofscribes.org

Calligraphy & Lettering Arts Society (UK)
www.clas.co.uk

Washington [D.C.] Calligraphers Guild
www.calligraphersguild.org

Society of Scribes and Illuminators (UK)
www.calligraphyonline.org

Friends of the Alphabet, Calligraphy Guild of Atlanta
www.friendsofthealphabet.org

Society for Calligraphy (Southern California)
www.societyforcalligraphy.org

Dedication

To my grandfather, Harold Frank Gauthier, who first introduced me to calligraphy, and to Julo Gauthier and Tim Gartman, two gentle and creative souls who unfailingly nurtured and celebrated the artist and individual in me.

Acknowledgments

Special thanks to Eric Dregni, Joey Brochin, Erik Mattheis, Nick Hook, Jeannine Bourdaghs, Linda Neubauer, Deb Pierce, Jim Walsh, Kris Manion, Pete Semington, Brenda Broadbent at Paper & Ink Arts, and to Darin Rinne, Verra Blough, and all the wonderful staff at Wet Paint—thank you, for your generous advice, support, and encouragement.

(Thank you also to Francis and Sassafras for being so patient and well-behaved while I was working, for not chewing or scratching too many pieces of paper, and for believing me when I told you that it is very important that kitty cats do not drink the calligraphy water.)

About the Author

Jeaneen Gauthier studied art, anthropology, and Chinese at the University of Minnesota, where she graduated *summa cum laude* in 1991. In the early 1990s, she co-founded the Lunalux Art and Design Workshop, a letterpress and book arts studio for custom-made invitations, calligraphy, and posters. As the principal designer at Lunalux, Jeaneen designed many product lines of stationery featuring her calligraphy and illustrations, as well as products and commissions for many others, including *Martha Stewart Living* and *Martha Stewart Weddings*.

She currently works as a self-employed artist specializing in custom-made invitations and stationery, illustration, photography, and textile design. She sells her line of handcrafted jewelry, barrettes, and greeting cards that feature her calligraphy and illustrations on her webstore at www.Joyology101.etsy.com.

Jeaneen also writes and performs alternative easy-listening music under the stage name of "Jan," and has released three CDs of original music to date. She lives and works in her home studio in Minneapolis, Minnesota.

Visit her website at www.jeaneengauthier.com

Passe-Partout Picture Frame
Enlarge 200%

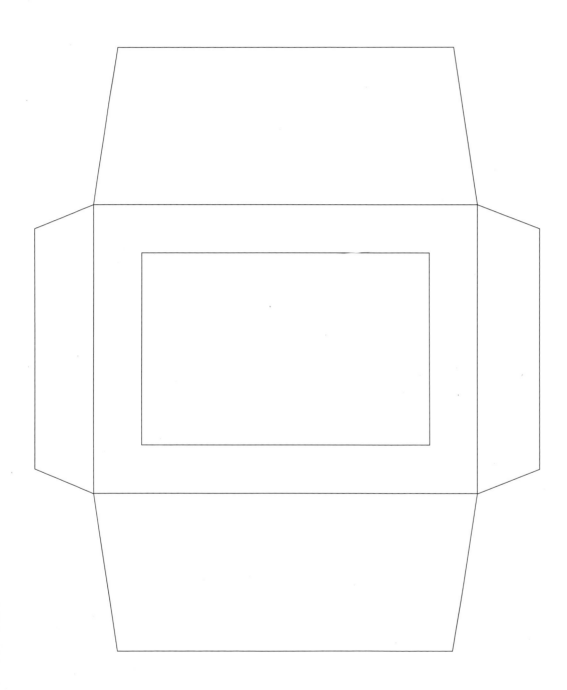

Wedding Response Card
Enlarge 200%

Index